CHALK STREAMS

A Unique Environment Worth Conserving

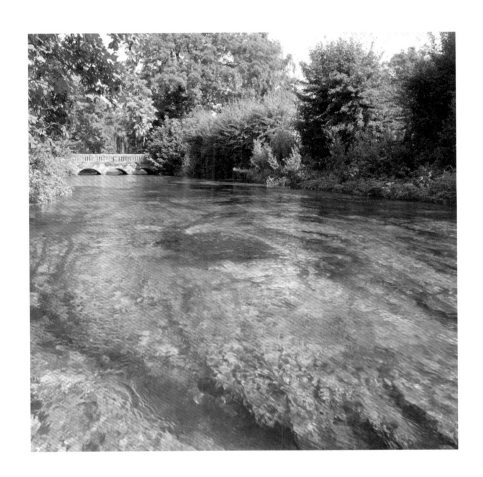

Dick Hawkes

ISBN: 978-1-913012-26-7

Published in partnership with Riverside Publishing Solutions.

Printed and bound by Jellyfish Print Solutions.

CONTENTS

INTRODUCTION

Chalk Streams – A Unique Environment Worth Conserving is a photographic view of what has been called England's "rainforest". Around 85% of the world's chalk streams are in England. They are beautiful, biologically distinct and amazingly rich in wildlife, but are under threat from man made issues of abstraction, pollution from chemicals and effluent, and climate change.

My aim with this book is to create a representative record of this precious and ecologically unique habitat, and hopefully illustrate why it is worth conserving. The sections of the book show through photographs the creation of the landscape by both natural forces and human intervention, an exploration of the ways in which it is being maintained and managed today and – the main focus – show the variety of flora and fauna to be found there.

This book is a lay guide to chalk streams and does not attempt to be comprehensive or to be a scientific record. It is representative collection of images from a small number of southern England chalk streams to capture the essence of these environments. Included are typical habitats and typical species of wildlife found in chalk streams and water meadows, highlighting those rare or most under threat.

All the images I have taken including the wildlife are in-situ – in their natural setting of the chalk streams – to give context and, where possible, show activity. For example birds hunting for food, ecologists from the wildlife trusts undertaking surveys of some of the rarer species and the work of the keepers and others who maintain the rivers. The majority of the photographs have been taken between 2018 and 2020, which has been a real challenge as wildlife do not appear to order and I live more than an hour and half drive away. The logistics therefore have been a significant factor in producing this book and I have relied on many people for help identifying likely locations for individual target species.

BACKGROUND INFORMATION

The chalk stream environment includes many stages, from headwaters and winterbournes to wetlands and lush water meadows. The chalk topography acts as an aquifer: ground water filtered by the chalk bedrock emerges as springs that are mineral-rich, gin-clear and have a fairly constant temperature. This encourages a wide variety of flora and fauna to make the chalk stream their habitat. The river banks vary from wild woodland to pristinely managed fisheries to urban areas to wide open floodplains.

Human intervention is a great part of the history of these environments. Leats, drainage channels, hatches and mill ponds were built in the 13th century to provide water to the many mills. In the 17th century, the water meadows system was created in Wiltshire and elsewhere with man-made carriers and sluices used to control flooding of fields, resulting in natural fertilisation and significantly higher returns from the land. This labour-intensive farming has long since been replaced by modern fertilisers and methods, but the infrastructure of carriers and the main river routes has created the chalk stream environments we know today. Over the last few decades the reducing return for farmers has led to more of the land being converted to other forms of agriculture or to be sold off for housing development. This has radically altered the landscape. The natural water management and floodplain system has been changed by dredging and the straightening of river channels, either in wartime for tank defences, or as flood defences that disconnect the river from its floodplain and paradoxically render it more prone to flooding. Man has shaped the chalk streams for centuries. Many are now maintained as natural environments by fishing societies, wildlife trusts and environmentally aware farming interests. Some are designated as SSI (Sites of Specific Scientific Interest) and SAC (Special Area of Conservation), but there are many pressures on these fragile habitats.

THE BEAUTY OF THE CHALK STREAM

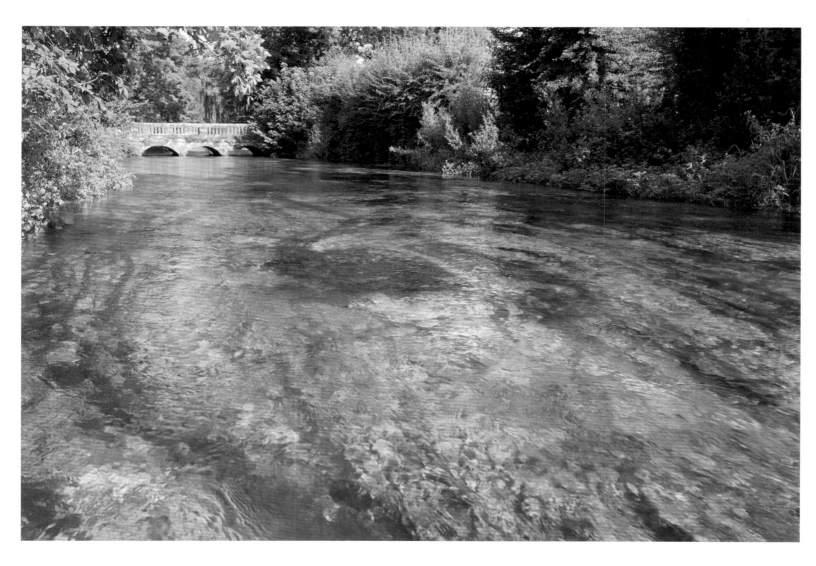

The upper Test with abundant Ranunculus.

The beauty of the chalk stream as epitomised by the middle Itchen.

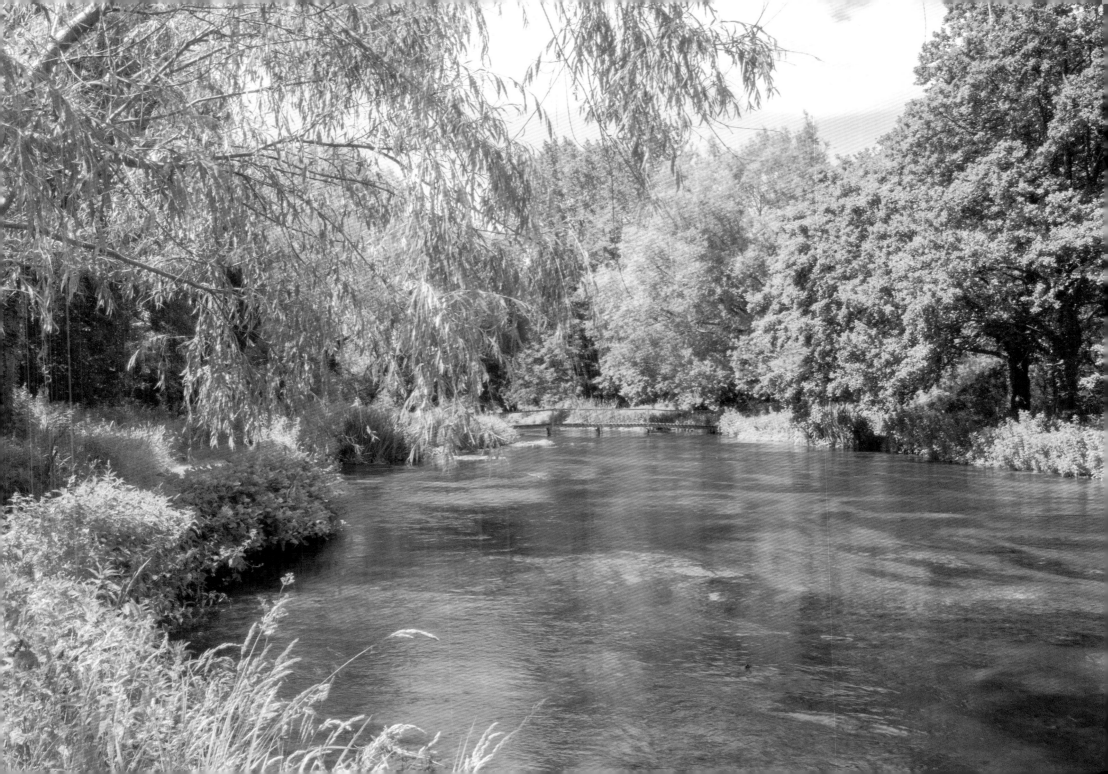

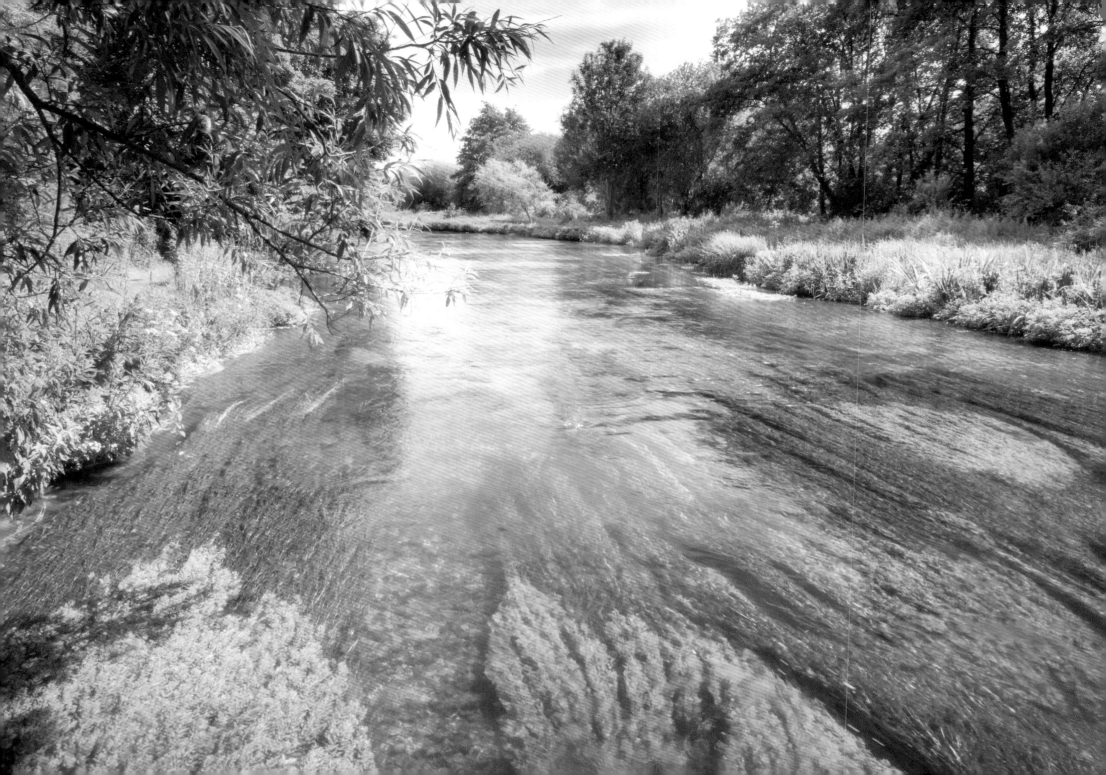

Plenty of healthy weed in clear water with good flow on the Itchen.

Typical footbridge across the river Itchen showing the invertebrate-holding aquatic weeds in the shallow clear water.

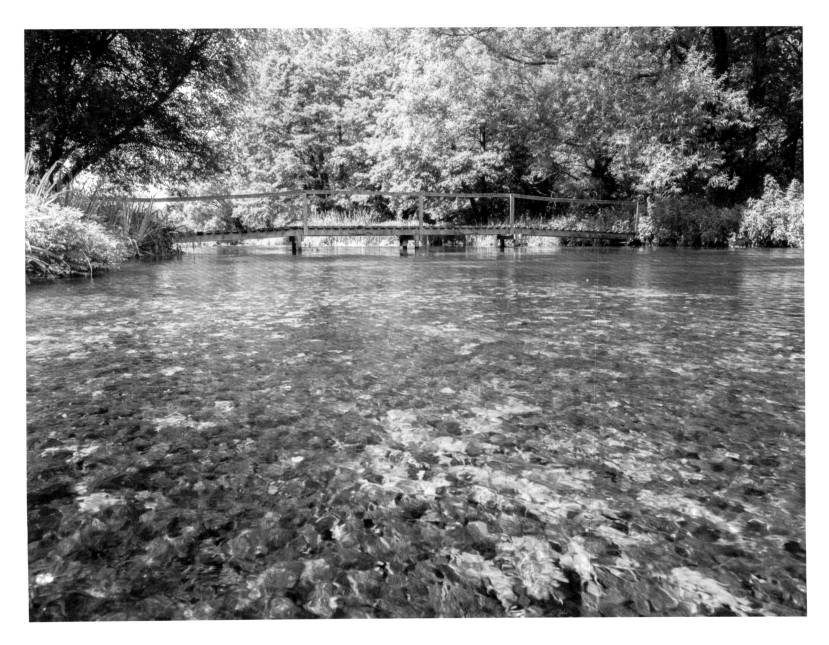

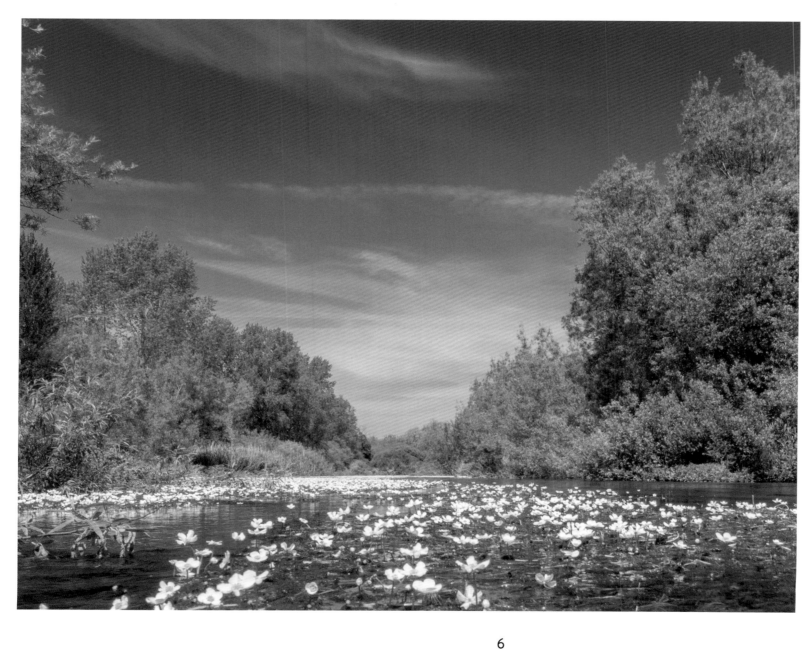

◄ Ranunculus in full flower on the Avon.

► Summer light on the upper Itchen.

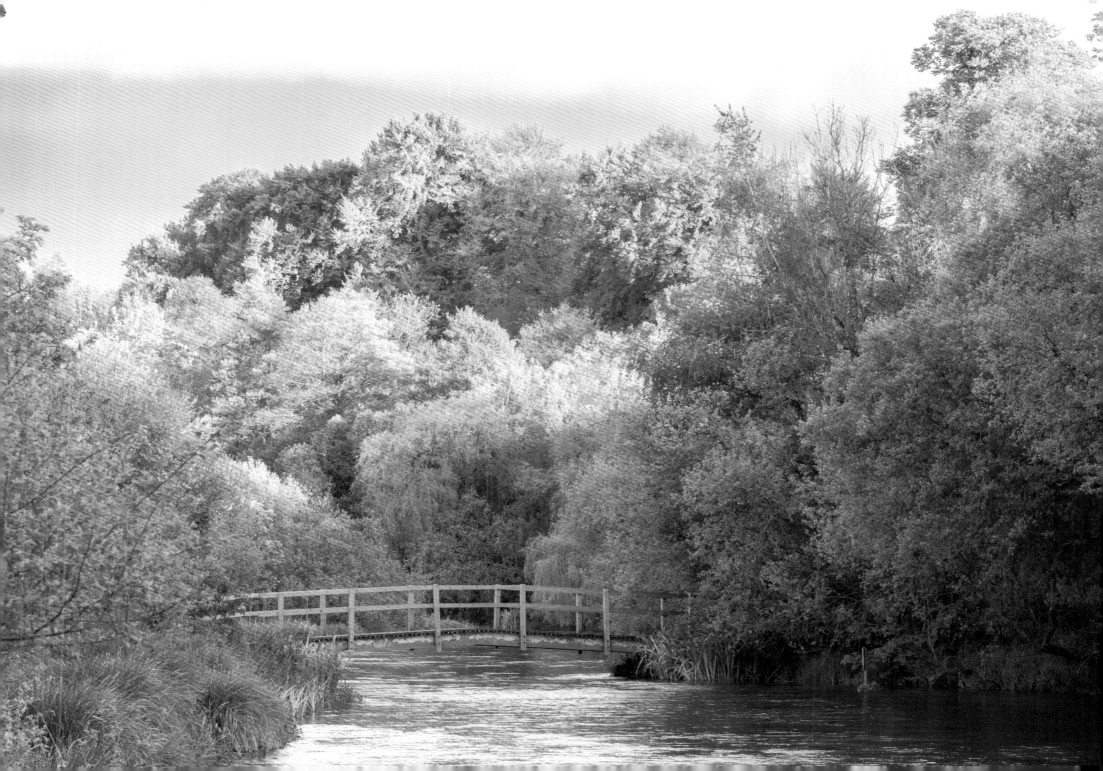

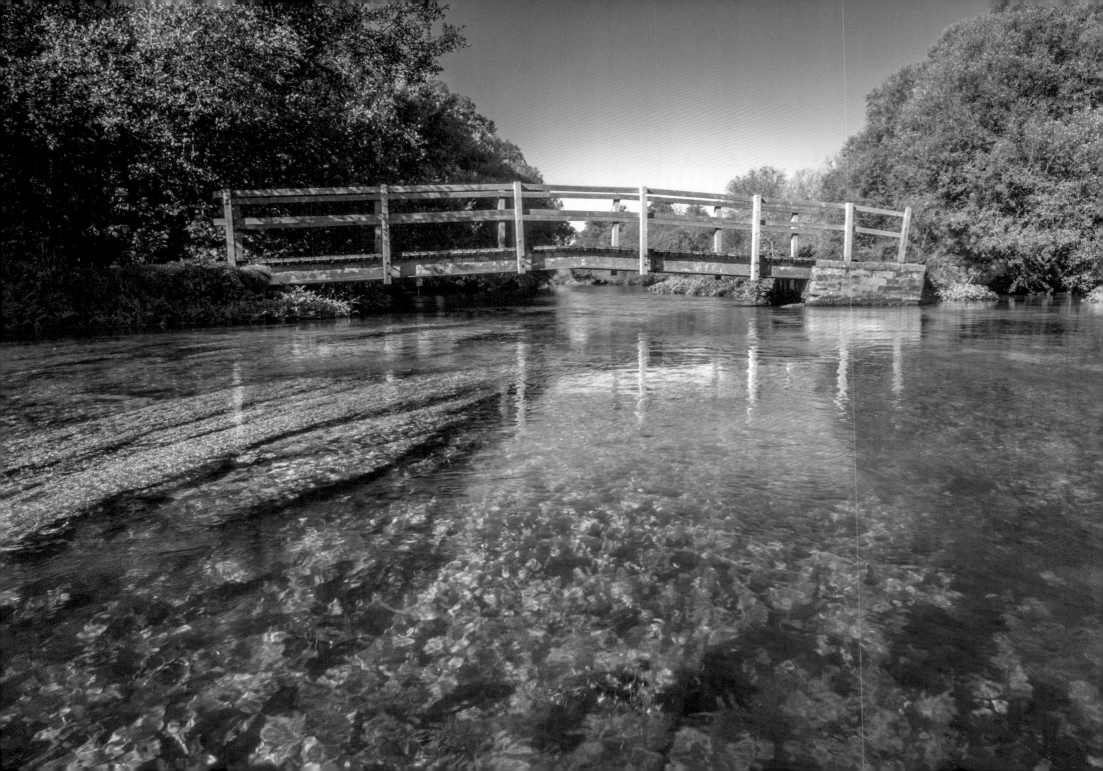

September light with just a hint of Autumn colour to the leaves and the weed still green.

The same stretch at dawn in winter.

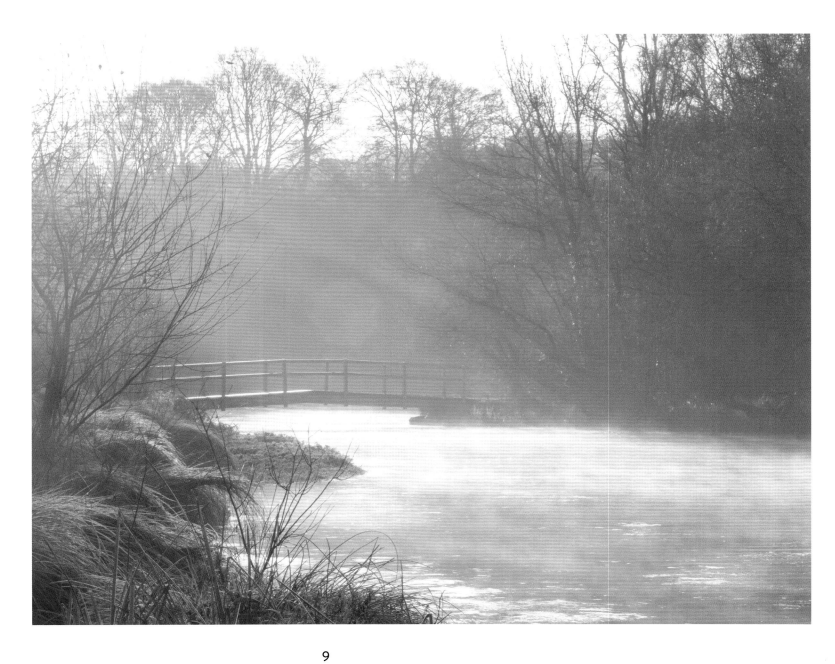

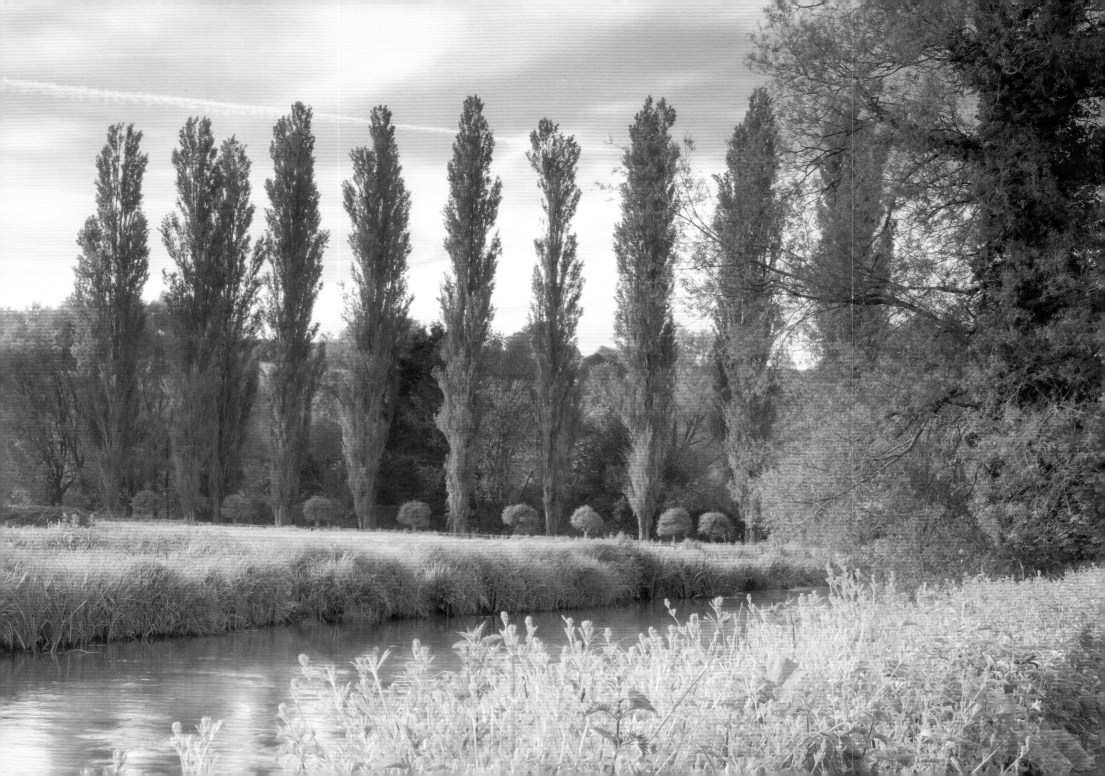

The Avon just before a converted
mill with attractive tree planting
on the approach road.

The Autumn light on the Upper
Test (below and overleaf).

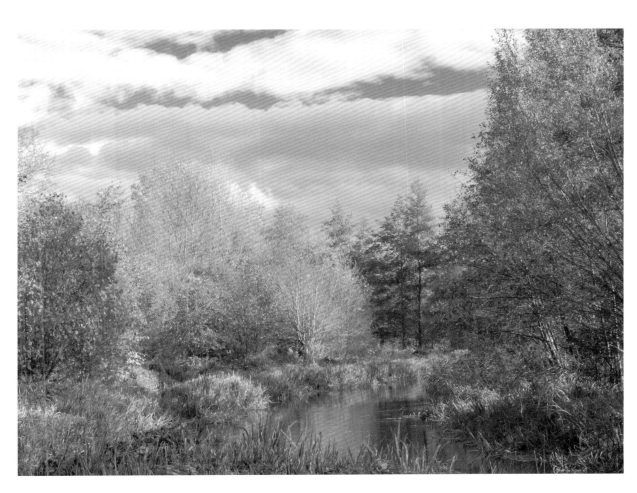

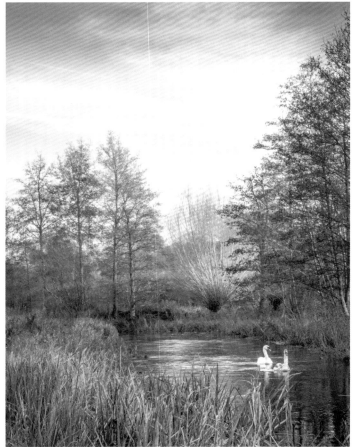

11

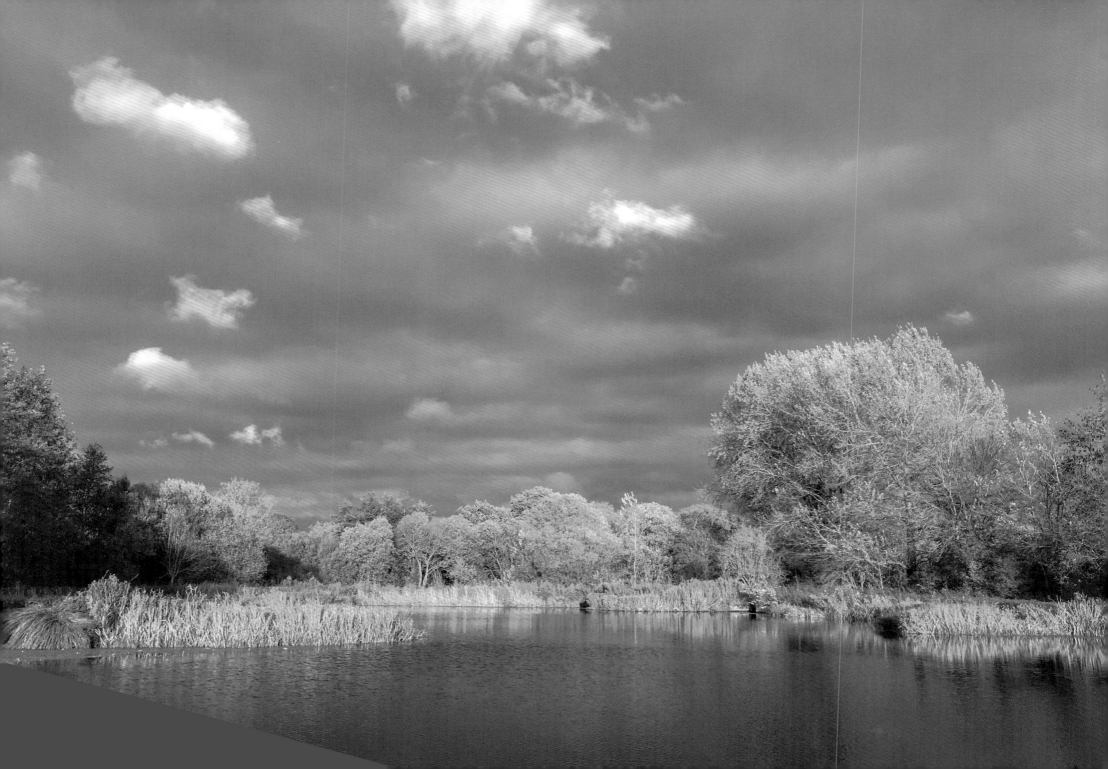

SOURCES

1. The Aquifers

One of the sources of a chalk stream is the network of aquifers in the chalk. Shown here are typical chalk downs in Wiltshire – the Wylye valley (previous page), the Woodland valley with the Avon (upper left and below), and the upper Itchen catchment area (upper right). The chalk is easy to see in any cultivated field.

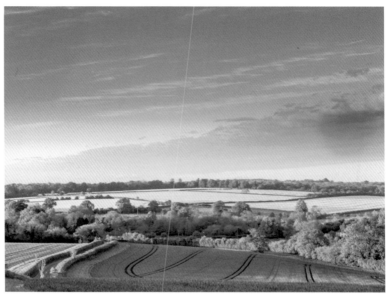

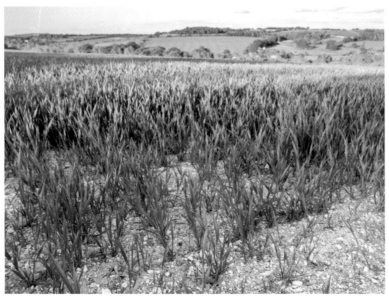

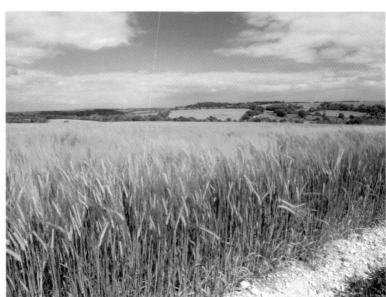

2. Winterbournes

Winterbournes, a source of the chalk streams. They channel water from the chalk hill aquifers during winter and early spring, but by summer are totally dry.

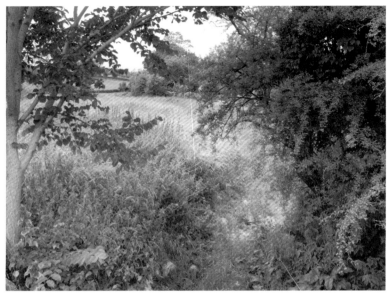

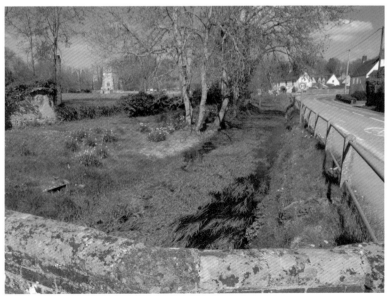

3. Headwaters

Much of the source of water for chalk streams is from springs fed all year by the winter rainwater which has permeated very slowly through the chalk aquifers. The springs occur throughout the upper river system. The top of the headwaters tend to be insignificant springs creating wetlands in the middle of fields as shown here. Top left is the source of the Test near Ashe. The other images show the sources of the River Itchen just above the village of New Cheriton. One shows the first rather unremarkable sign in the middle of a field, with a more obvious sign a couple of hundred metres along. There is separate source forming a channel just a short way North (bottom right).

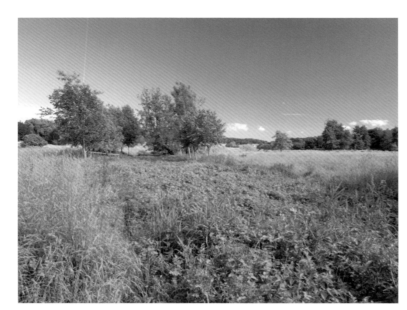

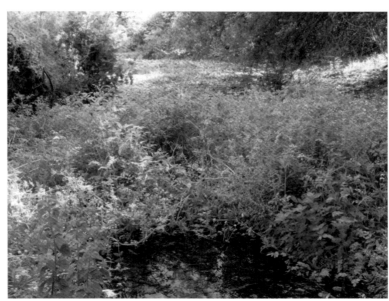 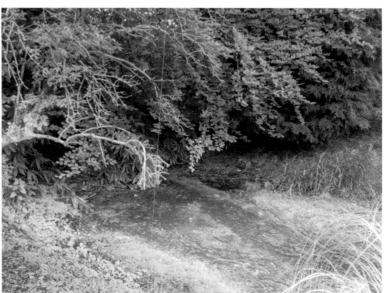

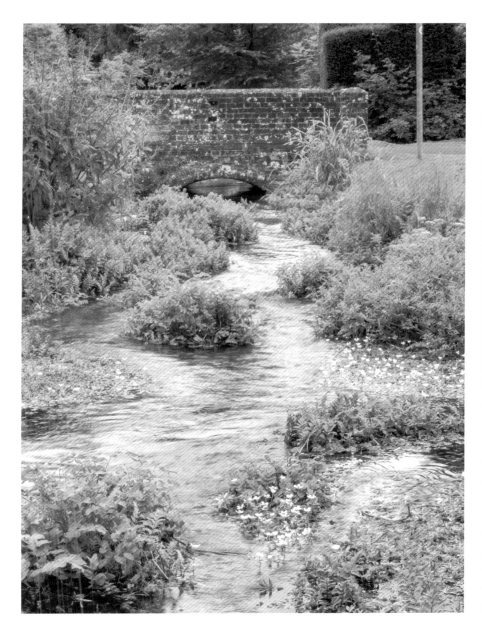

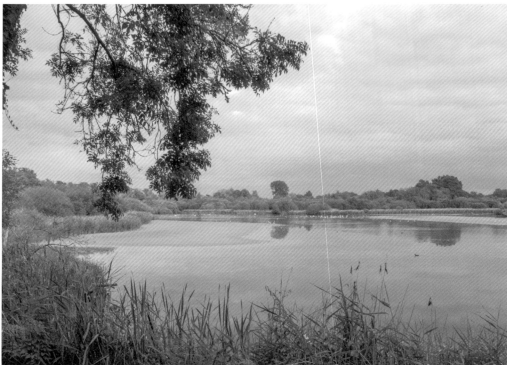

Only a mile or so from the source of the Itchen at Cheriton village the stream is already looking like the classic upper reaches of a chalk stream with good flow. This demonstrates how much of the water comes from the many springs from the bed of the channel throughout its length. This stretch is maintained by local volunteers with the flow monitored by the Environment Agency (left).

The Arle (overleaf) is a lovely tributary of the Itchen with the source being Alresford pond which is now badly silted up (above right). Just beside the pond is a large cress bed and salad washing facility. The image of the Arle shows the good flow only a mile or so from the source. This is another example of how much of the water comes from springs along the channel itself. The water is not as clean as first looks as there are increasing levels of chemicals finding their way into this sensitive environment.

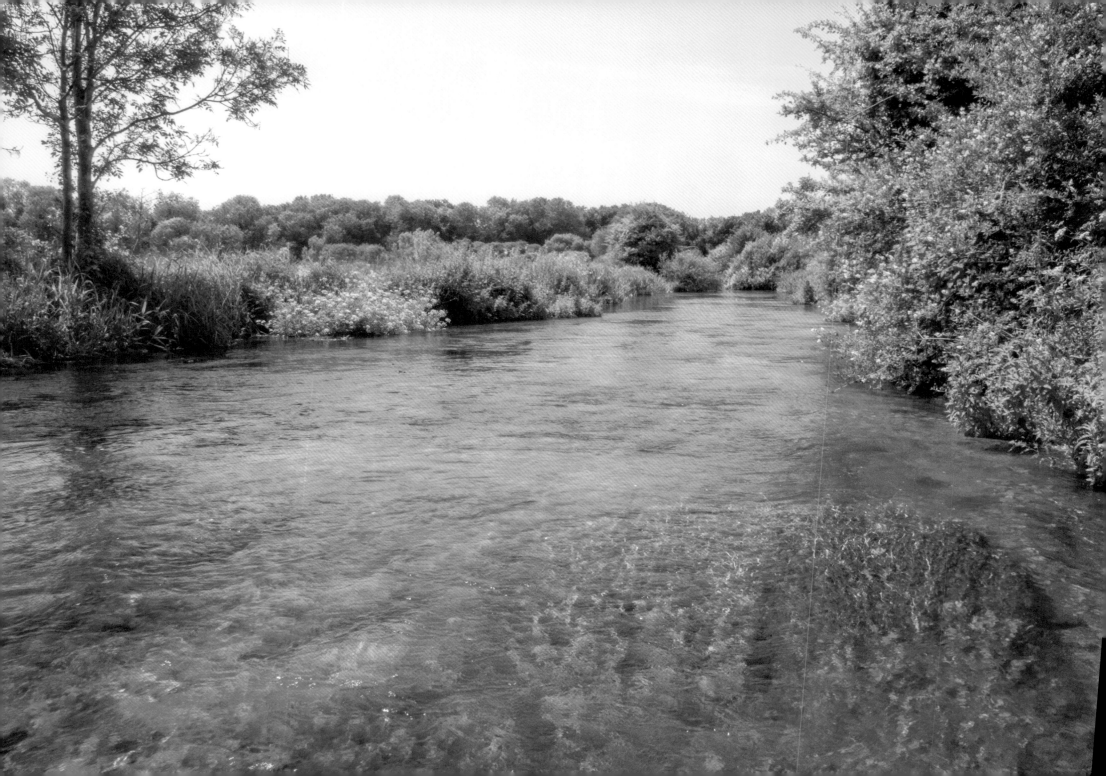

HABITATS

The images in this section show some of the varied habitats to be found in and around the chalk streams. A tiny channel running a few yards from one of the springs coming from a small chalk hill, one of the sources of the Meon (below left); the woodland headwaters on the Candover Brook (below right and overleaf); shallow crystal clear flows over pristine gravel and abundant weed growth in the meandering Bourne Rivulet (page 21 and 22), a tributary of the Test; the original channel route of the Avon running parallel to a mill leat runs into a thick tangle of woodland and bushes (page 23 left); the Wylye river course going through a Wiltshire downland valley before joining the Avon (page 23 right and page 24).

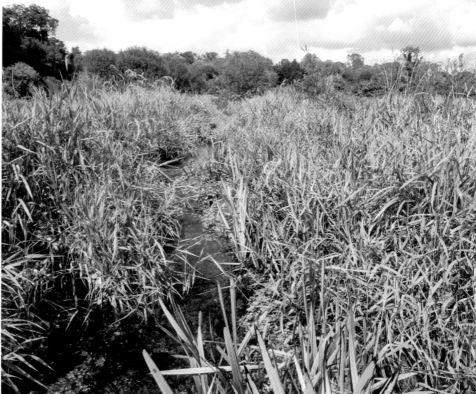

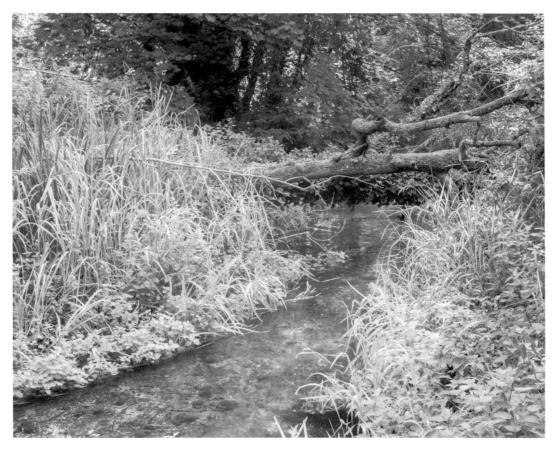 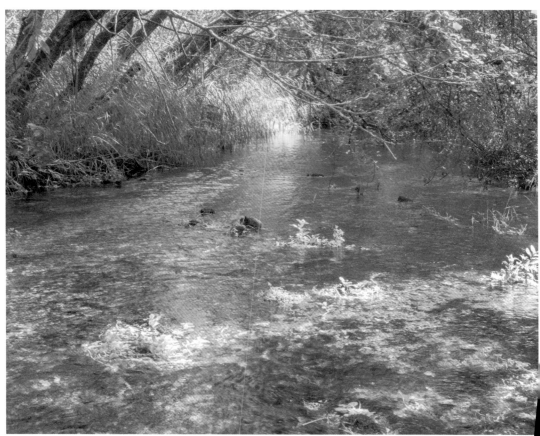

20

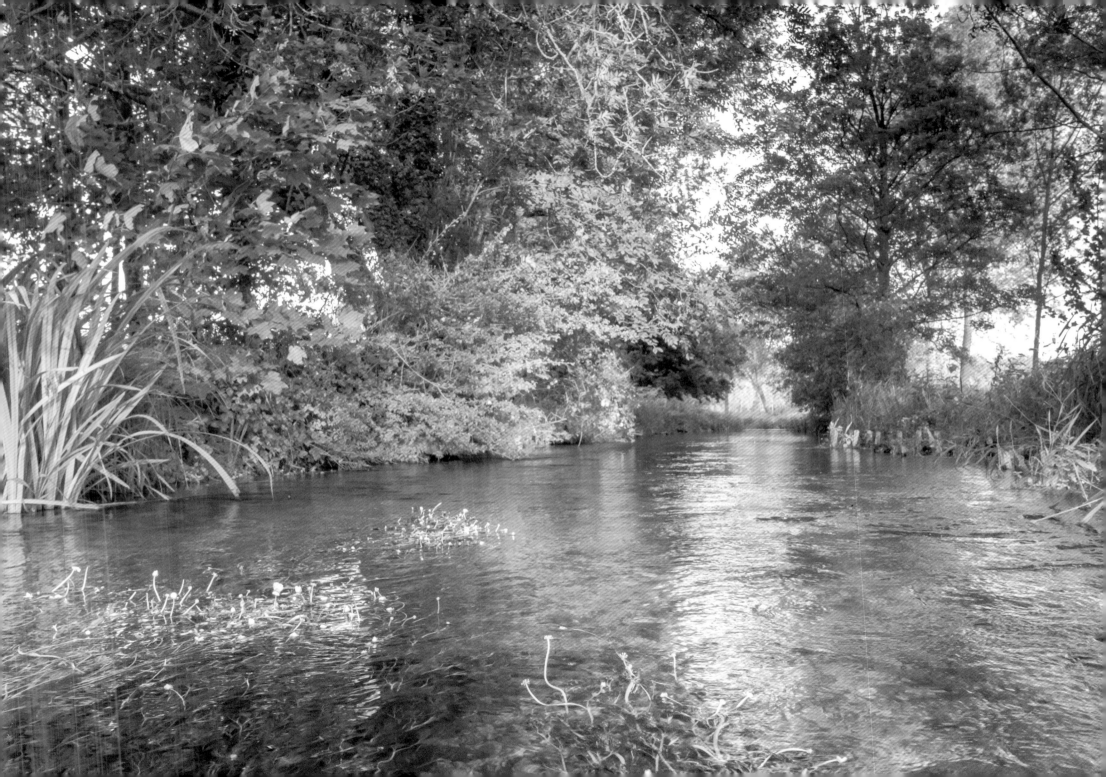

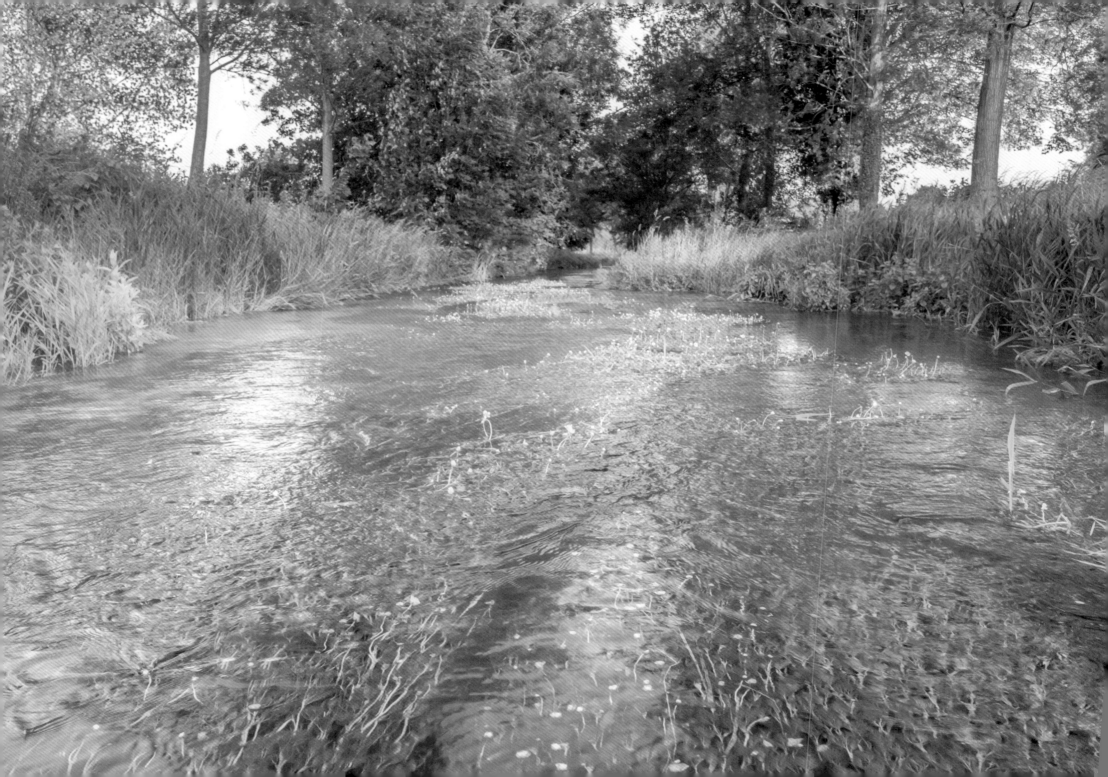

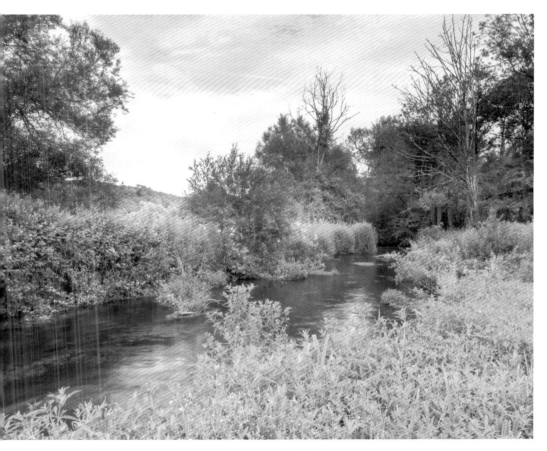 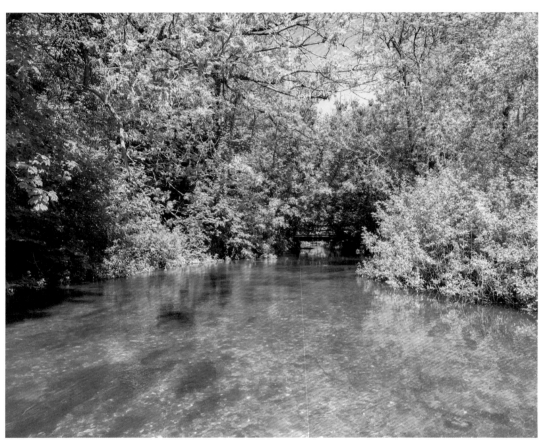

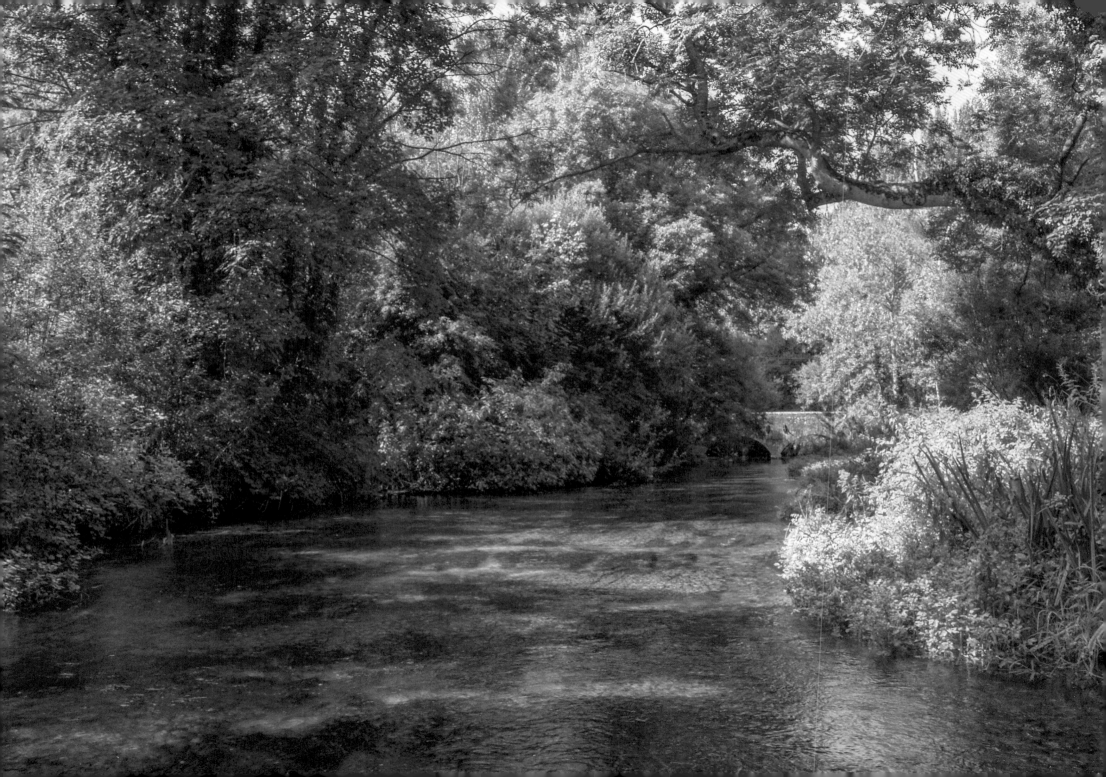

Itchen Stoke Mill on the upper Itchen is situated in a well preserved early example of a water meadow system. The early dating is suggested by the channels and carriers following the natural features of the land, rather than straight man made channels that are typical of later water meadow system. More of this later.

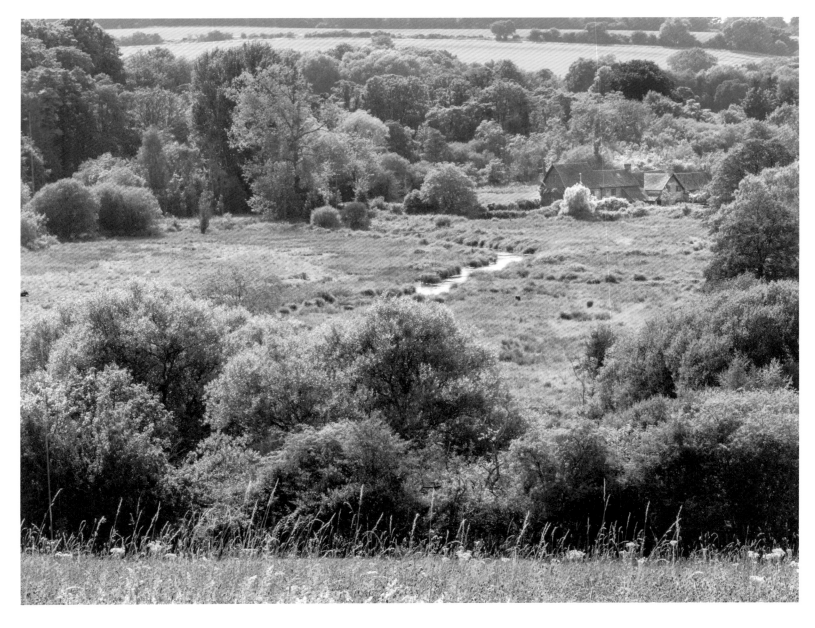

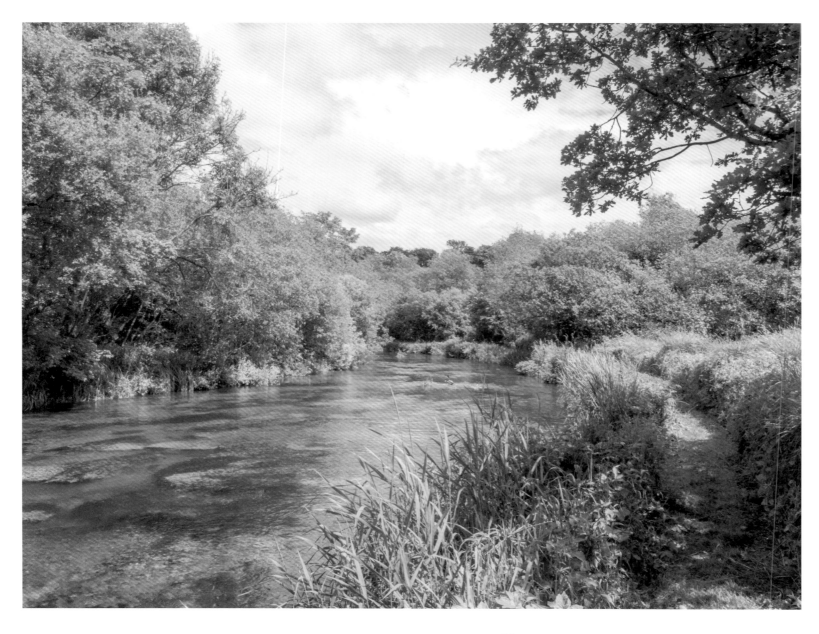

The main channel of the Itchen at Itchen Stoke Mill water meadows. A typical view of a chalk stream with plenty of life preserving weed such as ranunculus that depends on the good flows.

A wide shallow channel on the upper Itchen, not long after a weed cut, showing the chequerboard pattern used to control the flow so it gouges clear channels of gravel, yet preserves enough ranunculus and other weed to maintain good water levels and provide shelter for both invertebrates and fish.

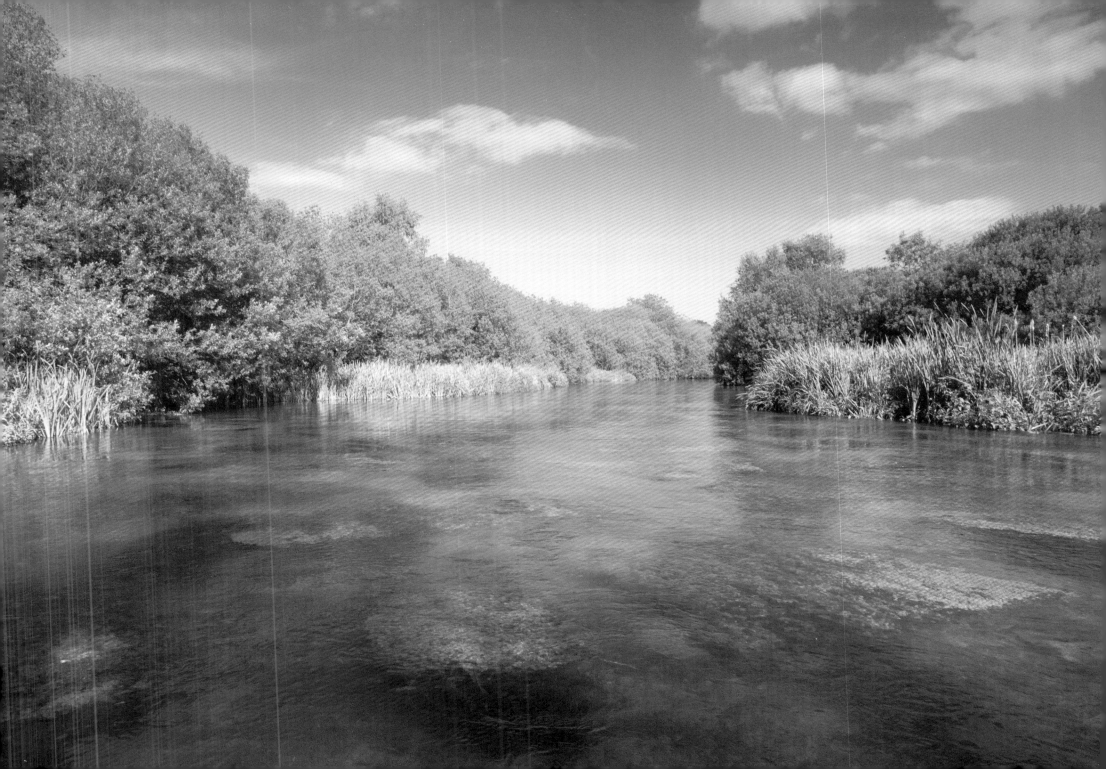

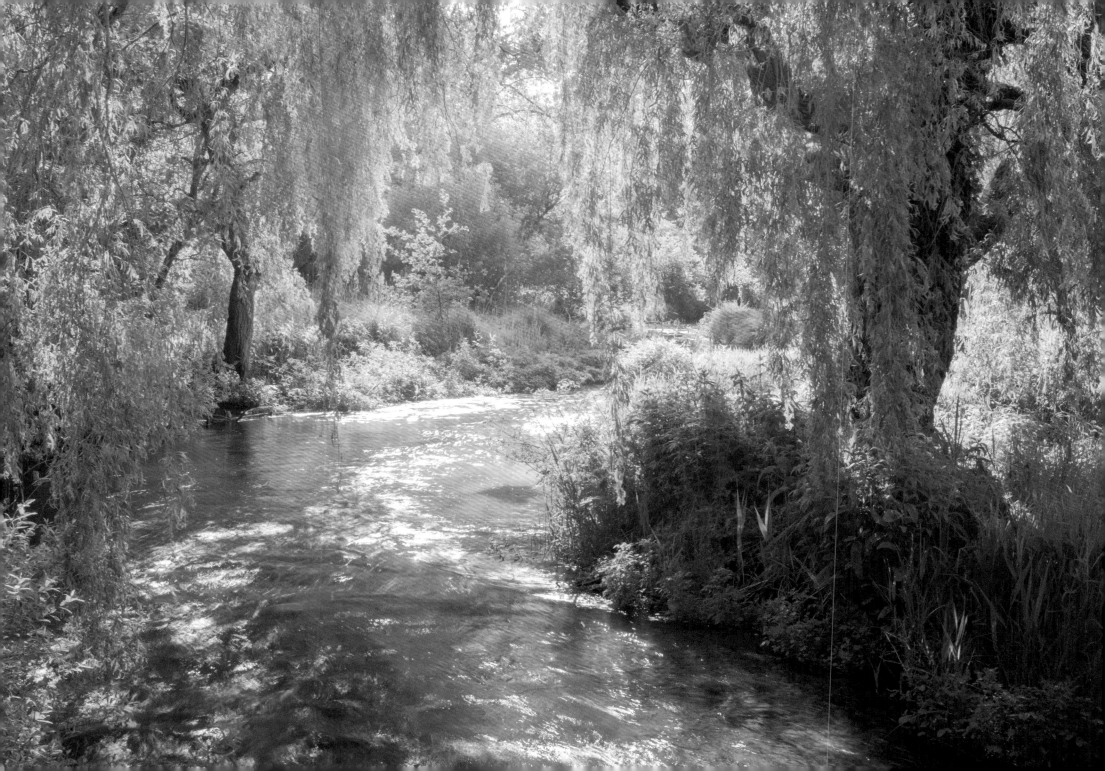

Early afternoon summer sun sparkling on one of several carriers in an area of complex channels that split the upper Itchen near Kings Worthy. The many channels and carriers, mostly man-made over the centuries, were to to divert the flow for irrigation and commerce.

The wide and more open stretches, such as at Abbots Barton on the Itchen, owned by the Hampshire and Isle of Wight Wildlife Trust.

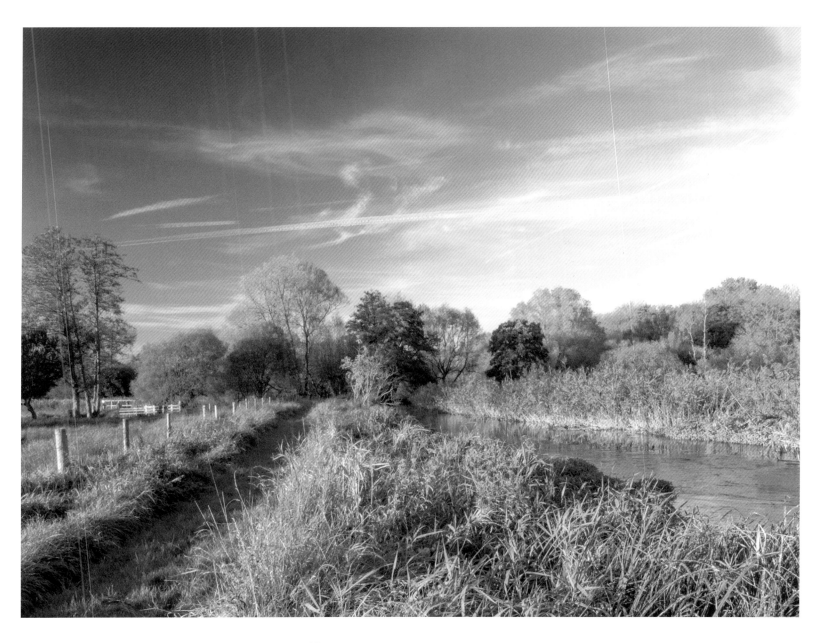

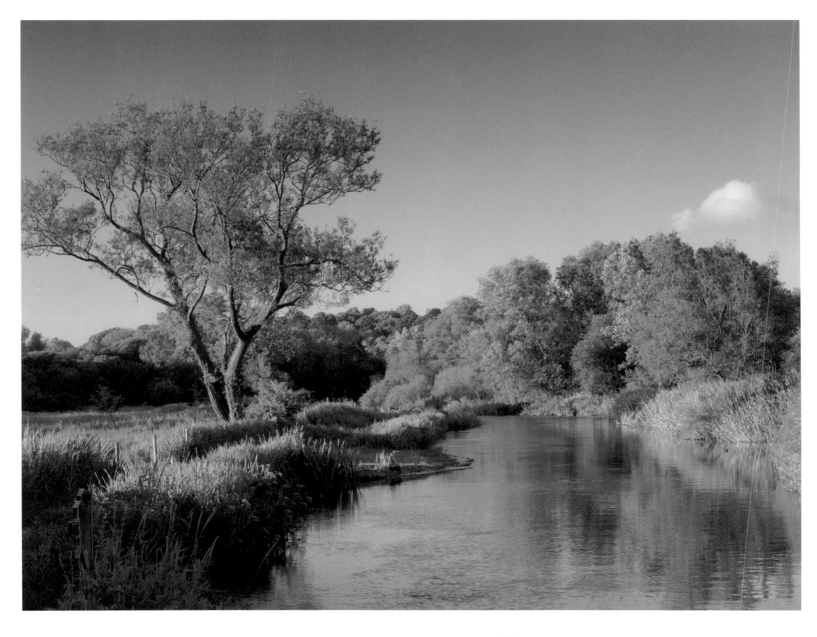

◁ Early evening light in summer on the Avon in the Woodford valley.

▷ Midday in early Summer on a wide shallow stretch of the Avon.

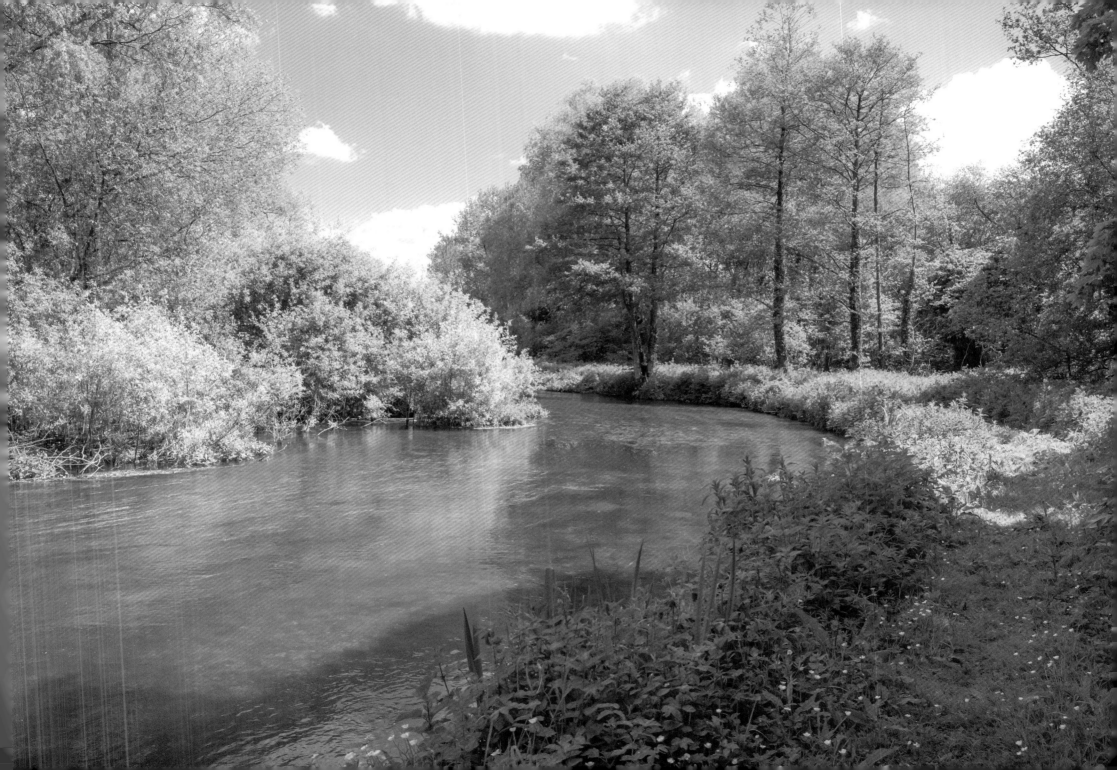

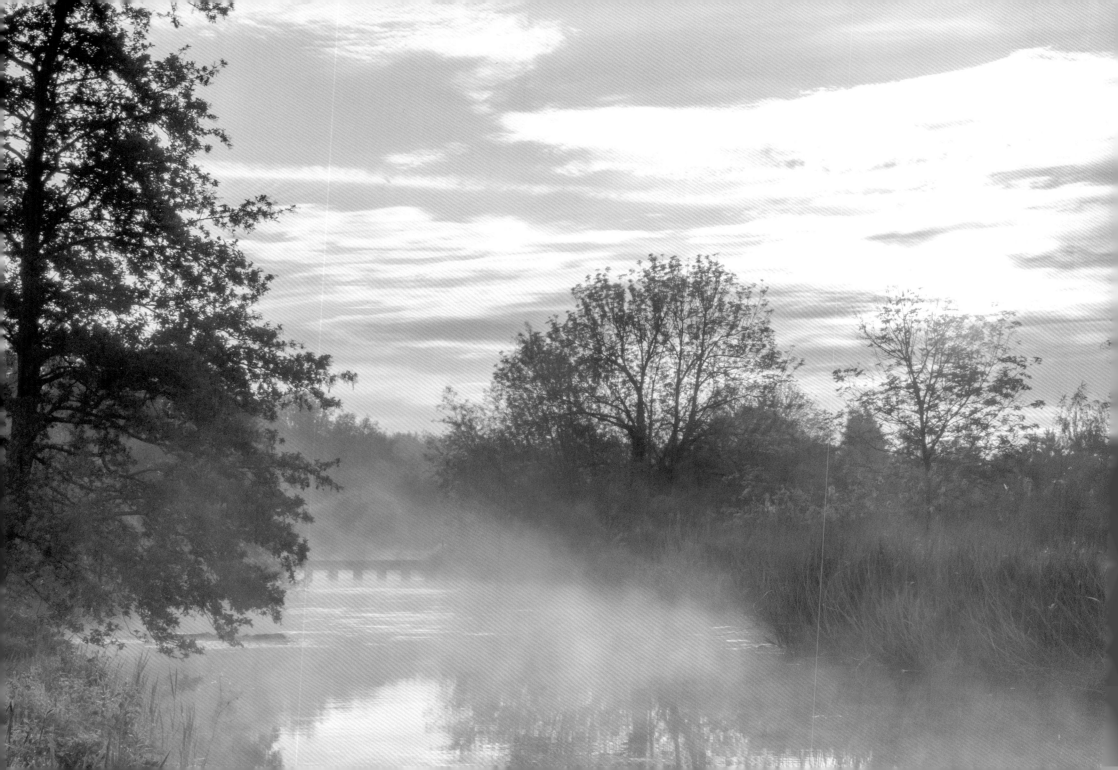

Misty dawn on the Avon in early summer.

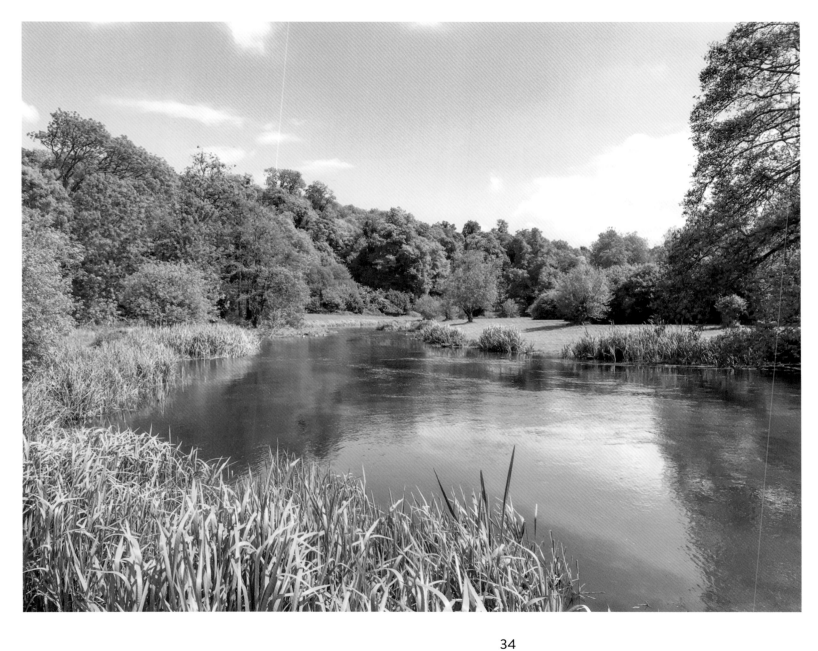

A wide stretch of the Avon running through the garden of a manor house.

A well preserved stretch of the Itchen, just south of Winchester, protected by a fishing society.

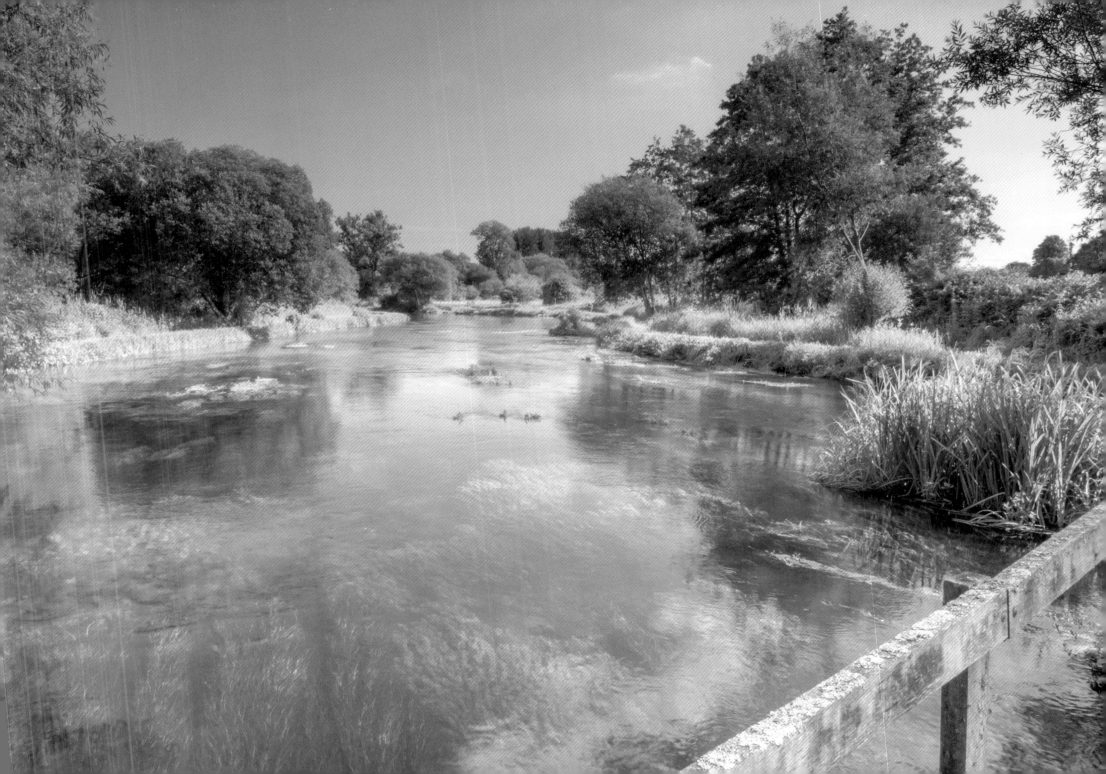

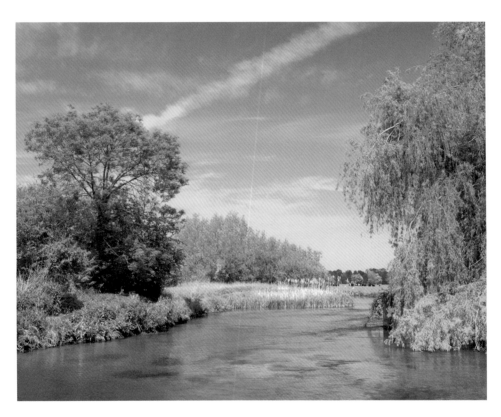 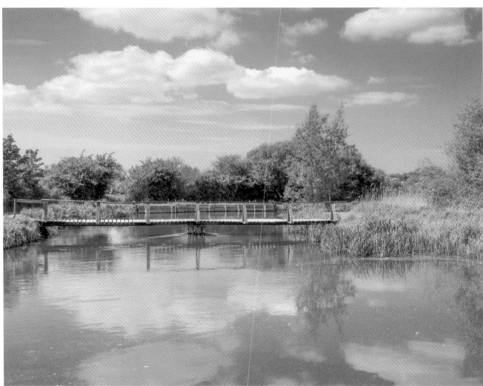

▲ The lower reaches of a chalk stream, just before reaching the estuary a few miles downstream.

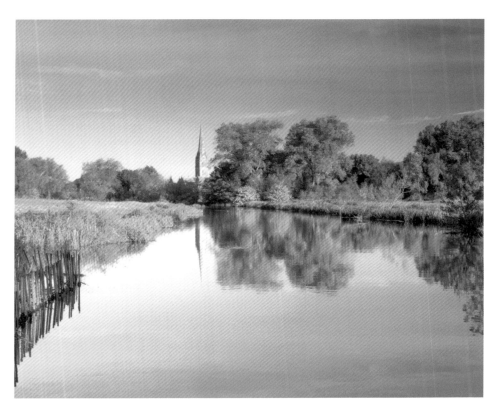

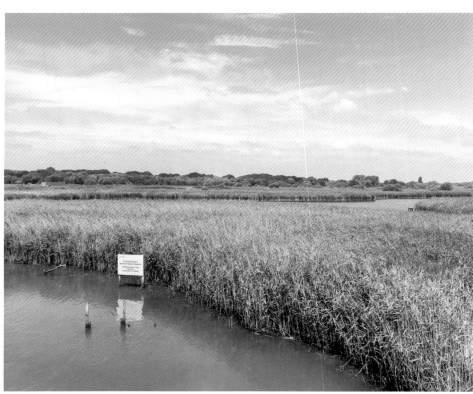

Avon just below Salisbury, when the river starts to lose the attributes of a chalk stream.

The Meon estuary.

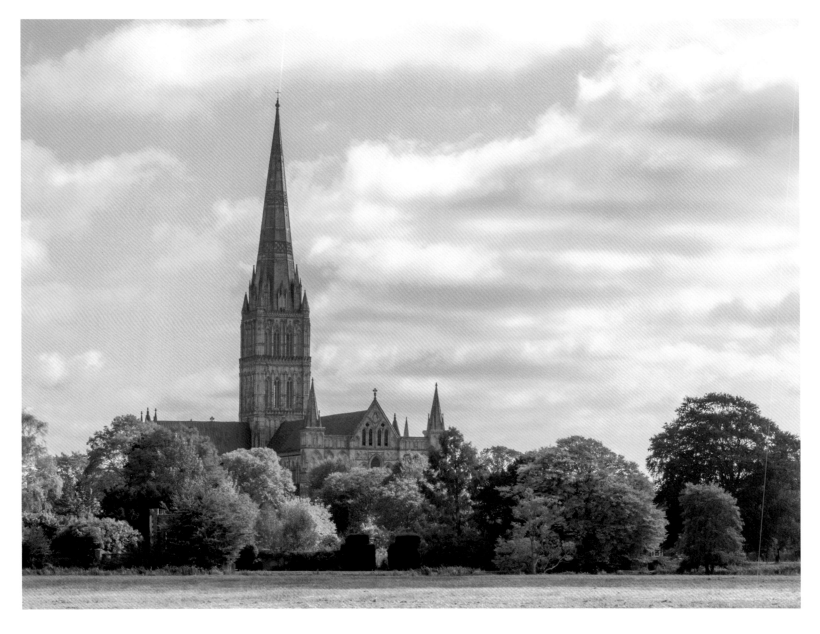

Salisbury Cathedral with a view across the water meadows made famous by Constable.

HUMAN INTERVENTION

Much of the chalk stream environment is the result of human intervention for agriculture and commerce over many centuries. Below is a diagram of a typical water meadow system. In sight of Salisbury Cathedral is Harnham Water Meadows where the undulations and structures can still be seen of a complex system designed to manage the deliberate flooding of the meadows. This was popular in the 17th Century in Wiltshire, Hampshire and elsewhere, resulting in natural fertilisation and significantly higher returns from the land. Marshes were drained and meadow irrigation was practised to create a nutritious-rich flow of relatively warm water over the meadows. This had to be flowing (not stagnant) at a carefully controlled depth for several days, then drained. This process required a complex system of carriers, drains, hatches and sluices. In Wiltshire this was controlled by highly skilled "drowners" who ensured the meadows produced early bite grass, either to feed sheep, who then helped fertilise the land, or to produce hay. Managed by the Harnham Water Meadows Trust, the meadows are still flooded several times a year. The levels are carefully controlled by hatches and inserted slabs of turf (just visible in the last image) to ensure the exact required level of water flows over the ridges of the meadow then back into the main channel via drains. Diagram credit: Adrian Bird/Hampshire County Council.

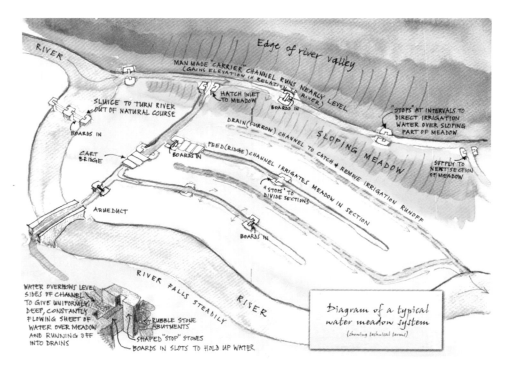

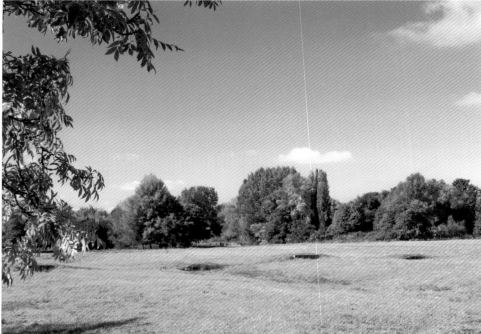

39

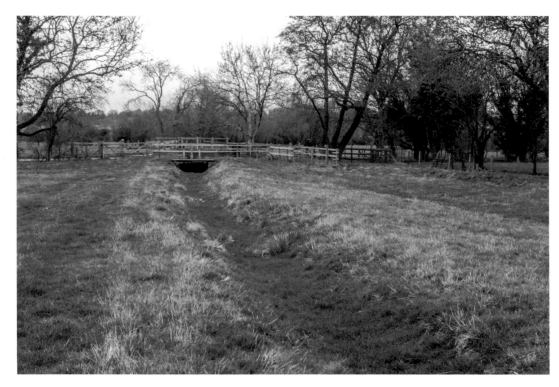
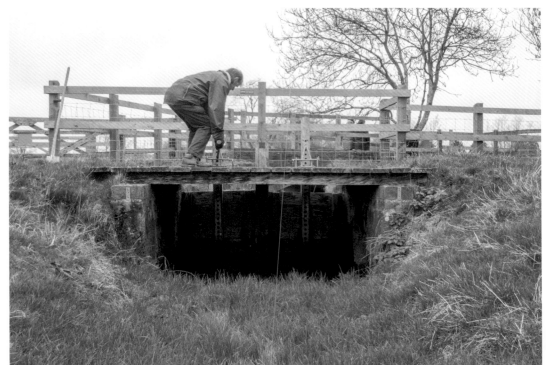
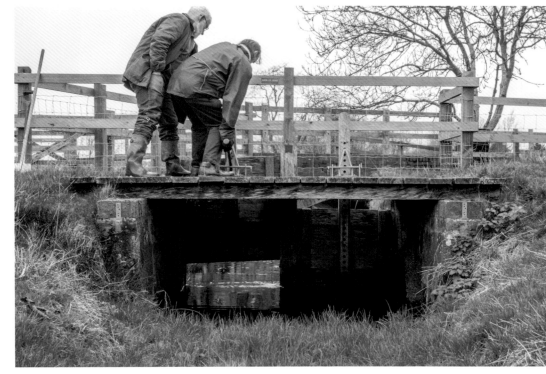
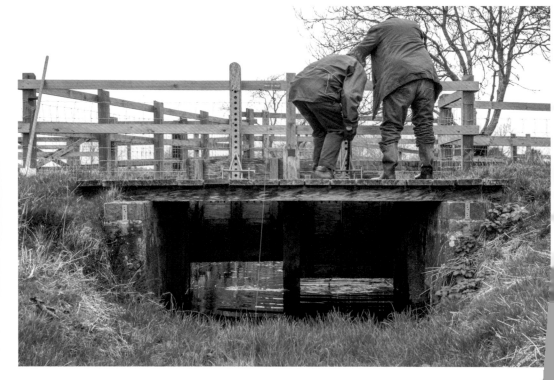

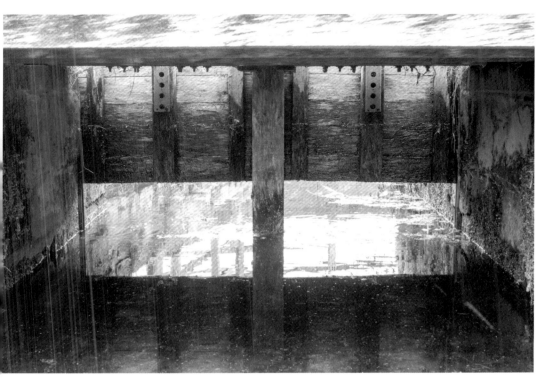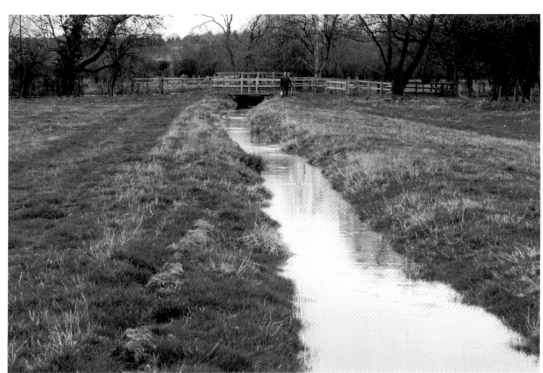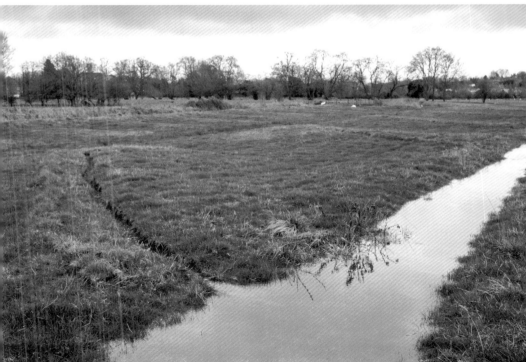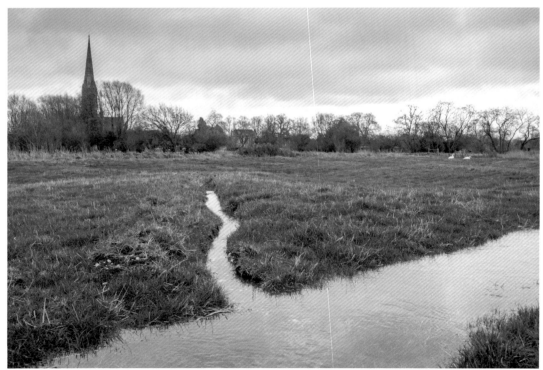

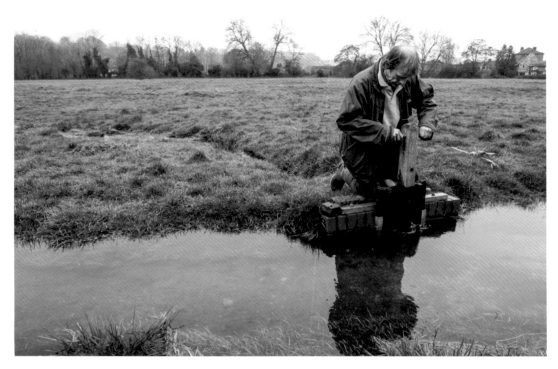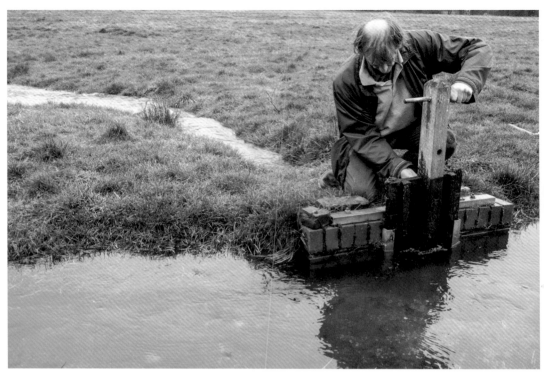
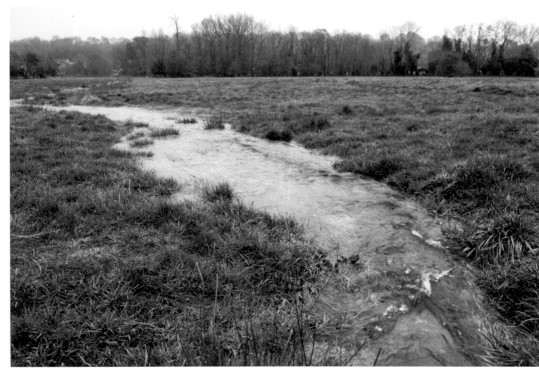

The Avon just downstream of Salisbury at Britford. The signs of the water meadows have all but disappeared with just a few broken down remains of hatches and the ruin of the substantial water power house (right and overleaf).

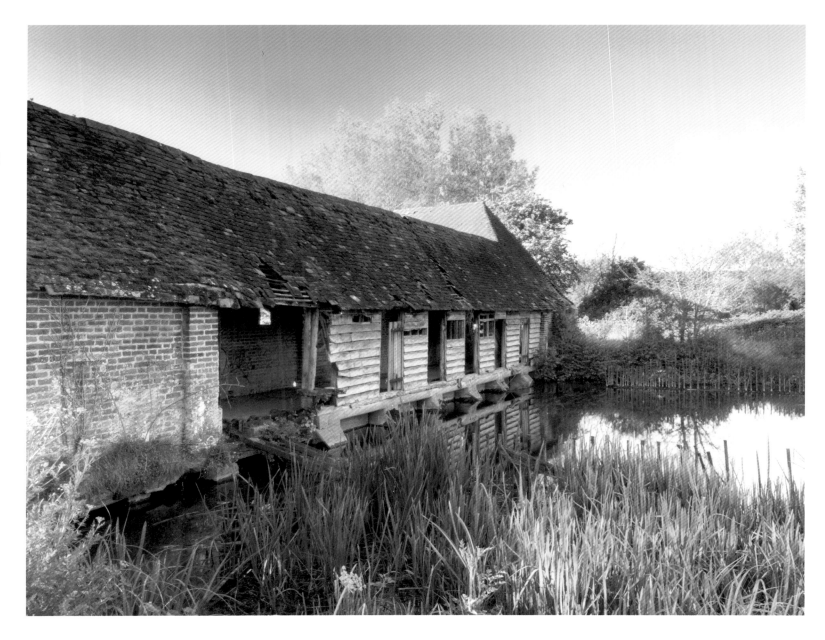

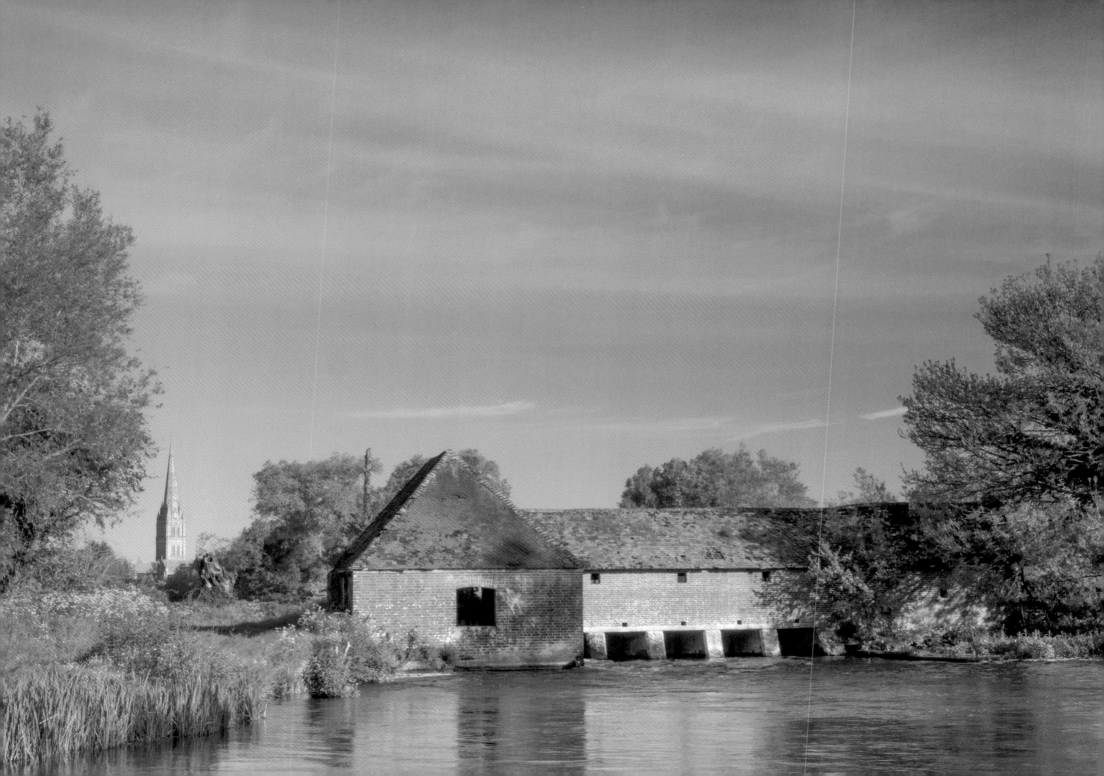

The chalk stream valleys were once the location for hundreds of mills which utilised the constant flow of clean water. Many have been destroyed or converted into very desirable homes, such as at Itchen Stoke. A few restored mills and their water wheels are to be found, with two examples on the River Wandle in the London suburb of Merton (located in a protected area in the middle of what is now an urban sprawl). In the Wheelhouse Museum at Merton Abbey Mills is a working wheel from 1860 used to drive the spools used to rinse silk after gumming and printing, destined for Liberty's. A second wheel, in Morden Hall Park, was used 200 years ago to power the Snuff Mills. The chalk stream valleys supported corn mills, examples being on the Avon, fulling mills for washing and thickening cloth, with an example being the one on the Arle just outside Arlesford, now a very attractive cottage over the river. A further example of a fulling mill is Gaters Mill on the lower Itchen which in 1685 was converted to a paper mill. After 1865 it was converted again, this time to a flour mill. There was a paper mill producing bank notes at Laverstoke on the upper Test, which is now where Bombay Sapphire Gin is produced. There is a still a working silk mill at Whitchurch on the Test.

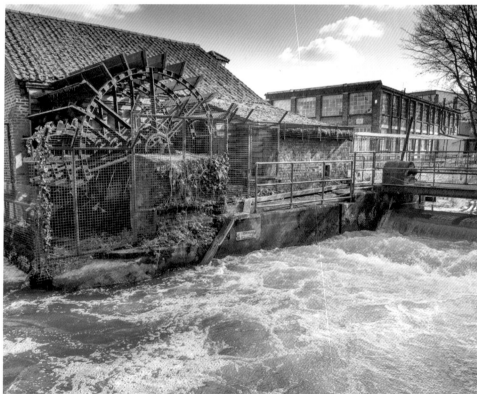

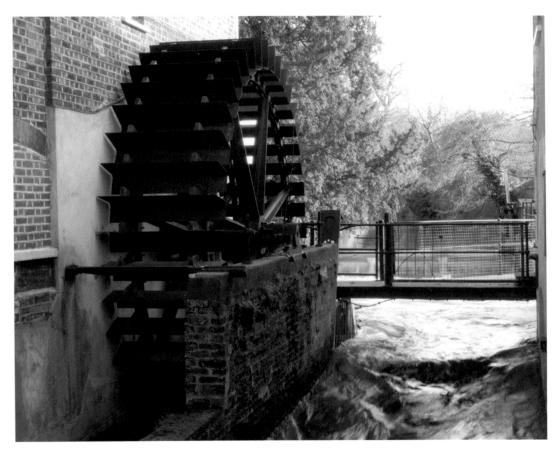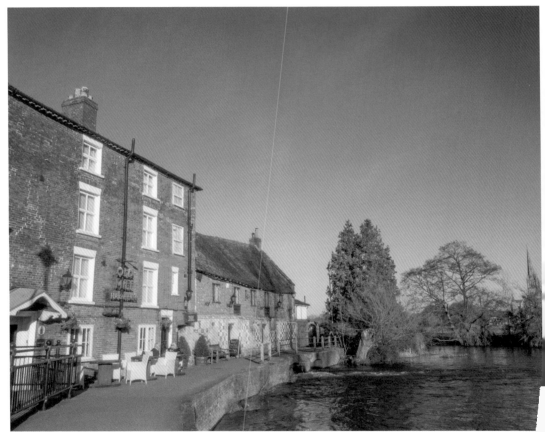

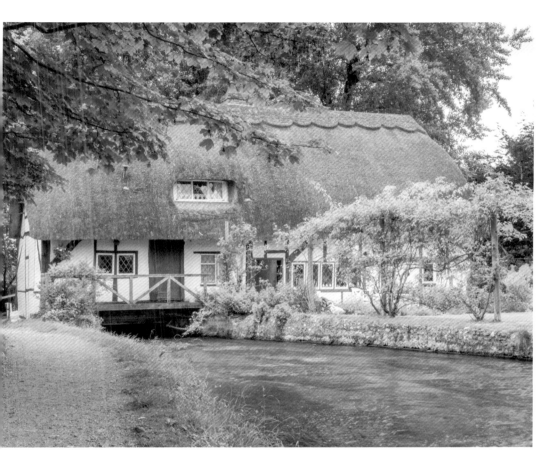 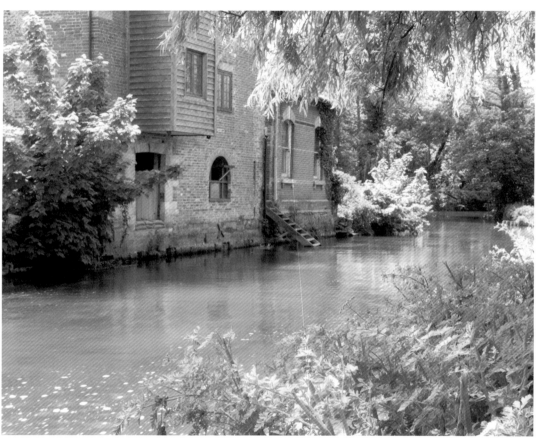

Man made structures designed to control the flow of water can be found throughout most chalk stream water courses. There are weirs, sluices and hatches, which were essential for diverting flows to the water meadow systems, floodplains, carriers and leats for the mills and other requirements. They control water flows and levels through the lowering or lifting of the hatches. Many of the remaining structures are now being removed as they are no longer required and can restrict the migration of fish.

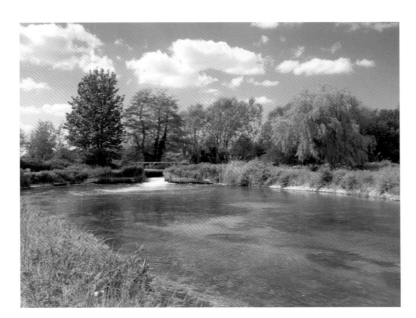

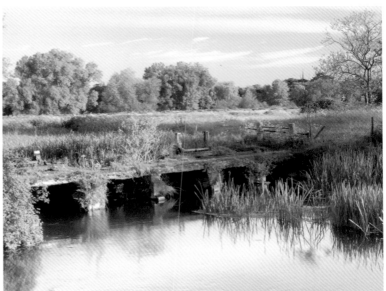

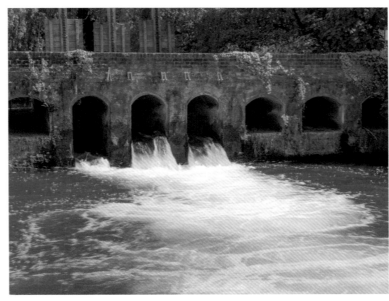

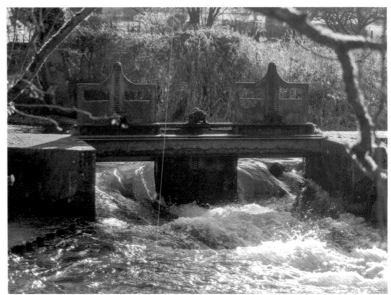

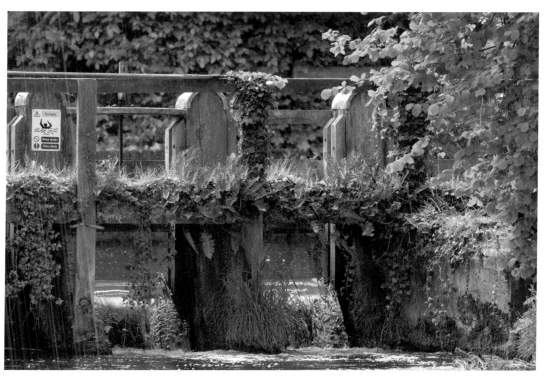
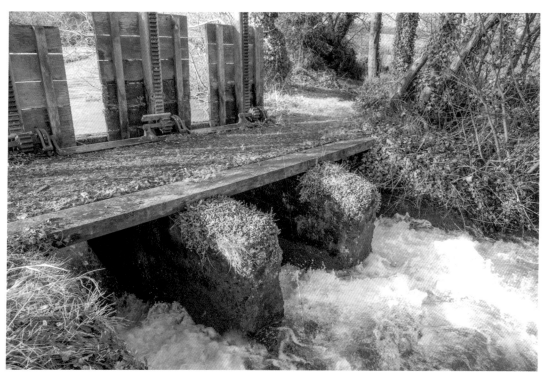
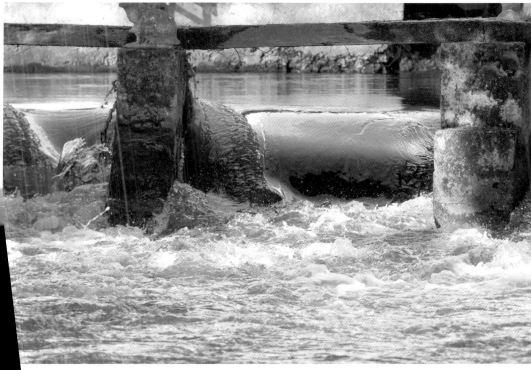

WILDLIFE

1. Mammals

Brown hares are frequently seen by walkers on the downs overlooking the Avon in the Woodford valley.
In late afternoon, wary of danger, the hares may be spotted popping their heads above the crops to listen and watch out for danger.

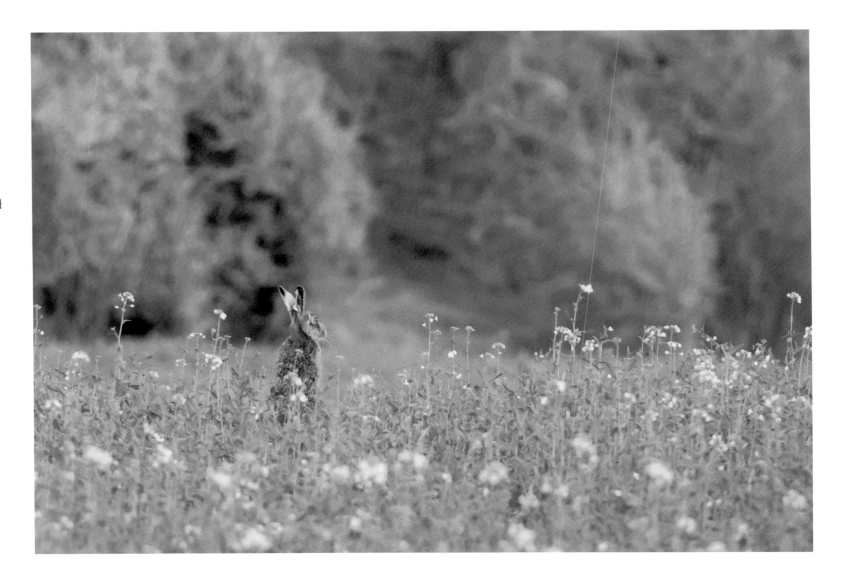

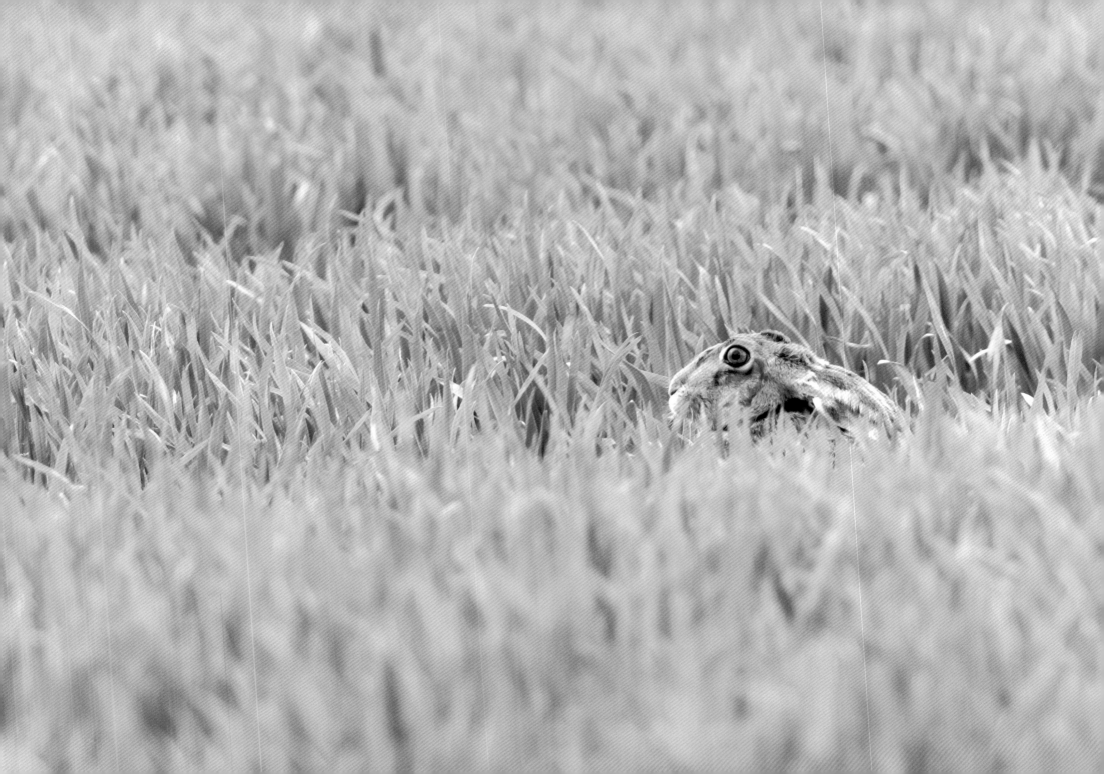

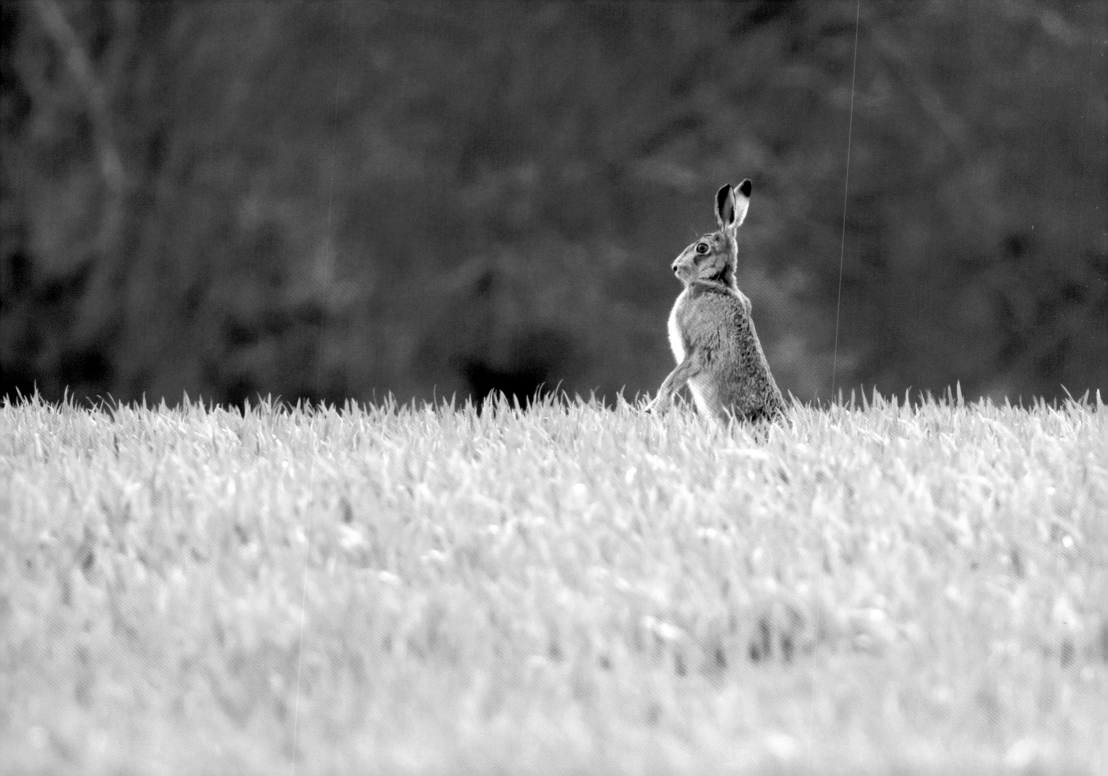

Water voles were nearly extinct in Britain until recently when Wildlife Trusts led a campaign to reintroduce them into suitable habitat such as chalk streams. They have protected status. Rarely seen but often heard by a "plop" as they drop into the water, Water voles mostly feed as the light fades. They have deep burrows in river banks with several entrances. Typically these entrances are above the expected water line as shown on the Itchen Navigation (below left). On the tiny channel of the Meon shown in the next image, the Water vole (pages 54 and 55) had at least one entrance at water level.

 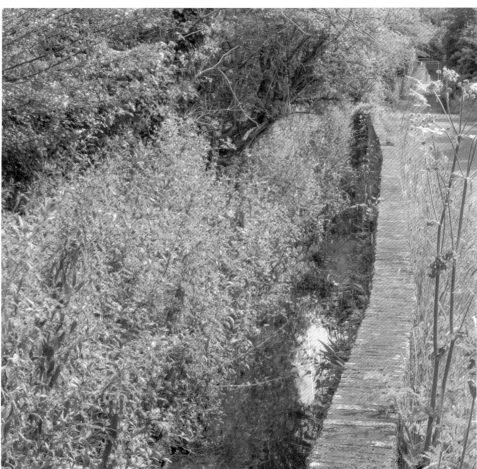

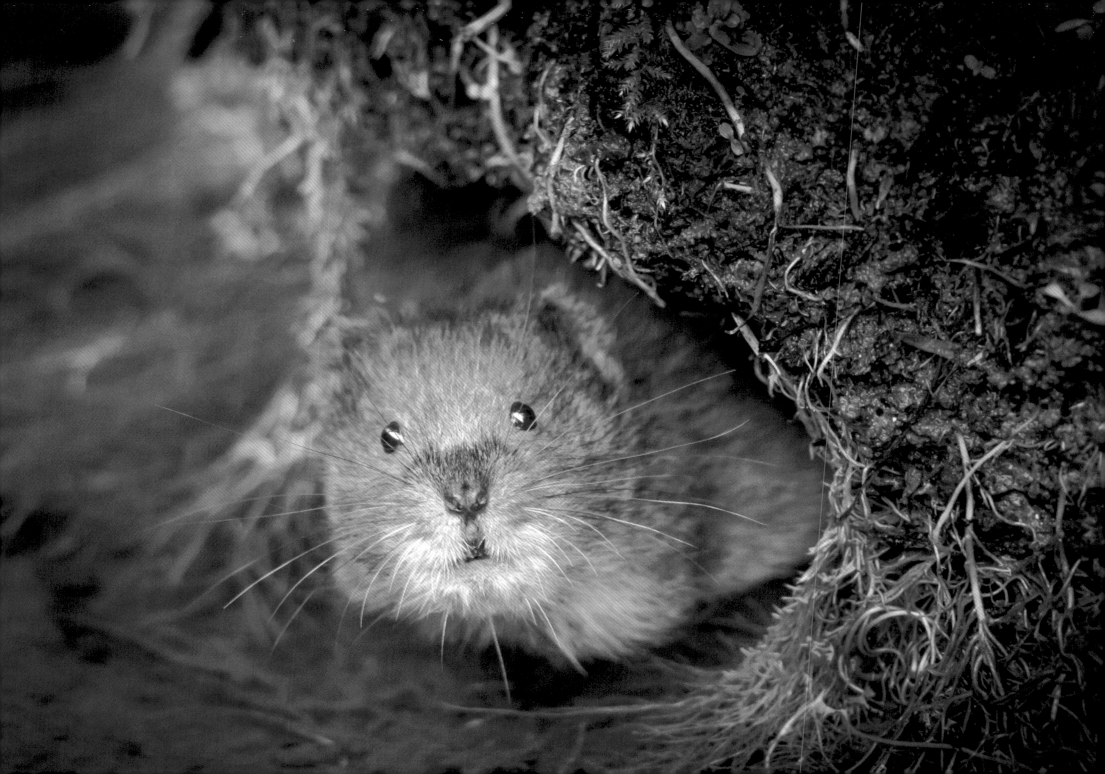

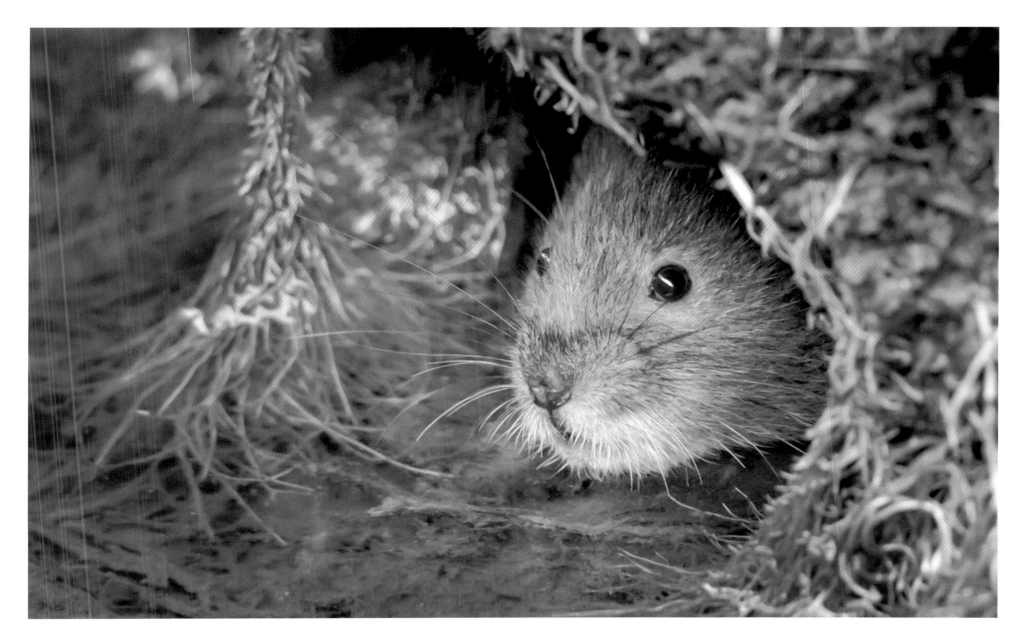

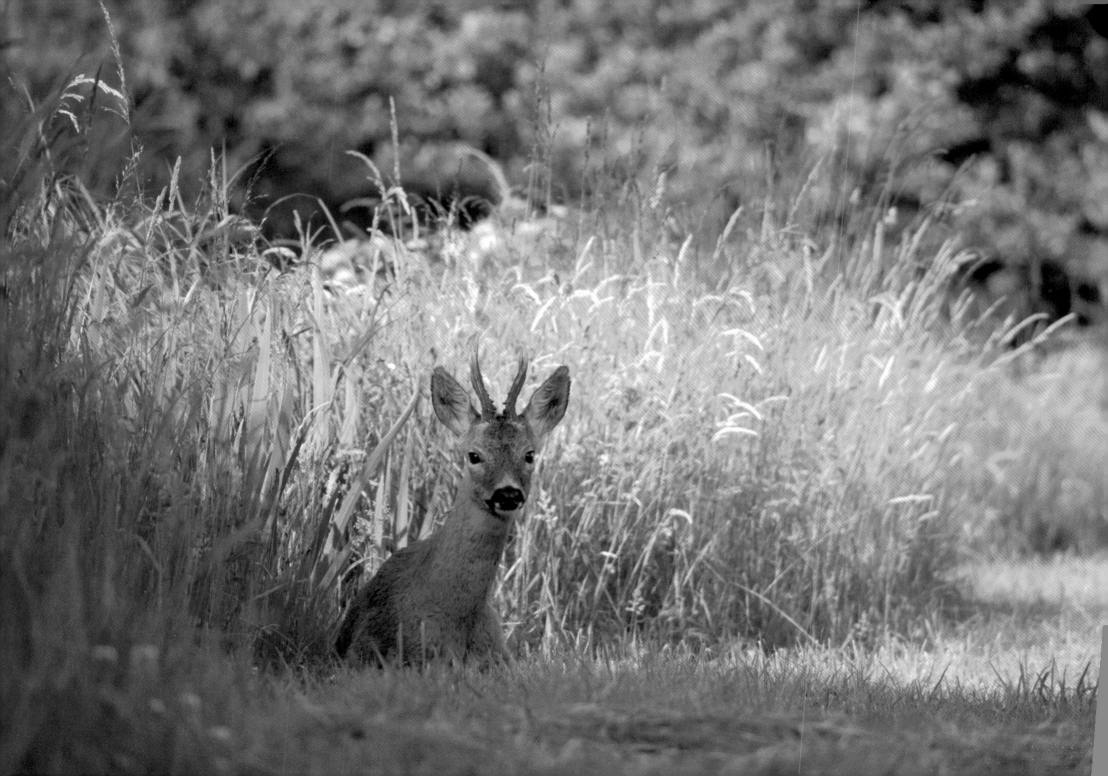

Young buck Roe deer on the middle Itchen at a nature reserve
run by the Hampshire and Isle of Wight Wildlife Trust.

Roe deer by the river Avon, that has not yet shed all of her winter coat.

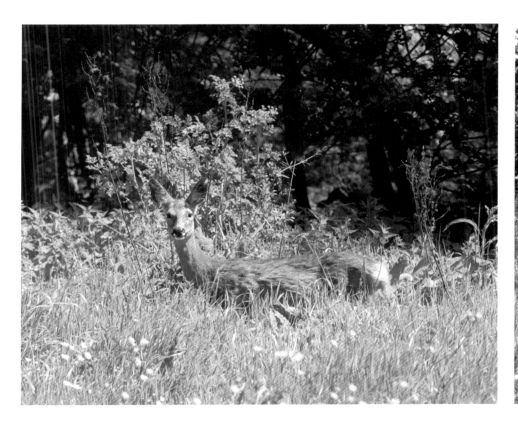
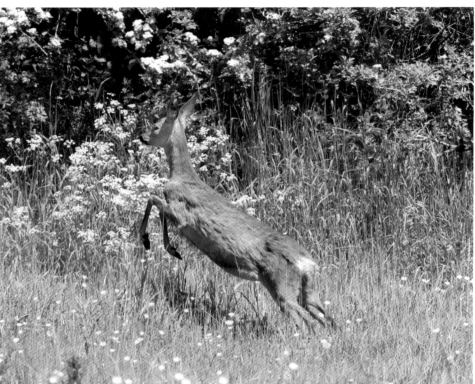

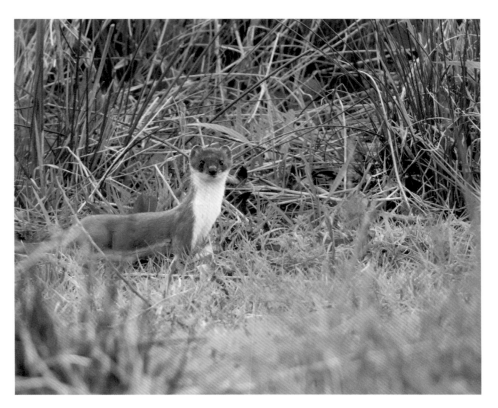

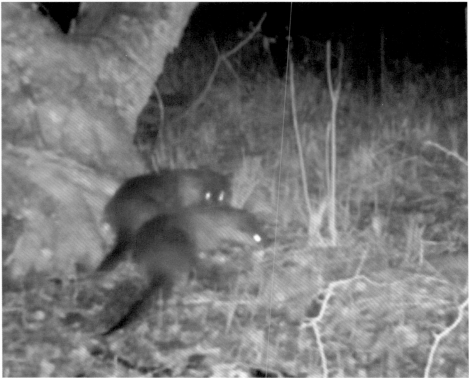

▲ A Stoat on the banks of the Avon.

▲ Otters are becoming well established again. Occasionally seen during the day, but mostly they come out of their holts just after dawn and at dusk to hunt. A pair of otters captured at night with a trail camera by Peter Hellard on the middle Itchen.

2. Birds

The chalk streams and water meadows are rich habitats for a very wide variety of bird life.

Kestrels, characterised by their amazing ability to hover absolutely stationary as they spot prey, finding a high vantage point on the upper Itchen – looking for prey such as field voles.

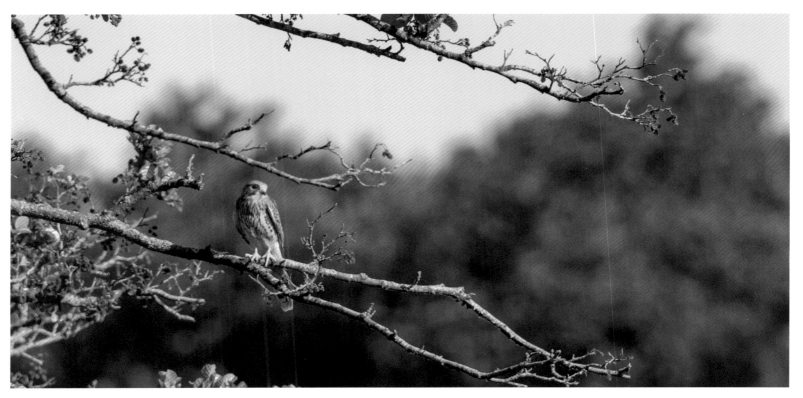

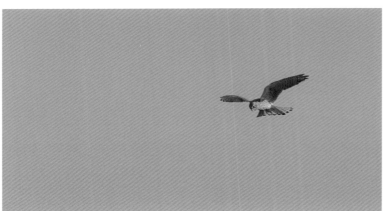

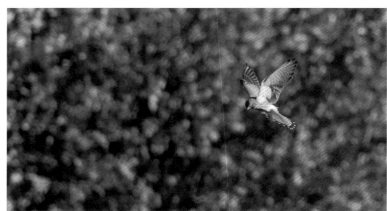

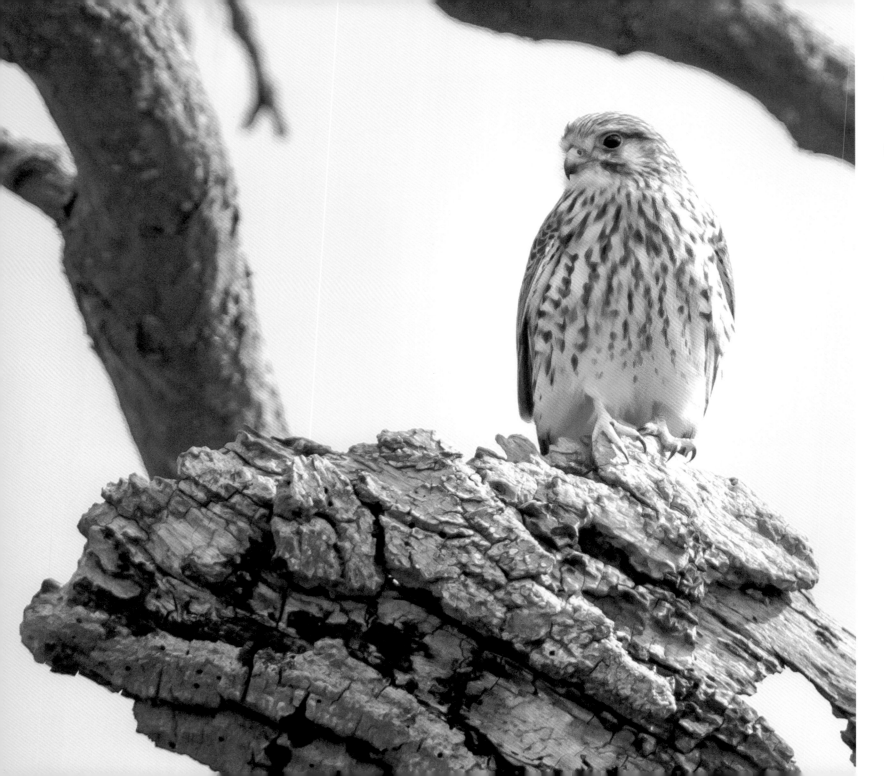

◀ Kestrel using a dead tree on the upper Test as an observation perch.

▶ Red kite in the Avon valley.

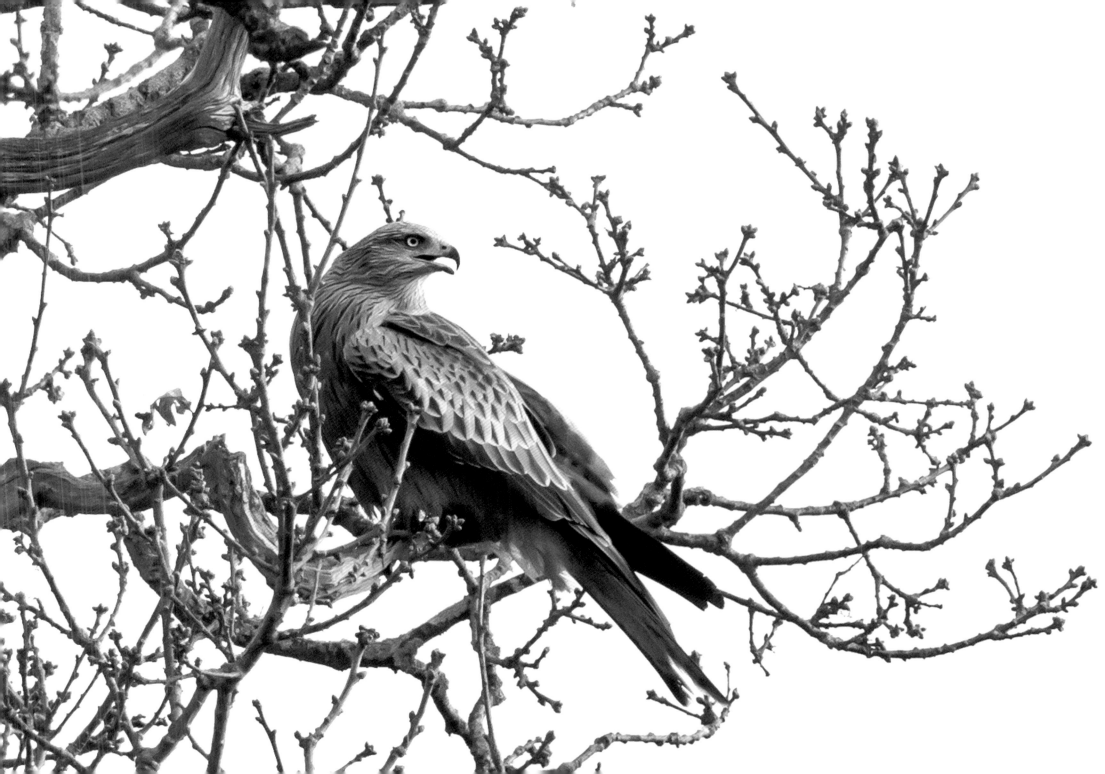

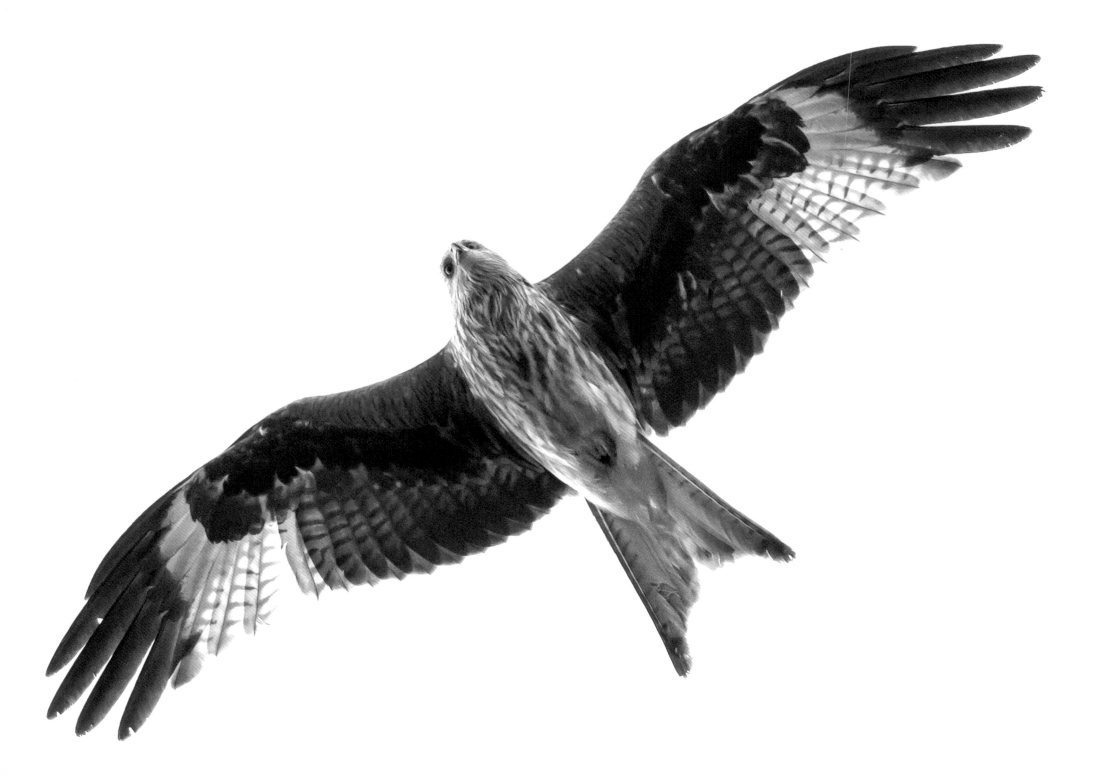

The Red kite hunting food in the chalk downs
above the Avon Woodford valley.

The Grey wagtail is frequently seen on the Avon, Test and other
chalk streams and in this sequence from the Avon a Grey wagtail
can be seen catching insects in flight over a hatch pool.

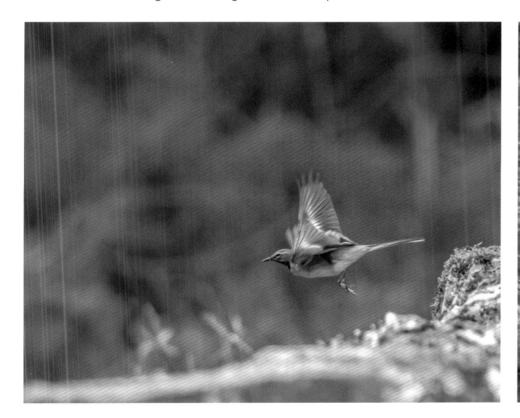

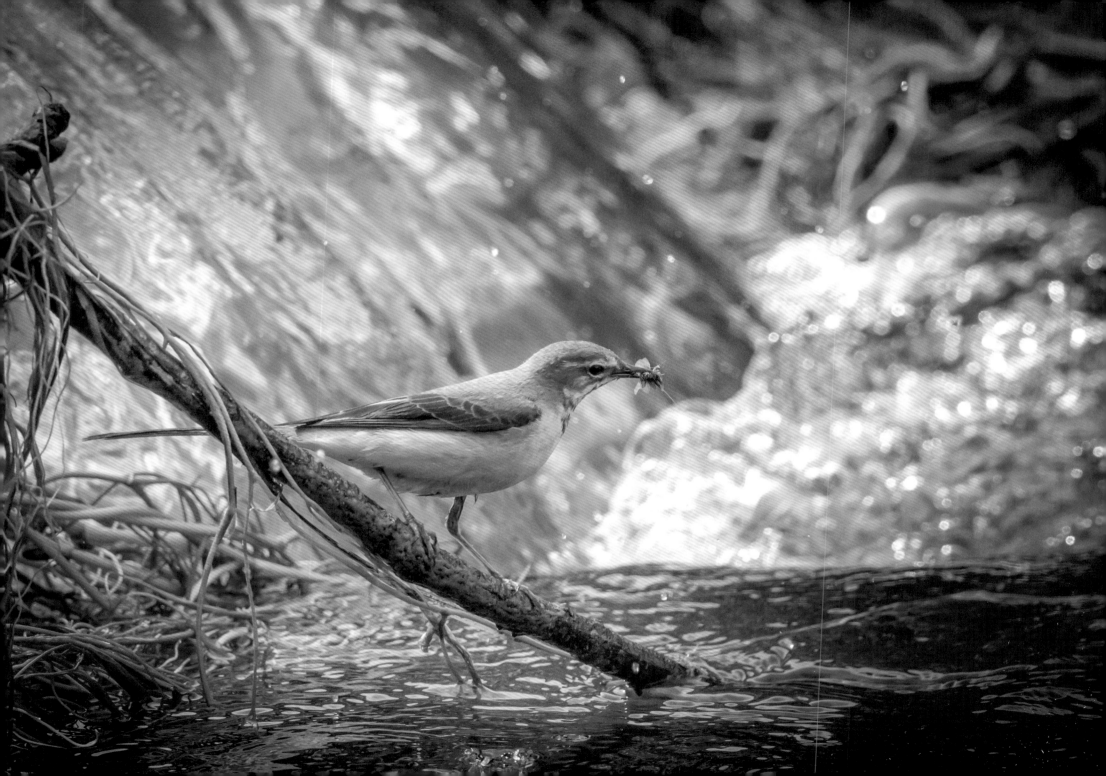

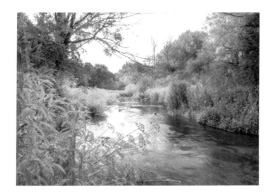

The Kingfisher is a protected species and an iconic sight on the chalk streams. Usually seen as an iridescent streak as it flashes past at great speed checking on its territory, which can be up two kilometres. This kingfisher used the perch that can be seen at the bottom of the image (left) on a suitably slow flowing eddy on a side stream of the river Avon, to spot tiny fish such as minnows and then dive vertically to catch them.

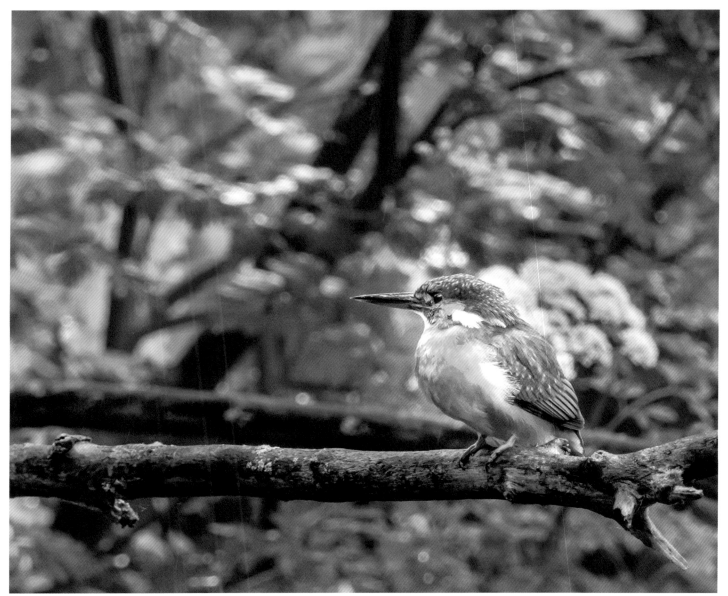

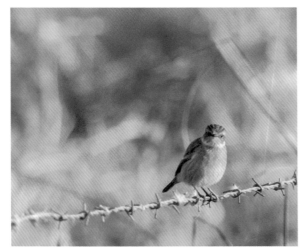

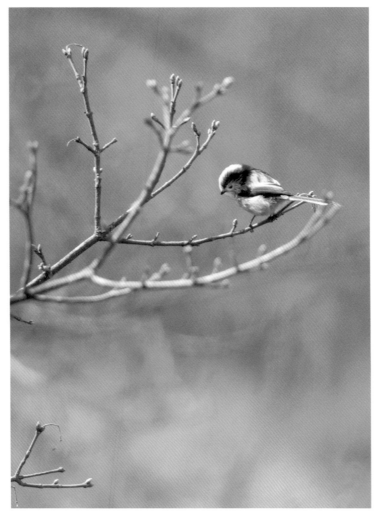

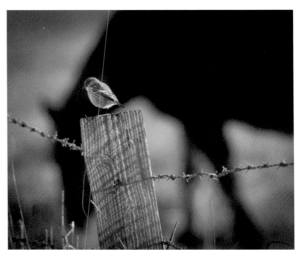

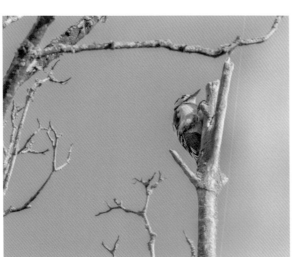

Stonechats (top left and right) are often seen on fences and fence posts (upper Itchen). A Long-tailed tit in Winter on the upper Test (centre). Greater spotted woodpecker on the Wylye (bottom left). Very rare sight – a Great bustard photographed at the breeding reserve on Salisbury Plain (bottom right).

Wren, easily seen but only briefly before they take flight and disappear into the undergrowth.

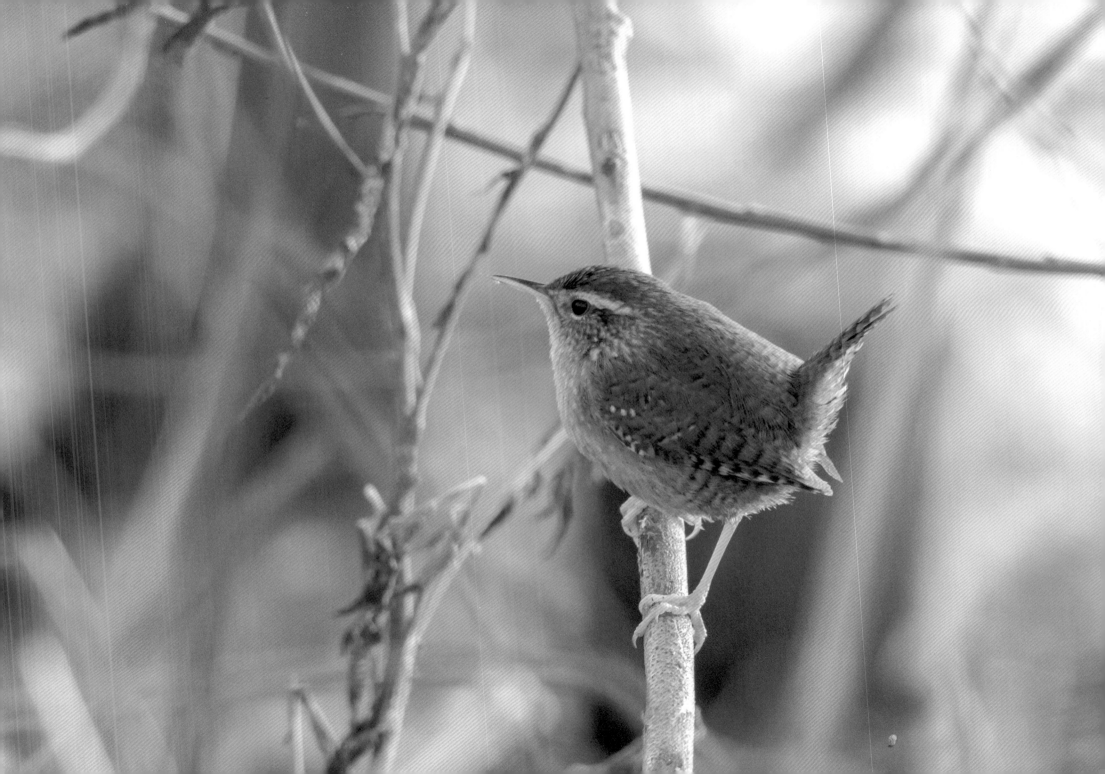

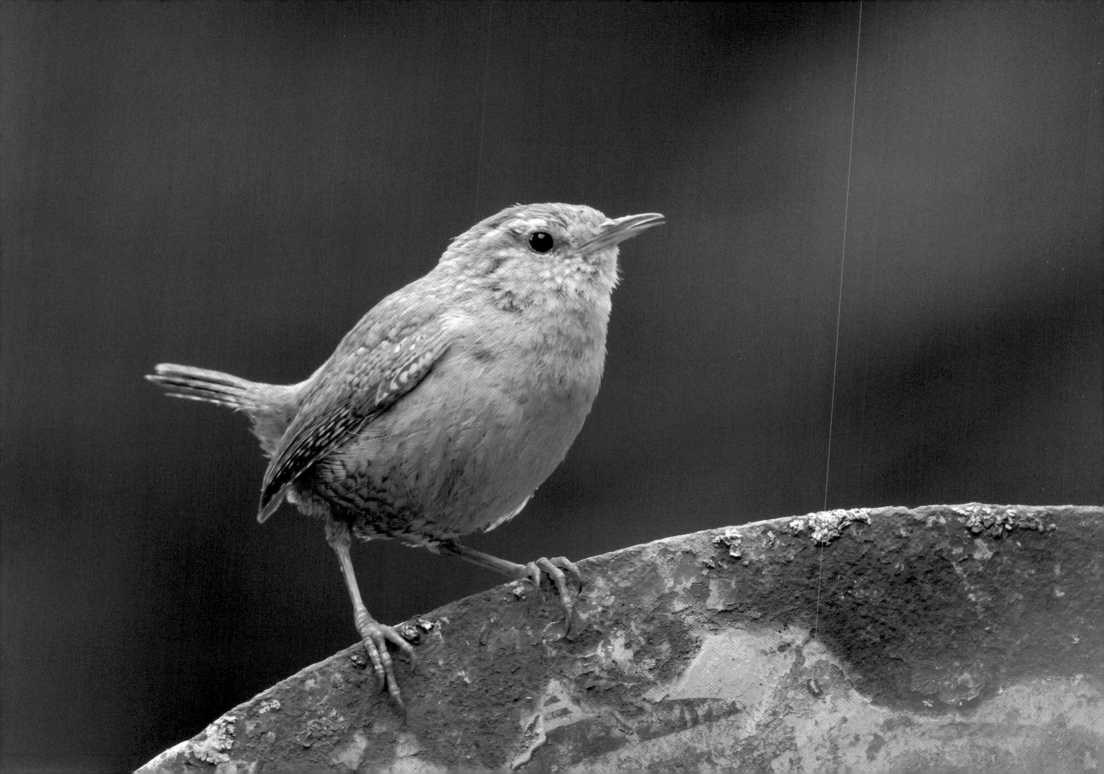

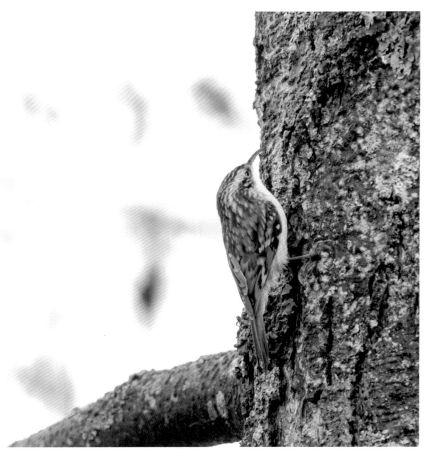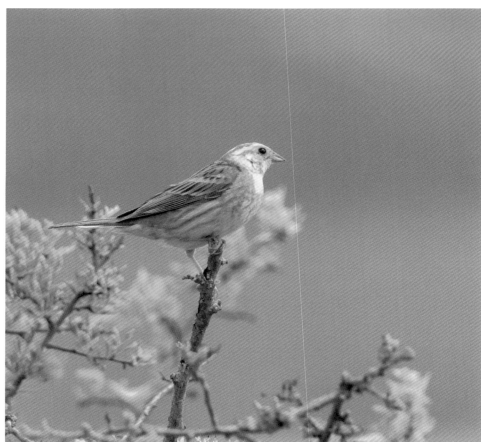

Treecreeper on the upper Test (left) and Yellowhammer (right) on the chalk hills above the Avon valley.

A Wren perched on old sign by the Wylye.

69

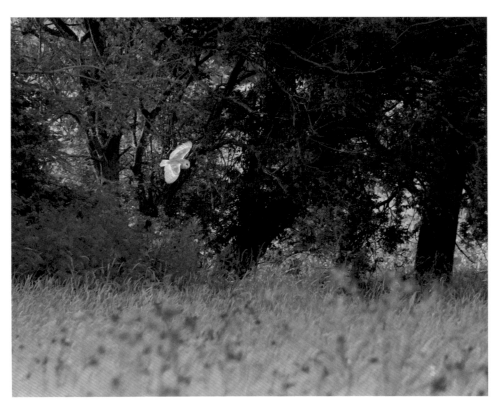 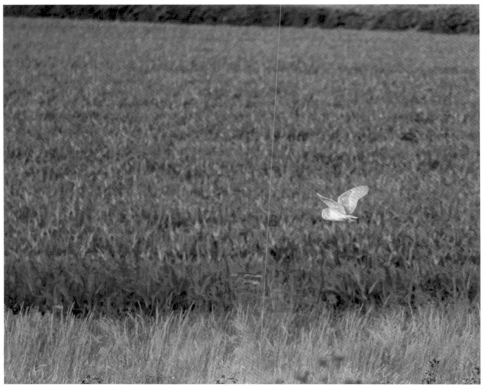

▲ A Barn owl quartering the field in the early evening (Avon).

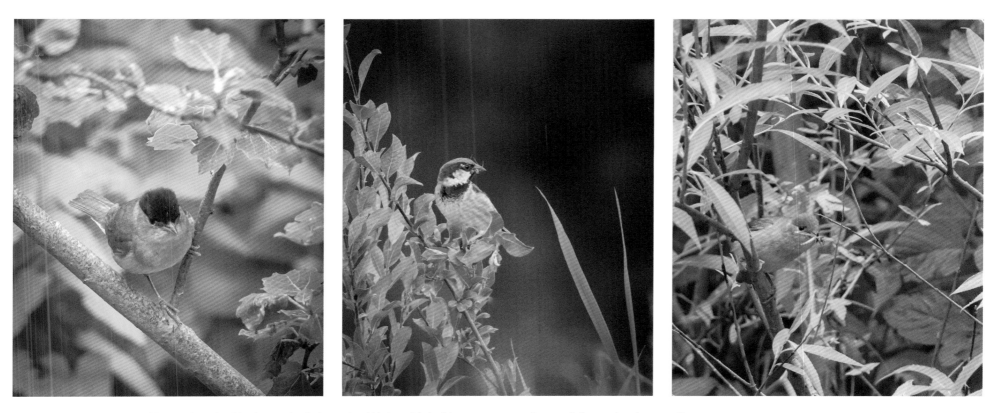

A male Black cap (left) and female Black cap (right) on the Wylye. Male House sparrow (centre) from the Avon valley.

There is a wide variety of water birds to found in the chalk stream valleys with swans being the most prominent. The image of the swan with the flowering Ranunculus is from the Avon, the one in the early morning mist is from the upper Itchen. Others are from the upper Test with one of the images showing a swan making a nest beside the river. Grand sight though they are, swans can clear vast areas of precious weed, home to the invertebrates that are so important for the food chain. Most swans are white, but there are a few black swans on the Avon and elsewhere. The multi image sequence is from the Avon.

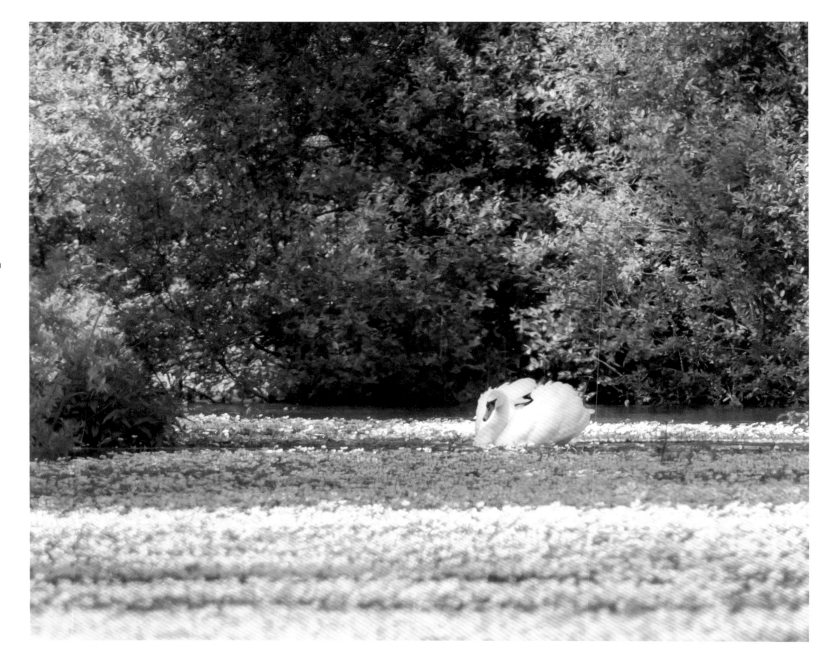

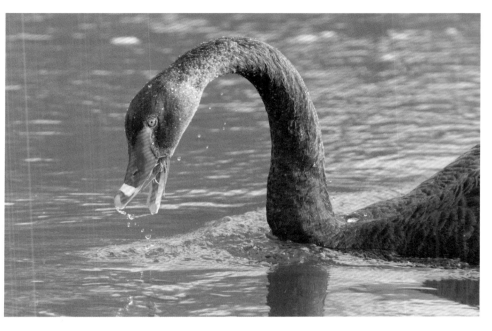
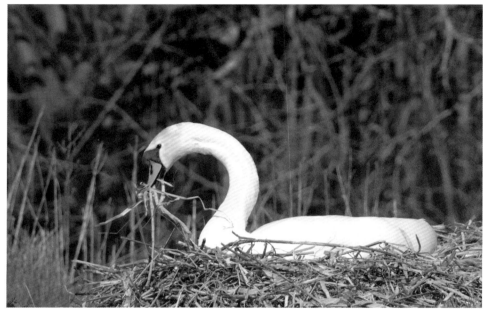
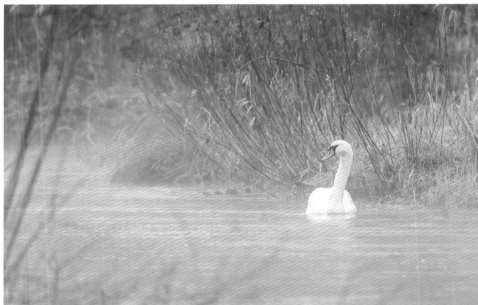
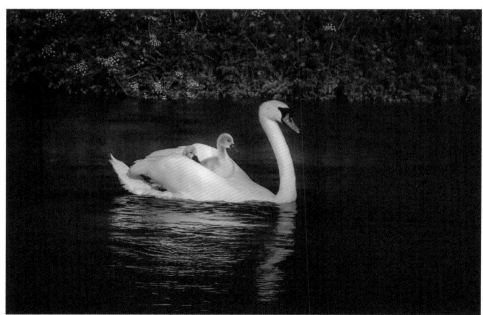

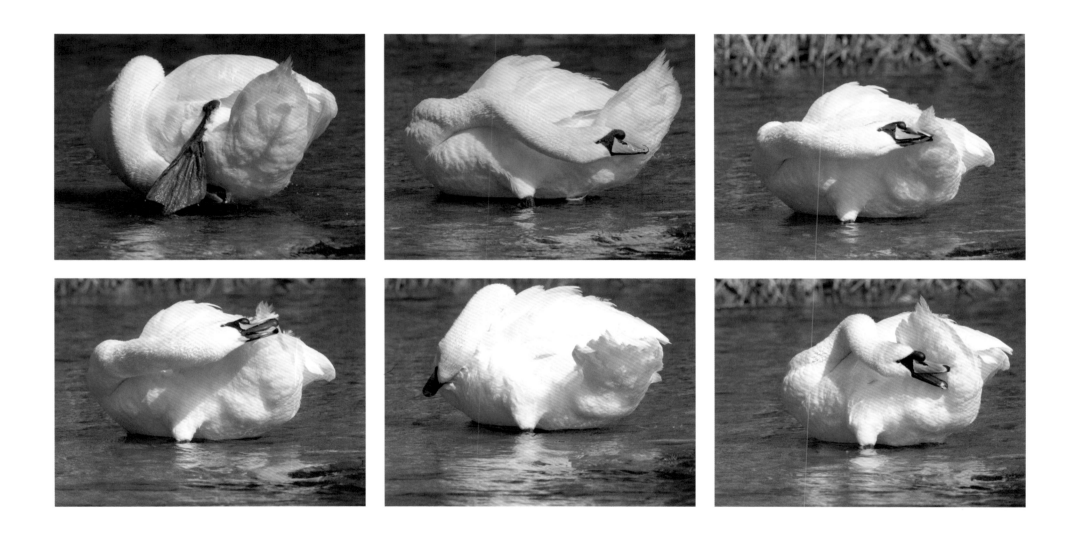

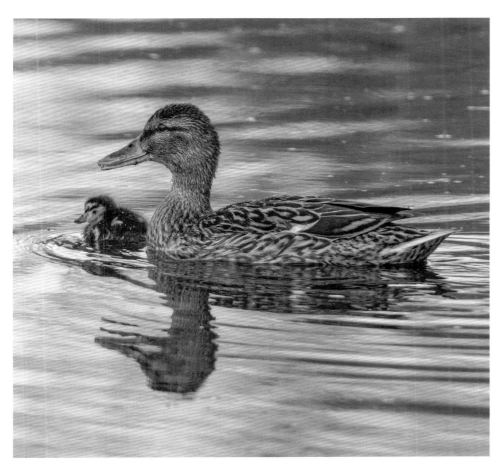

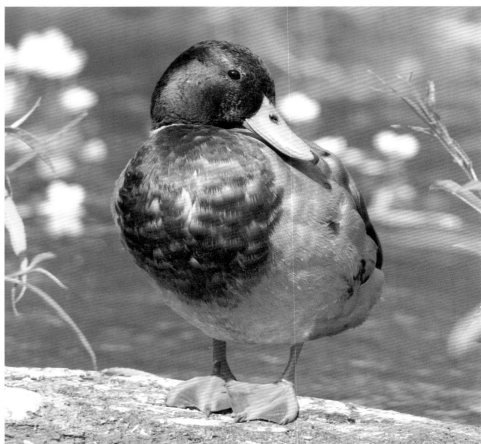

Female Mallard and duckling on the Test.

Male Mallard on the Avon.

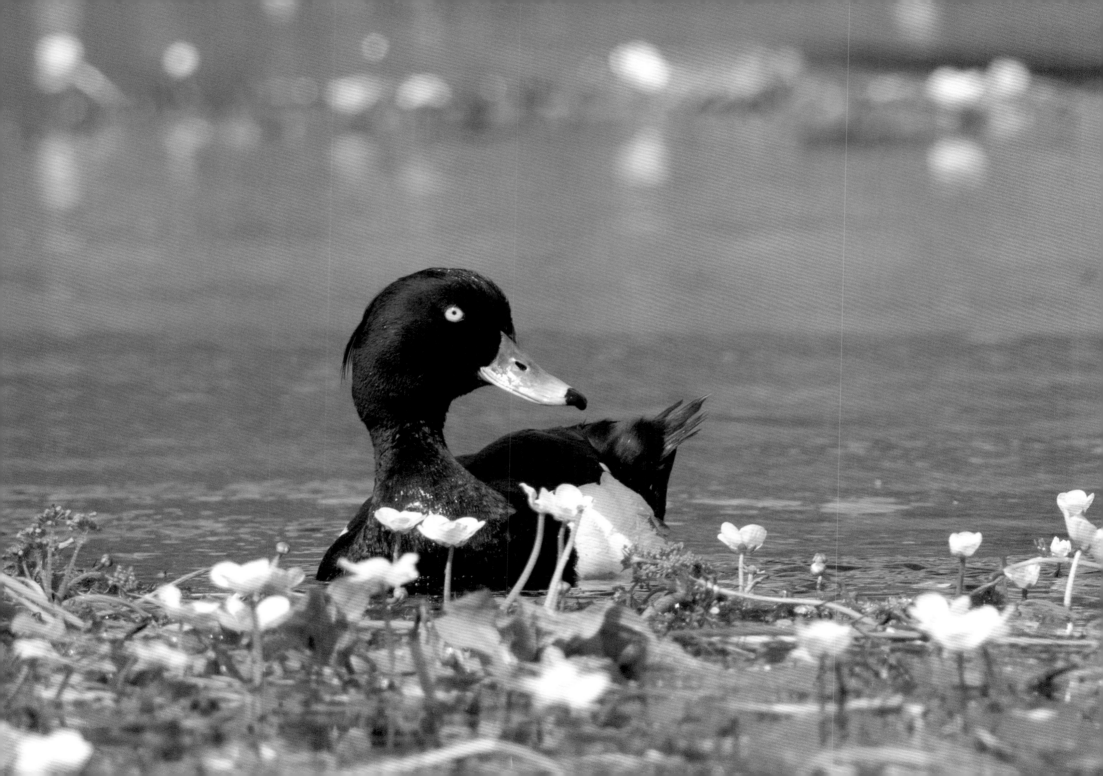

Tufted duck on the Avon.

Herons, like this juvenile (top right and bottom left), are a common sight (Wylye), but less common is the Little egret (Itchen).

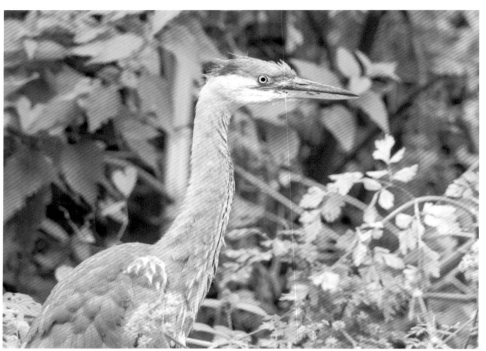

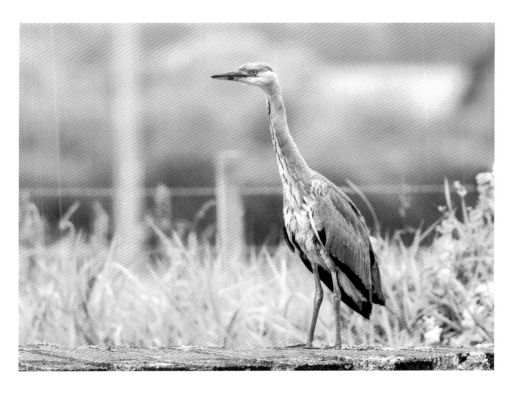

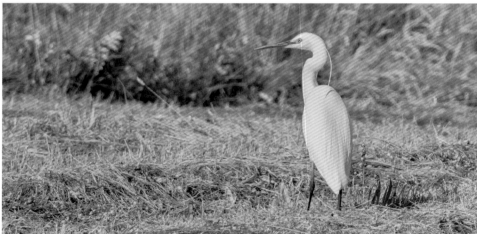

3. Insects

Shown here are only a few examples of the wide variety of insects found in and around the chalk streams.

Sedge (Caddis fly) during a classic evening hatch on the Avon.

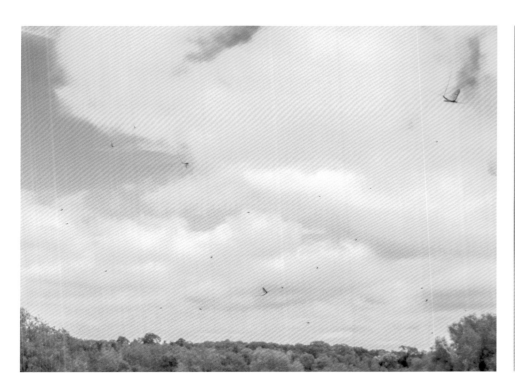 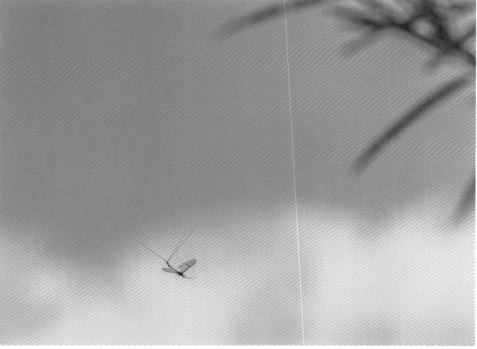

The flyfisher favourite Mayfly, seen mostly in a fortnight in late May. They emerge during the day when conditions are right and then the adult males return to the river looking for females. These male spinners were seen swarming over surrounding bank side vegetation on the river Avon.

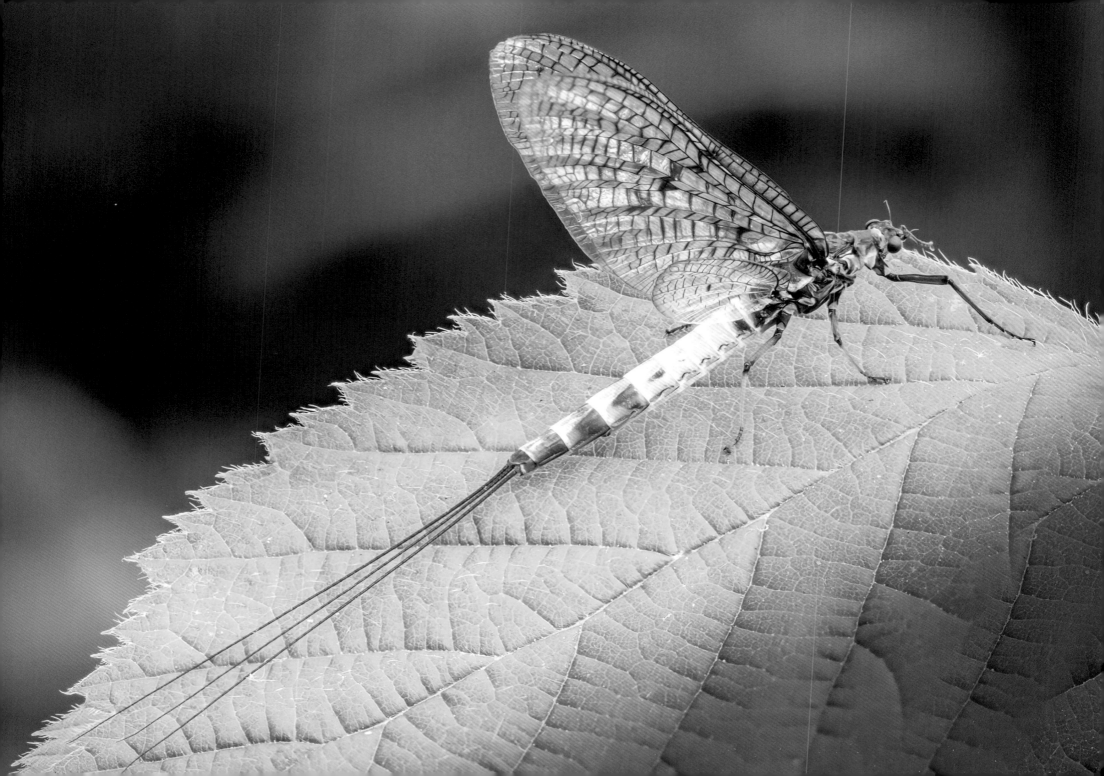

A close-up of a
Mayfly spinner.

A male Blue winged olive
(BWO), so typical of
healthy chalk streams
(middle Itchen).

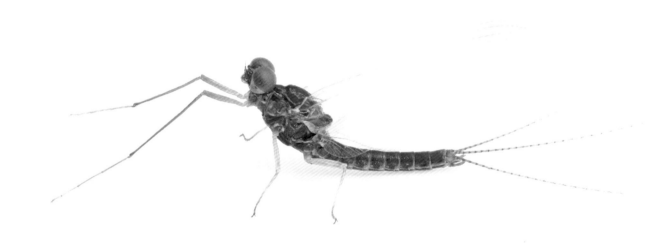

Aquatic insects such as the Sedge larva (Cased caddis) can be seen in the bed of a clean river.

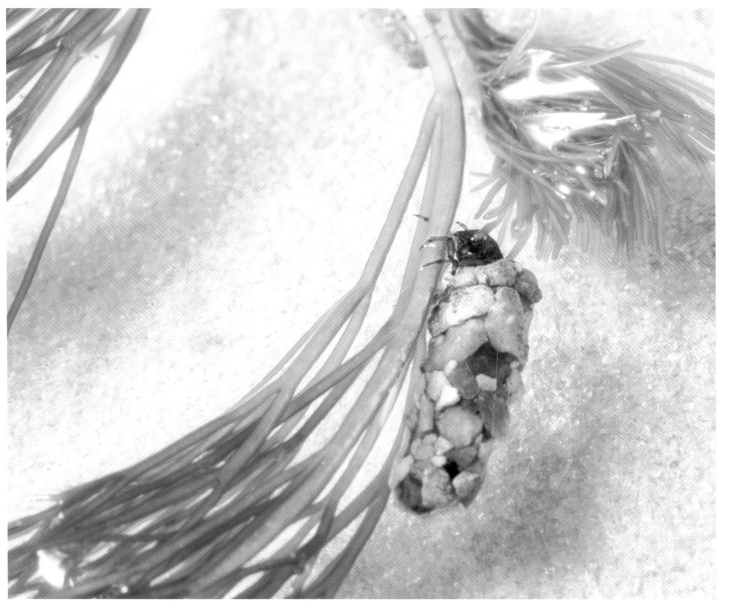

Crustaceans such as Gammarus (freshwater shrimp) are an indication of the health of a river (Avon).

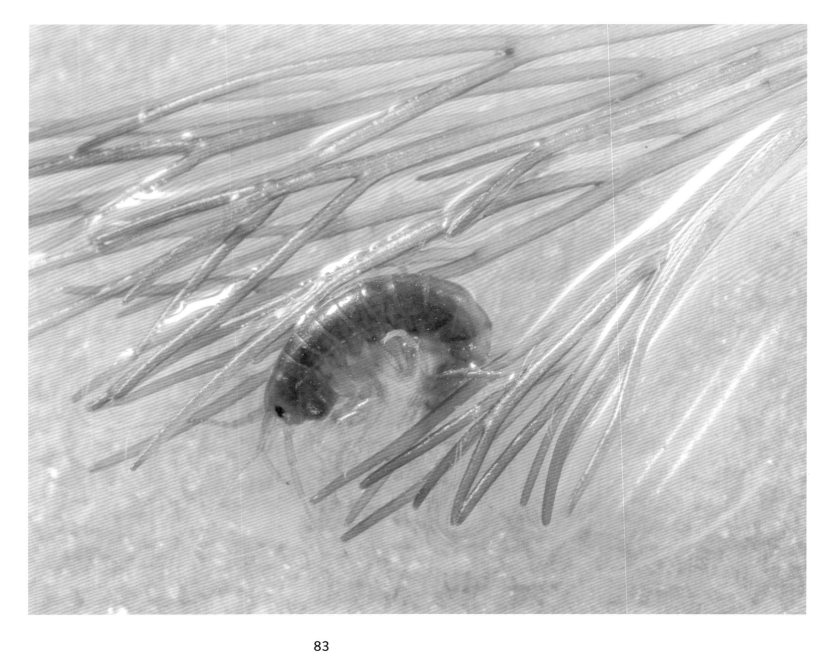

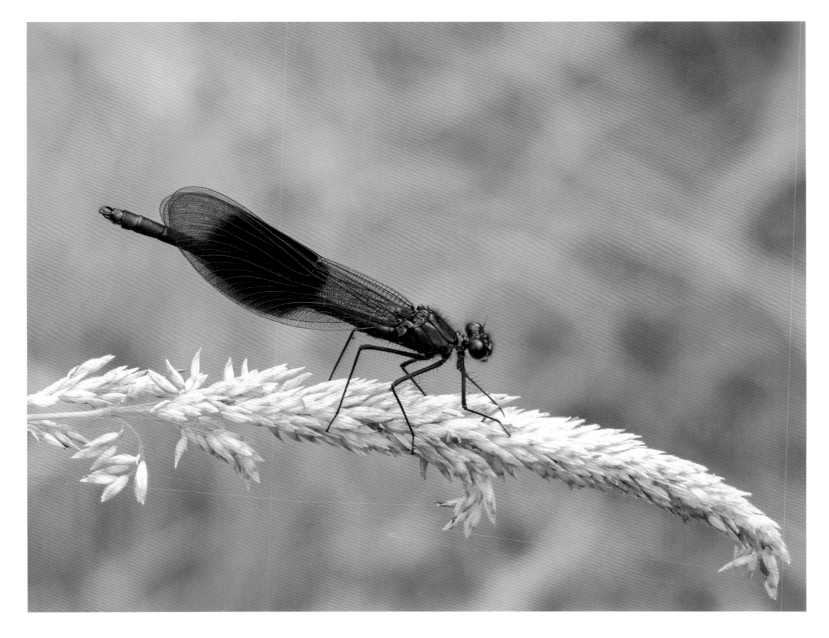

Banded demoiselle at the Hampshire and Isle of Wight Nature Reserve at Winnal Moors.

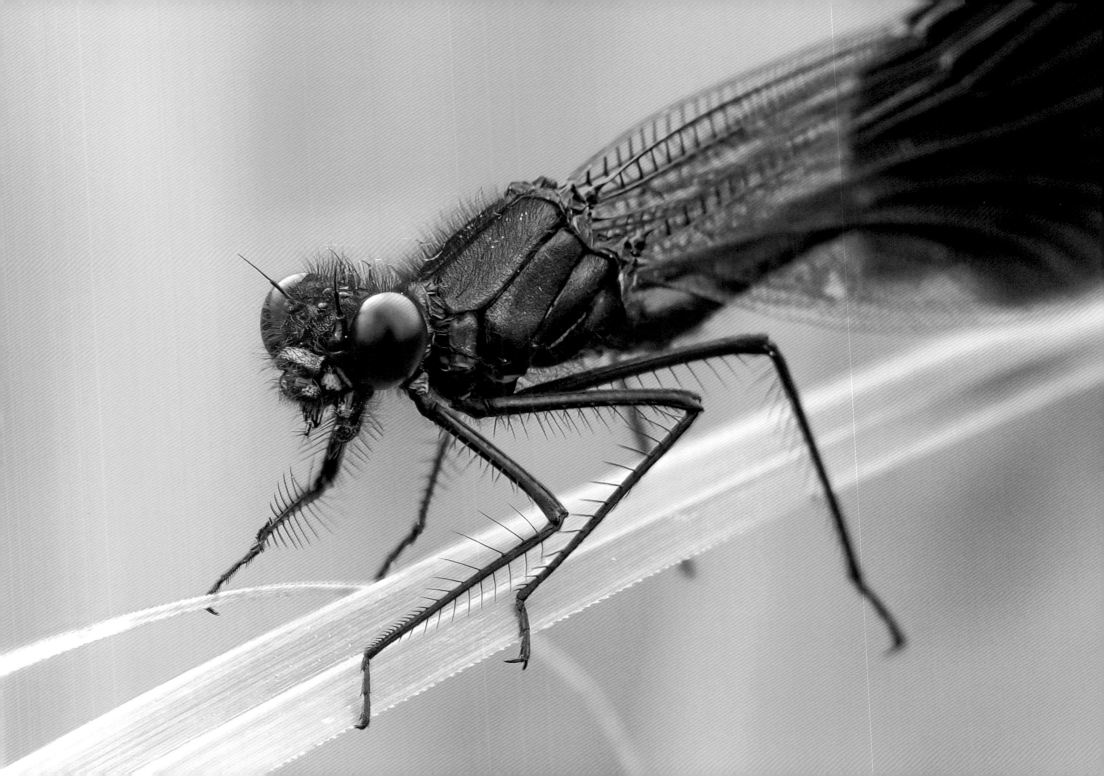

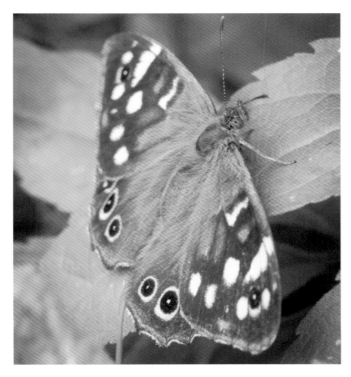

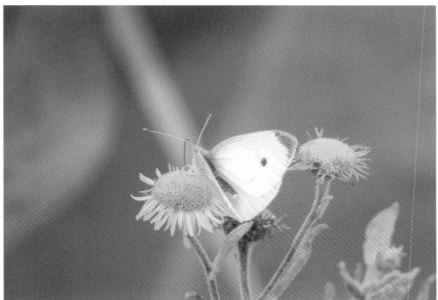

Speckled wood butterfly (Itchen), Large white (Itchen), Red admiral (Meon), Comma (Wylye).

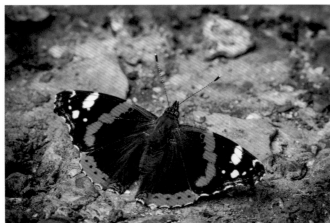

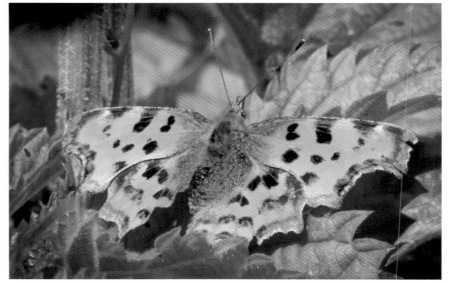

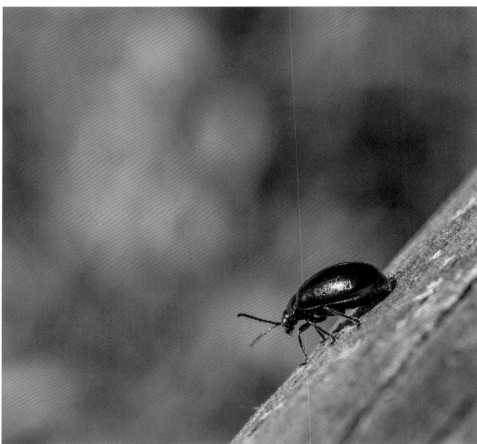

A Common leaf beetle on a footbridge over the Itchen.

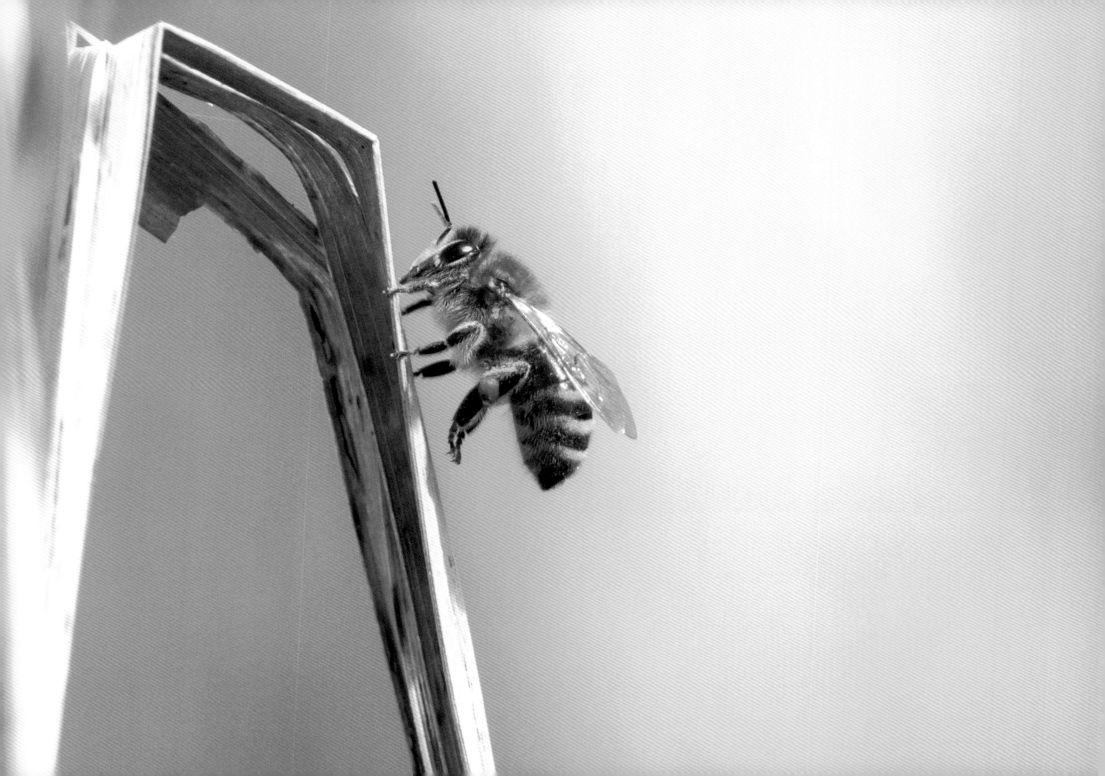

Bee on reeds beside the upper Test.

Female Common darter on fences by the upper Itchen.

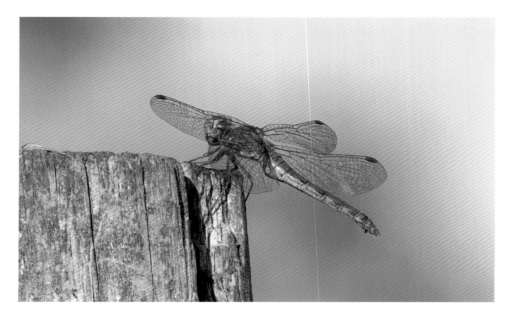

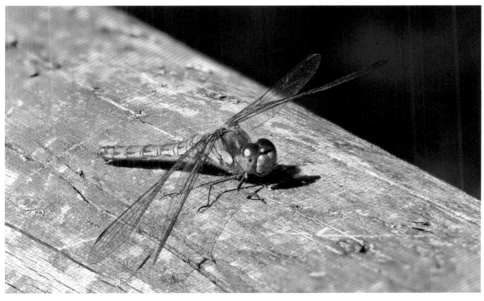

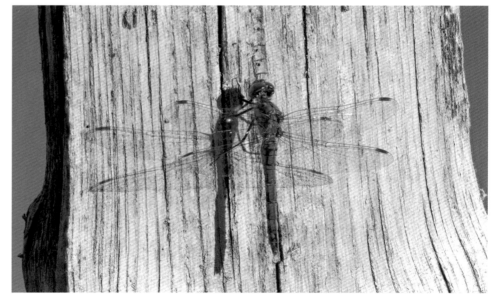

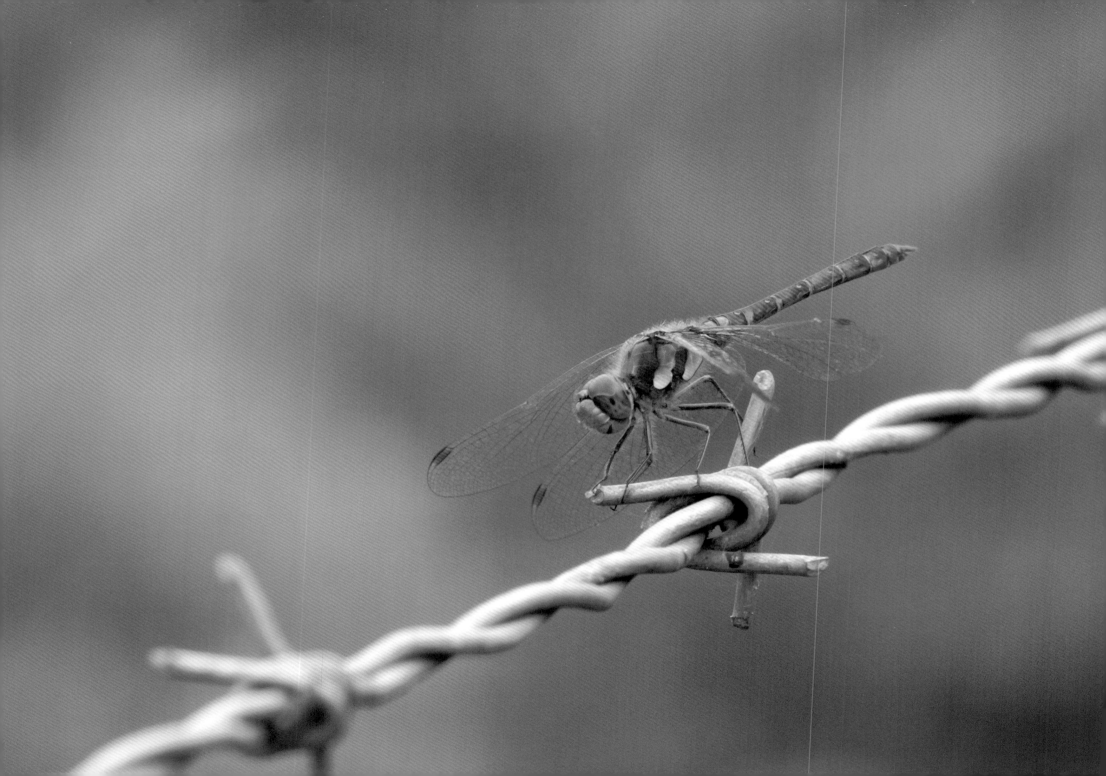

◁ Male Common darter (Itchen).

▷ Four-spotted chaser
dragonfly on the Meon.

▽ Golden-ringed dragonfly
on the Itchen.

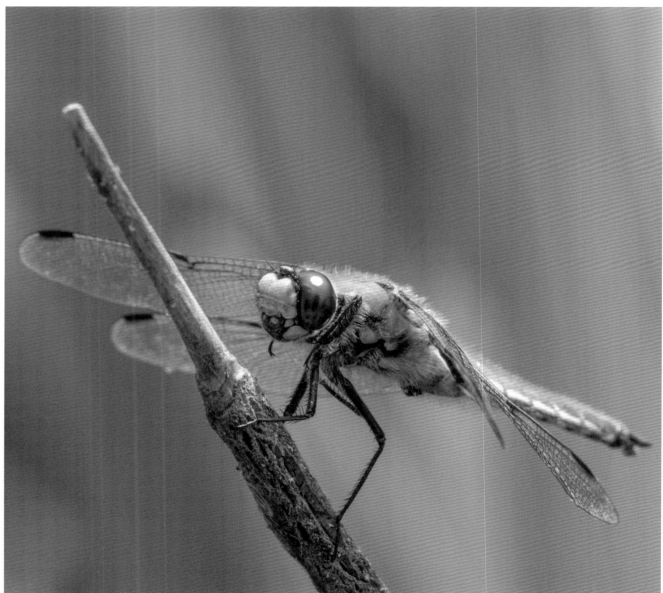

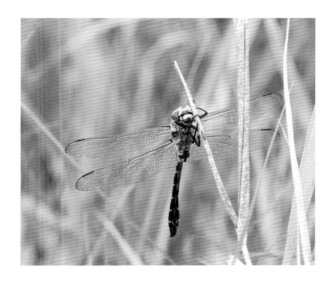

4. Fish

◀ Bullhead in the Avon
(left) and Wylye (right).

▶ Grayling in the
upper Itchen.

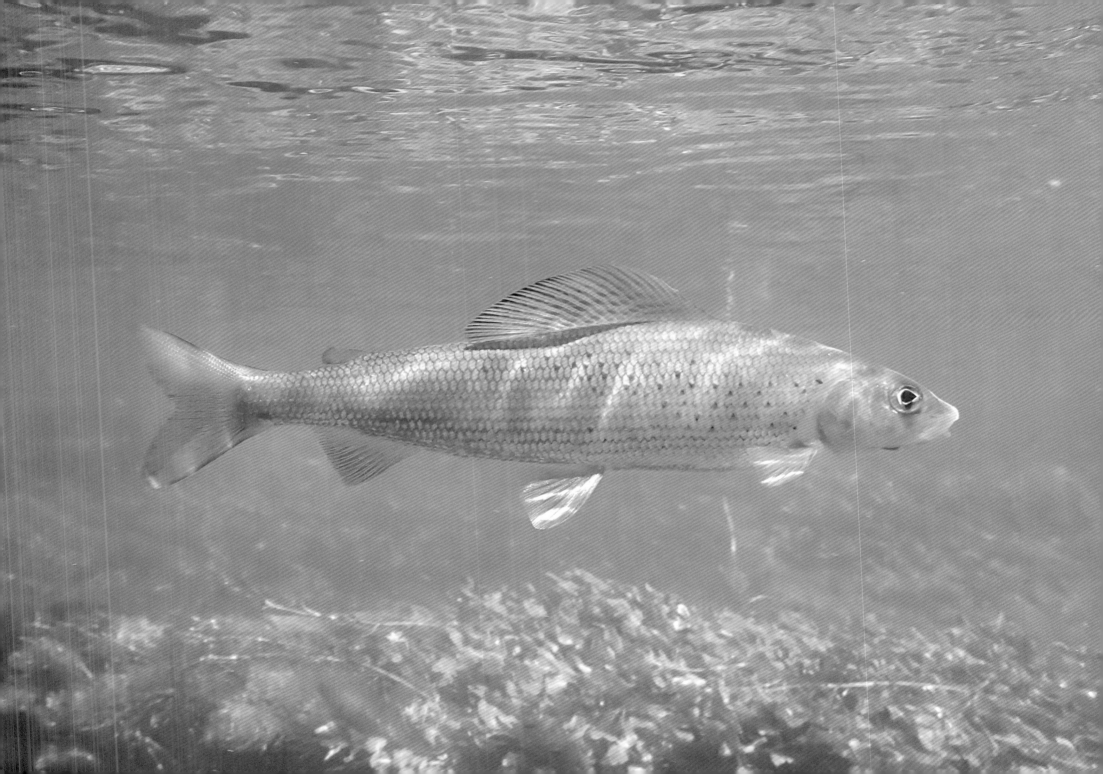

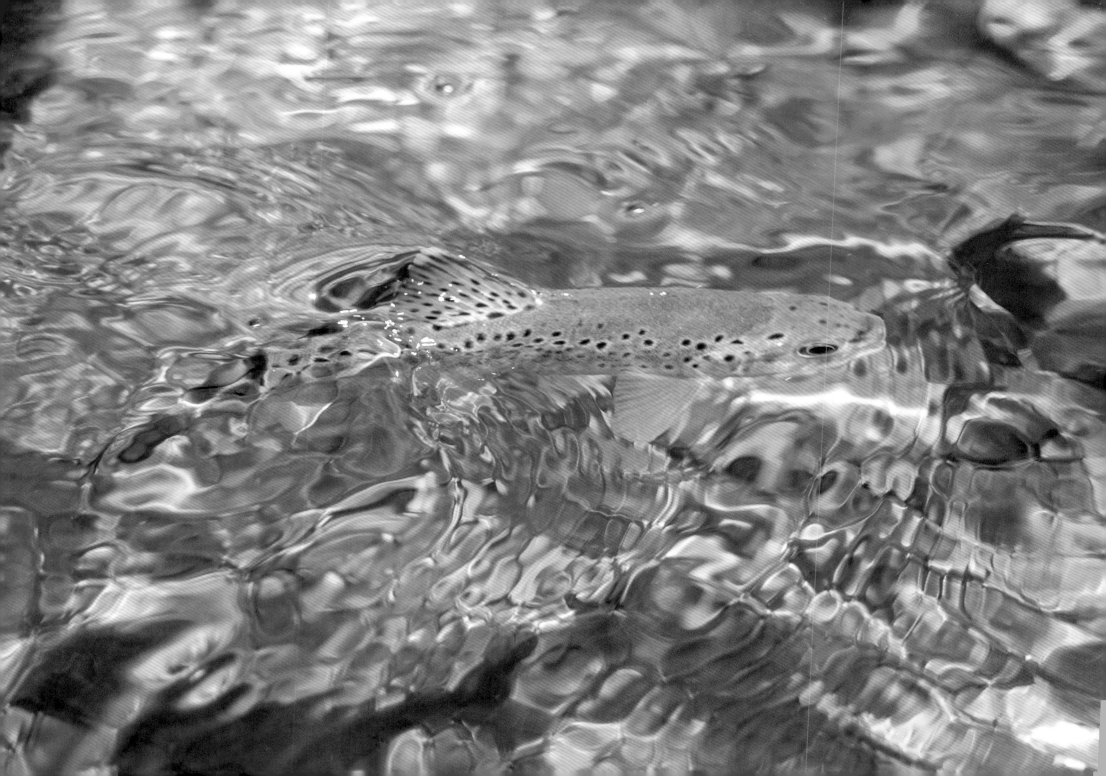

Brown trout in the upper Itchen.

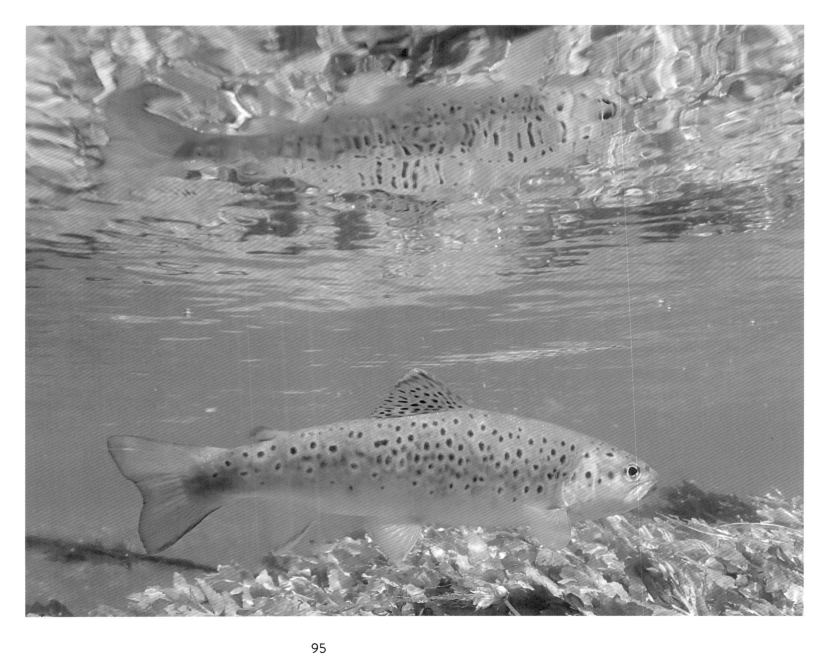

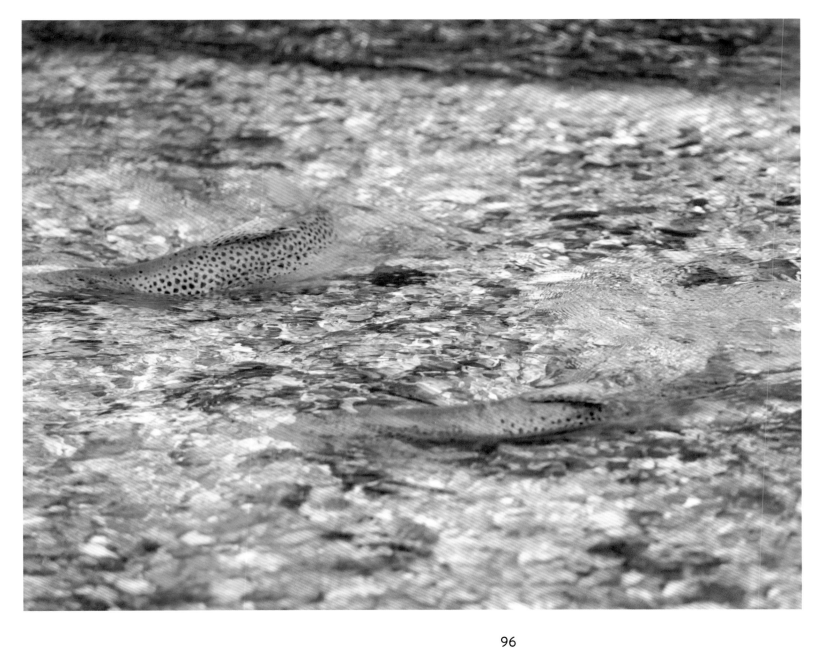

◁ Cock and hen Brown trout spawning activity on the Bourne Rivulet.

▷ Hen fish strongly flapping her tail to create a redd, a shallow depression in the gravel river bed for laying eggs.

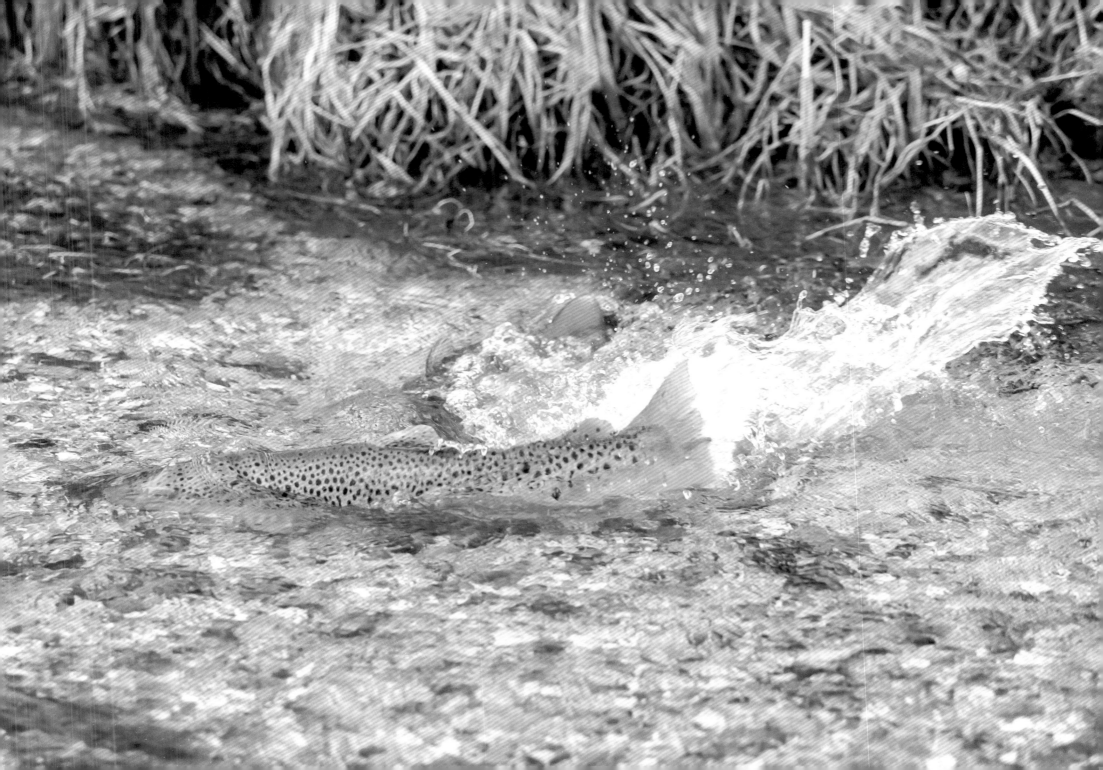

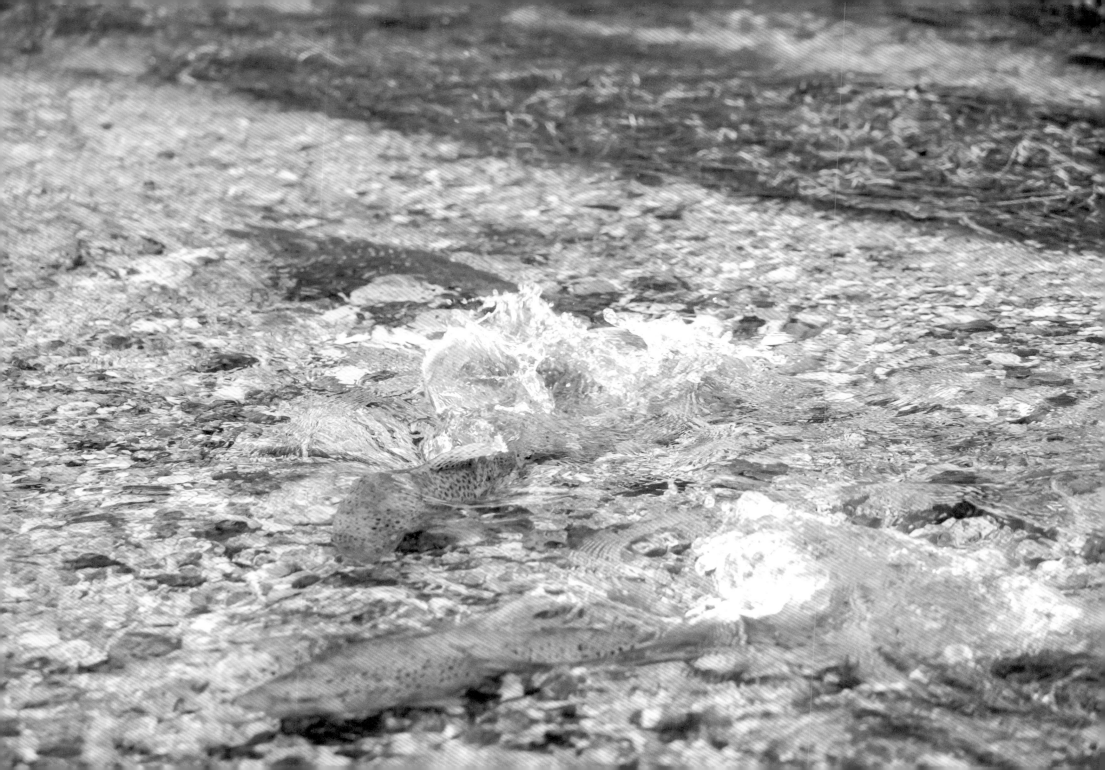

Cock fish chasing off other males.

Hen turning on her side and flapping her tail to move small gravel over the redd, which she will do to cover the eggs when they are fertilised by the cock fish.

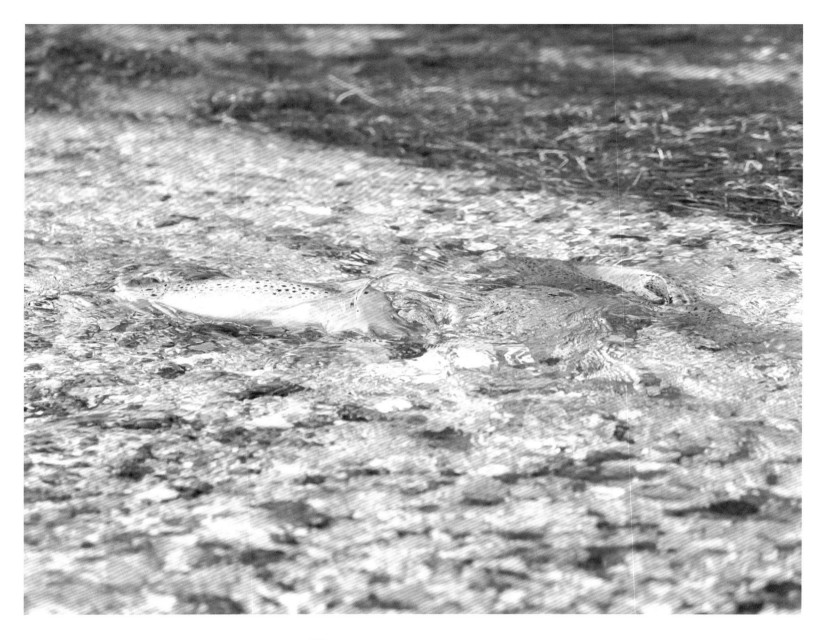

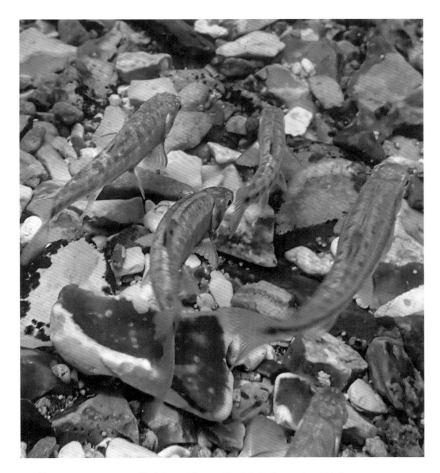 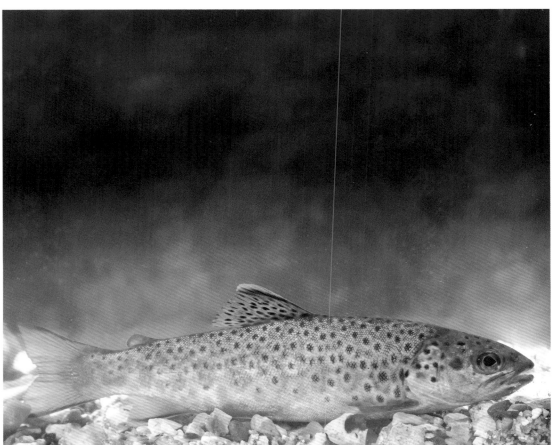

▲ Brown trout parr (left) and juvenile (right) on the Wylye.

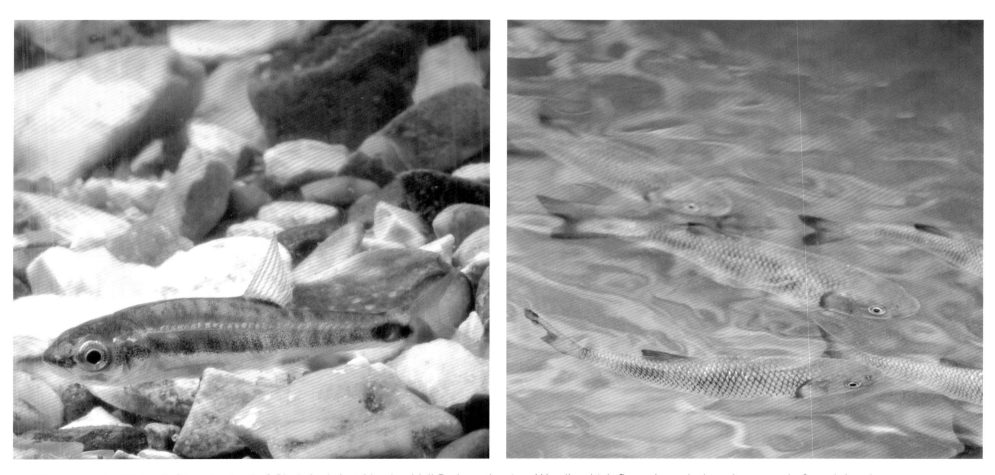

Minnow on the Wylye (left) and a shoal of Chub (right) at Morden Hall Park on the river Wandle which flows through the urban sprawl of south London

FLORA

1. Aquatic Plants

Ranunculus (River water-crowfoot) below a shallow weir (upper Itchen).

Ranunculus over clean gravel in clear water with good flow (Wylye).

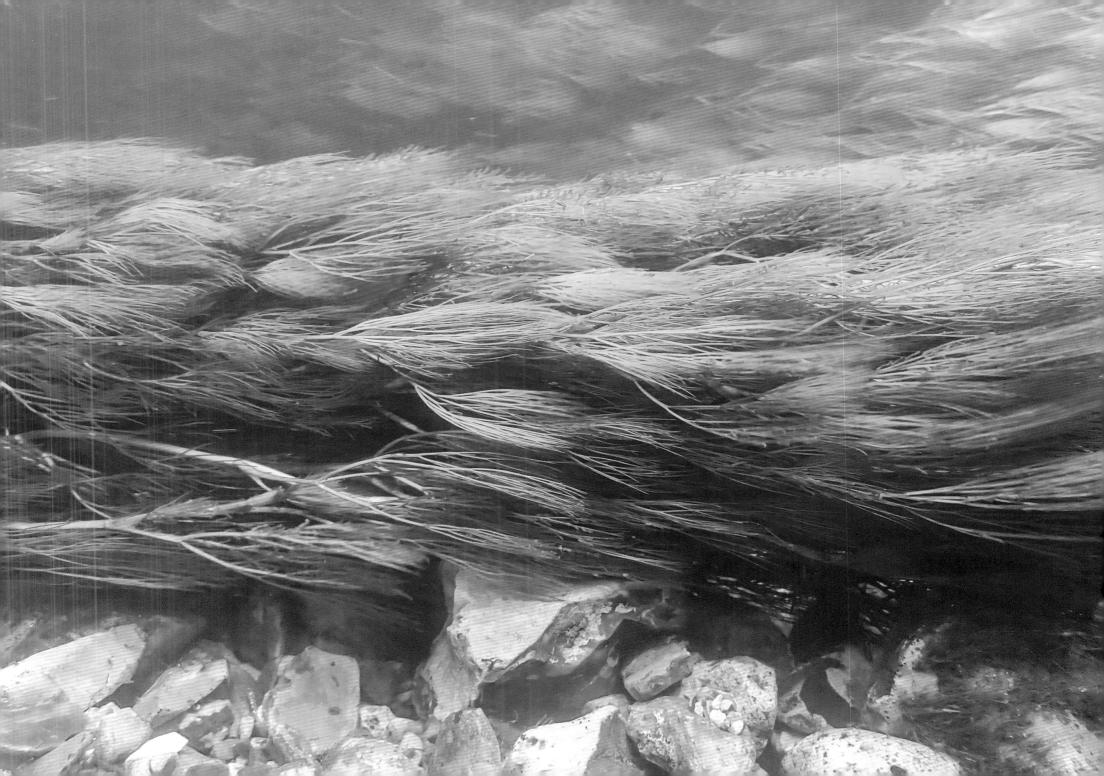

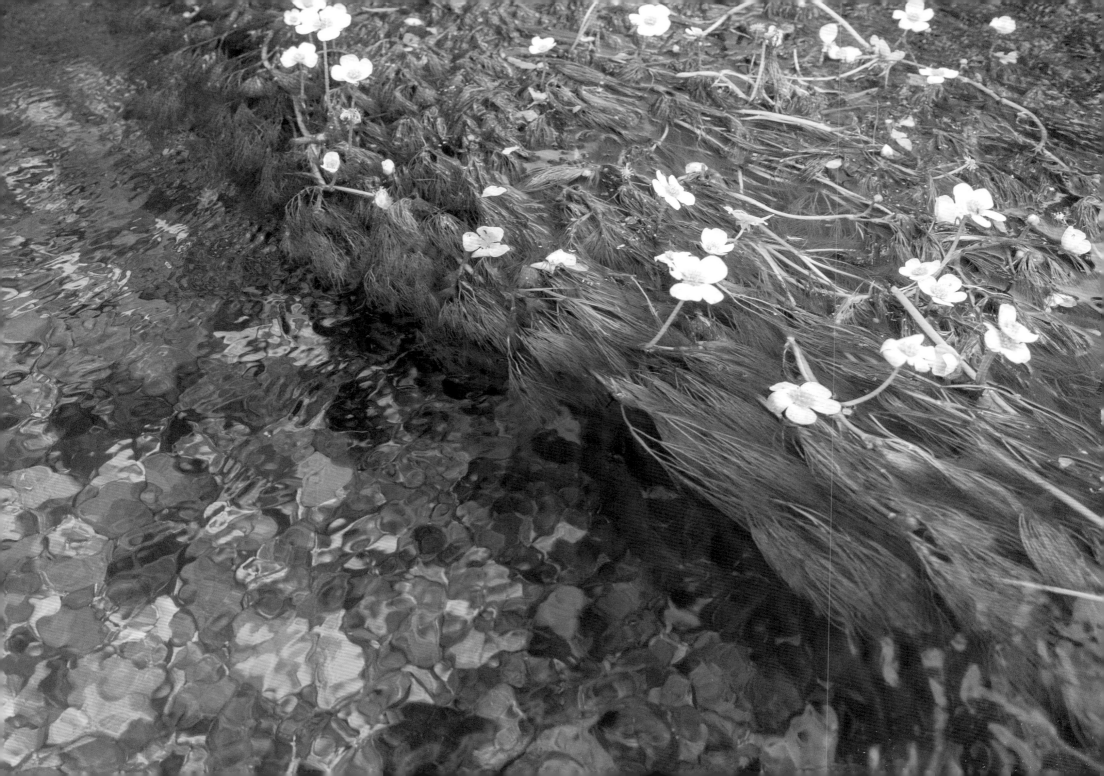

Flowering ranunculus, (Wylye).

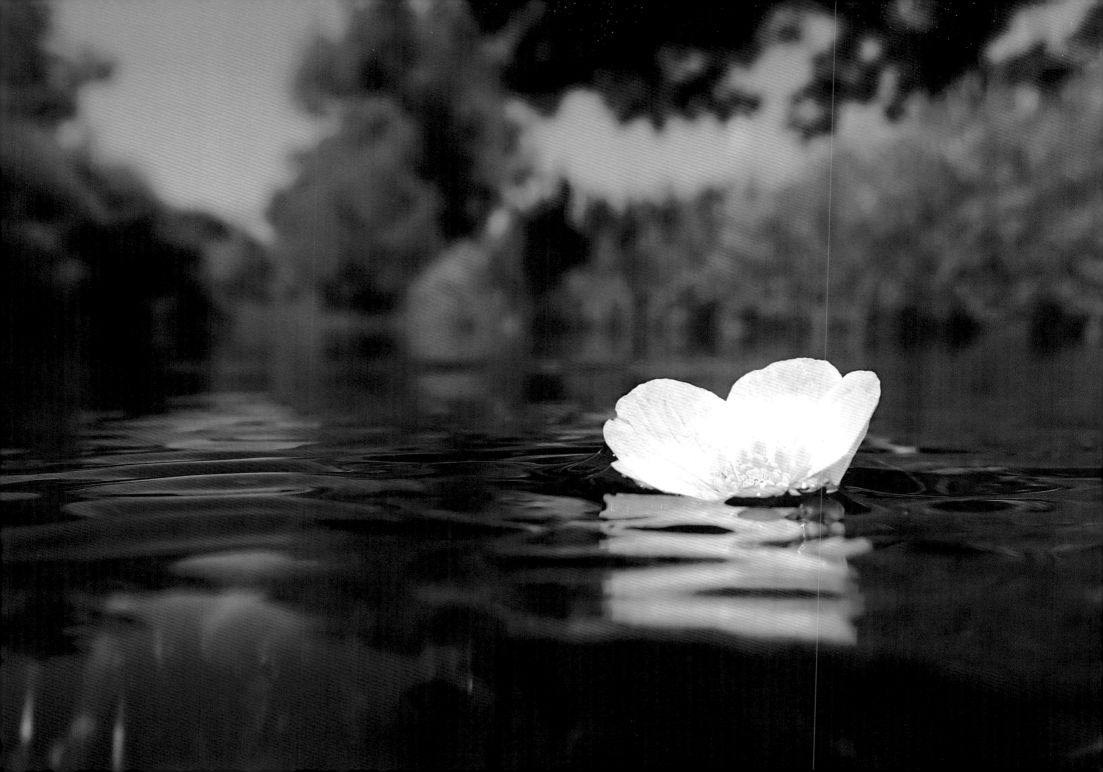

Close-up of the
Ranunculus flower
with insect (Avon).

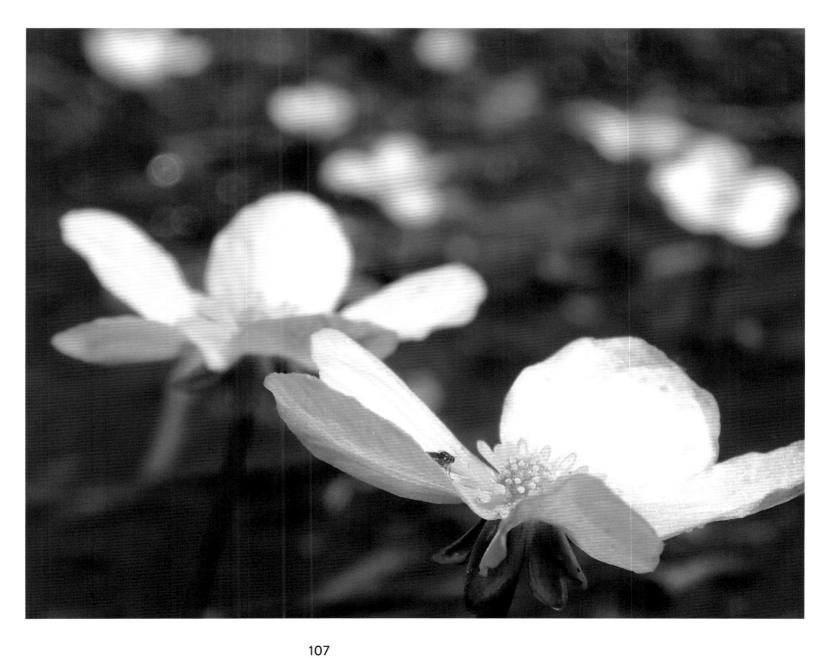

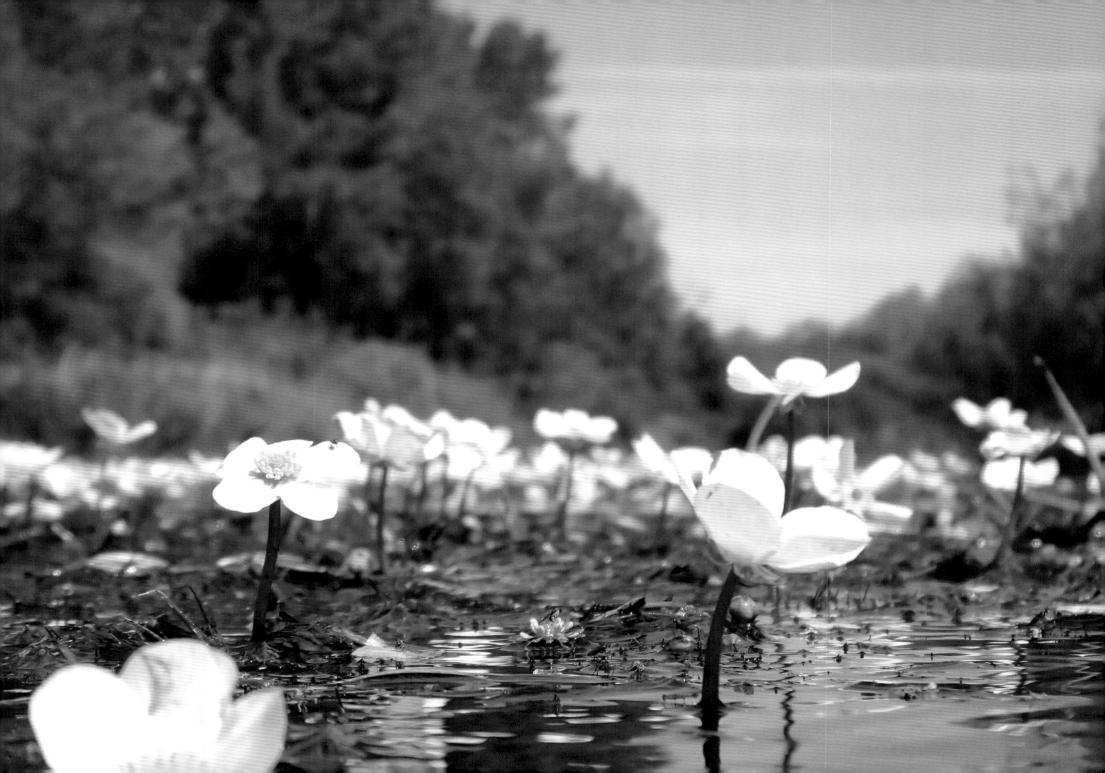

On closer inspection the Ranunculus is teeming with insects.

Lesser water parsnip and Fools water cress on the Wylye. Water cress growing vigorously in late summer (lower images), growing out from the edge and narrowing the stream (Itchen and Wylye).

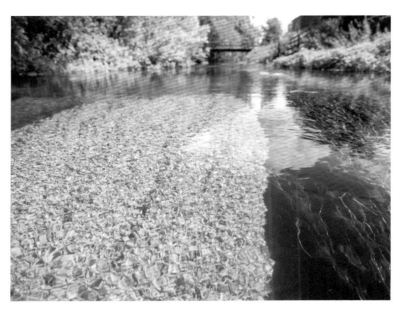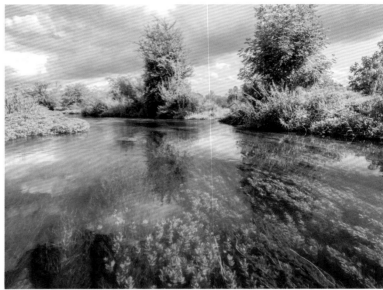
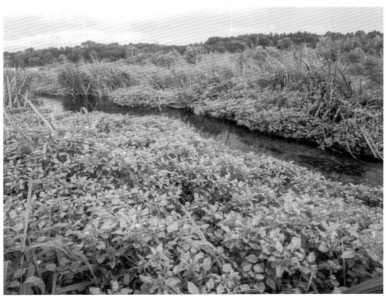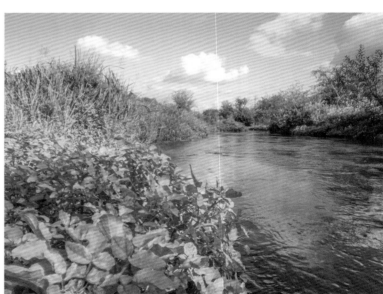

2. Bankside Plants

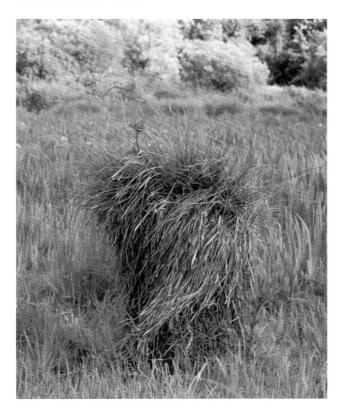 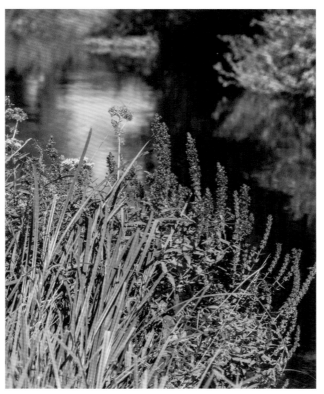 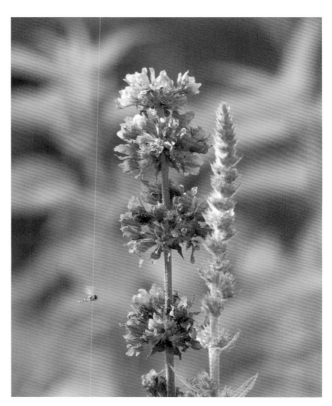

△ Greater tussock (upper Itchen) and Purple loose-strife (upper Itchen and Avon).

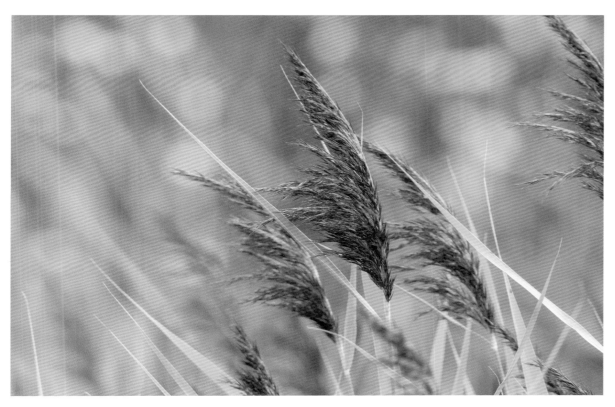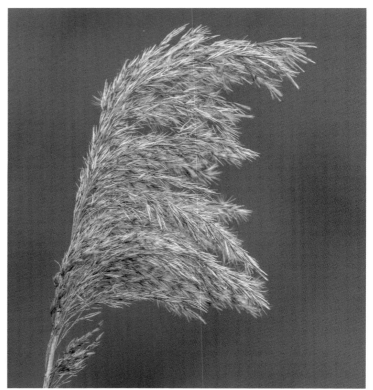

Grasses, Bull rushes and Teasels – looking just as attractive in winter (above and overleaf)

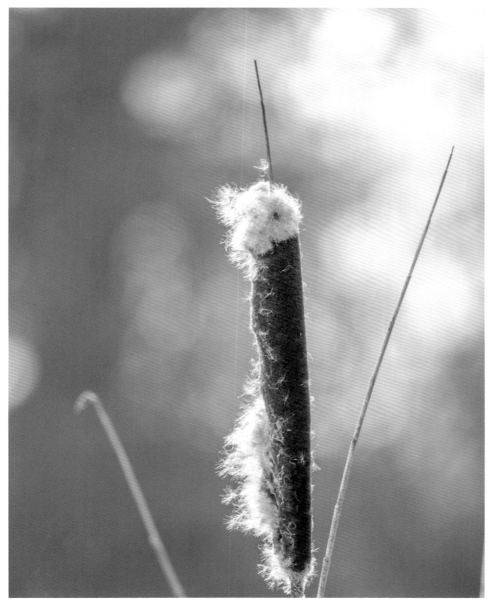 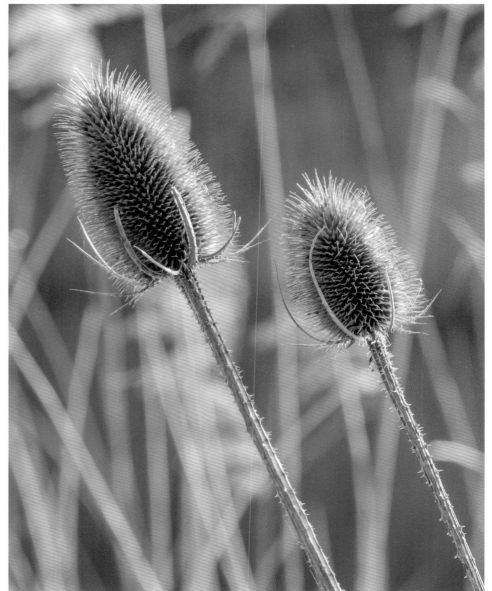

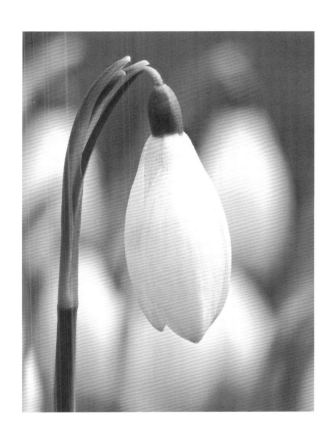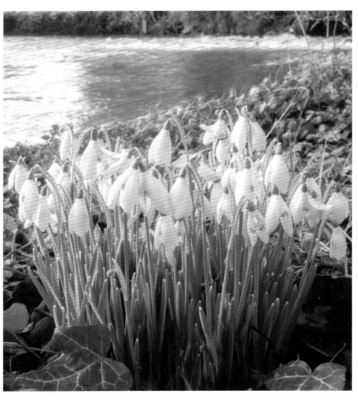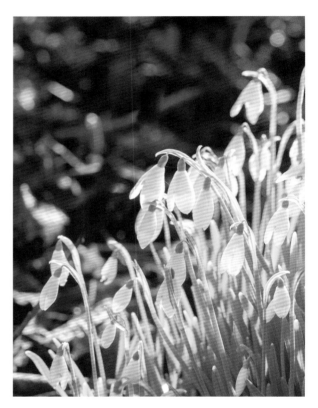

Snowdrops. Close up from the Test, and early Spring sunshine on the Avon

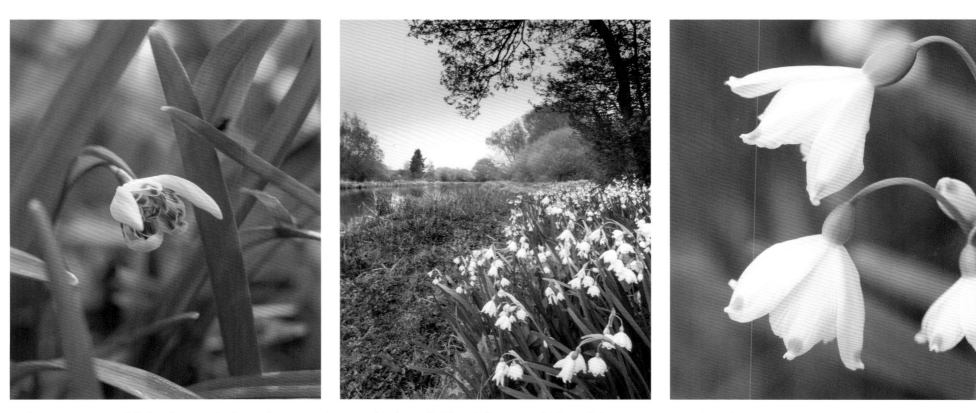

▲ The more unusual Galanthus nivalis flore pleno snowdrop on the Avon (left) and the rare wild Snowflake on the banks of the Avon.

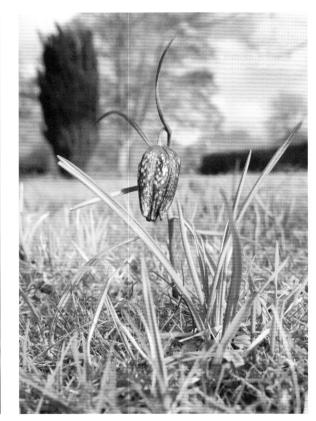

Orange balsam on the Upper Itchen (left), wild Orchid (centre) and Snake's head fritillary (right) on the banks of the Avon.

Flag iris (Avon).

3. Trees

The iconic Willow tree, so representative of the chalk stream. This one at Abbots Barton was made famous by writer and angler, G.E.M Skues.

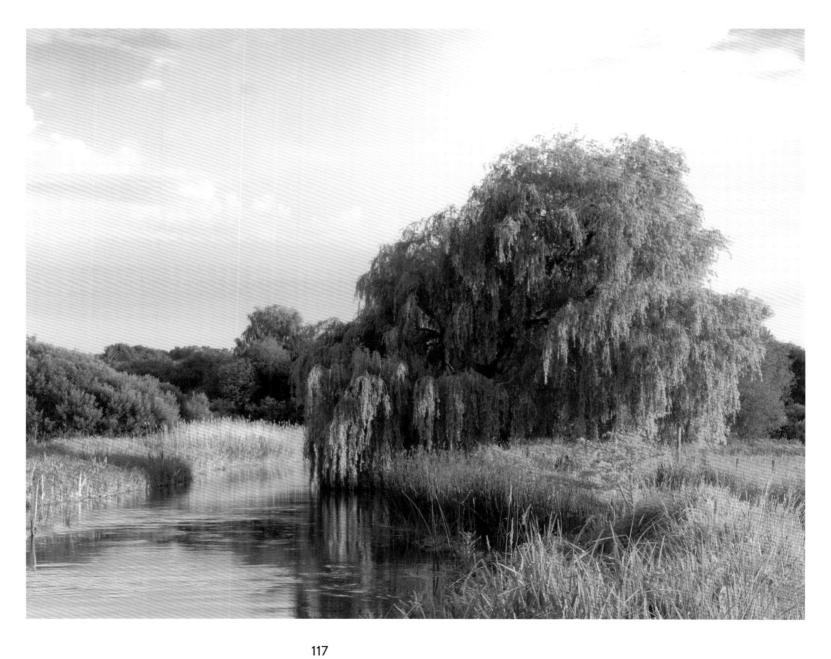

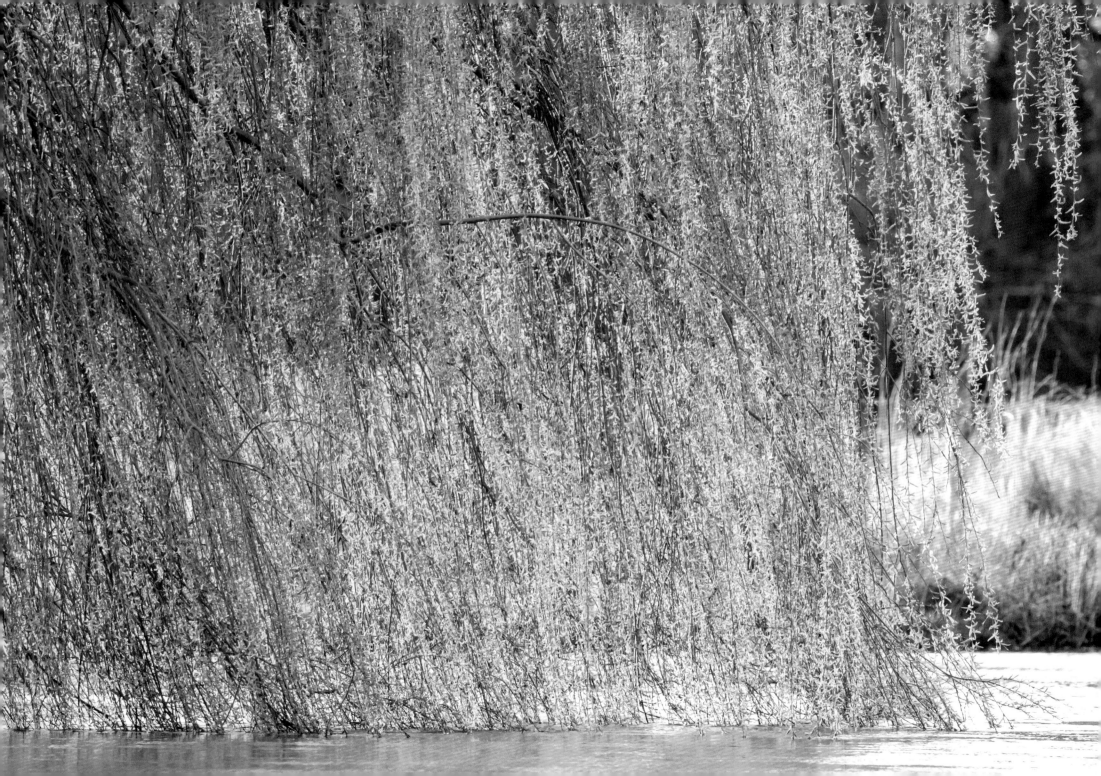

Early Spring growth on a Willow hanging over the Avon.

Pussy willow (Avon).

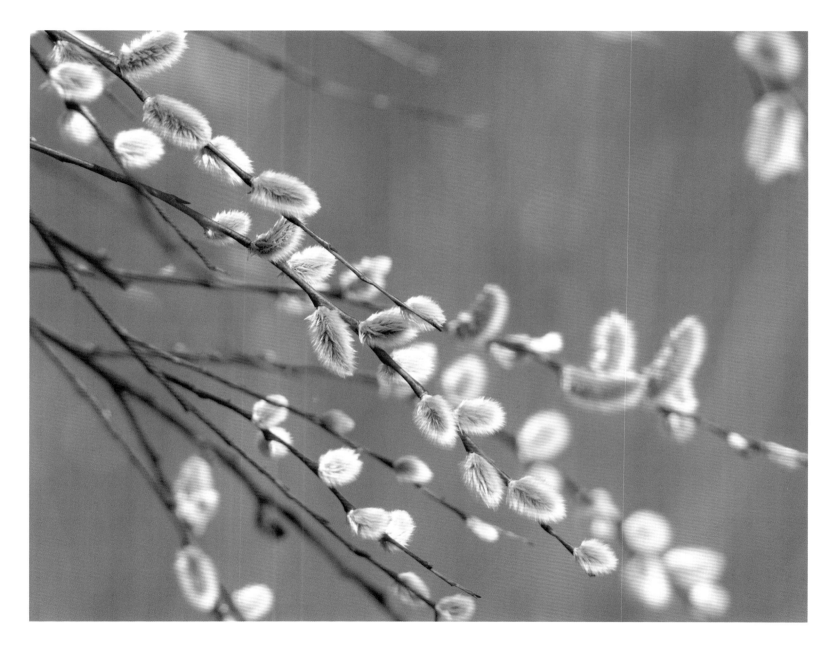

119

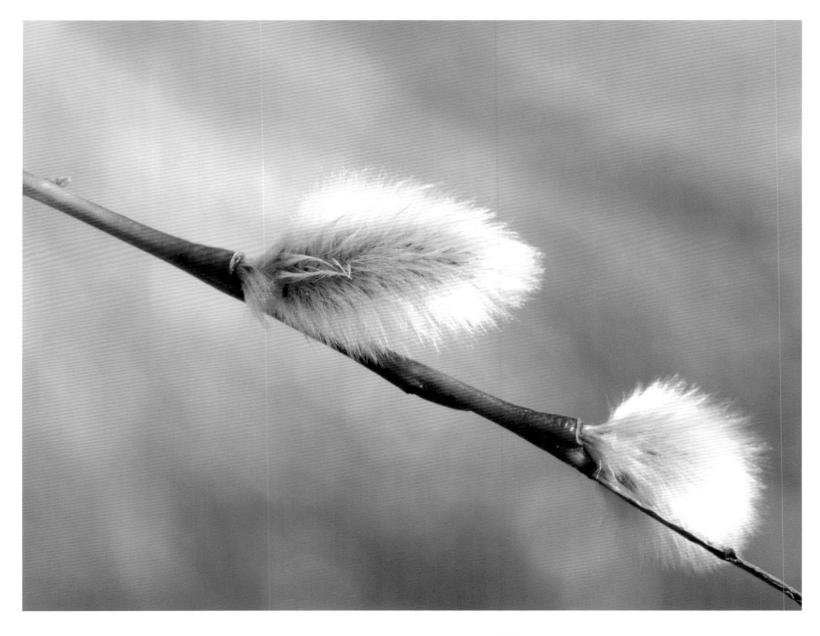

◀ Close-up of Pussy willow.

▶ Blackthorn on the upper Test.

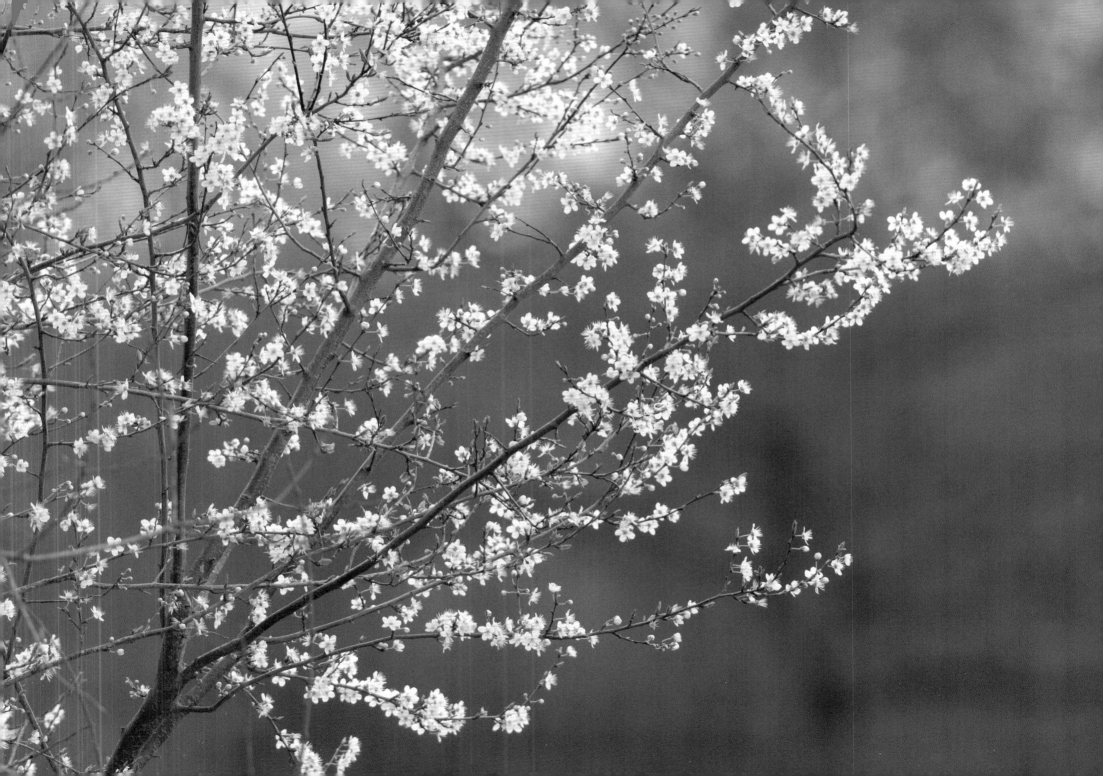

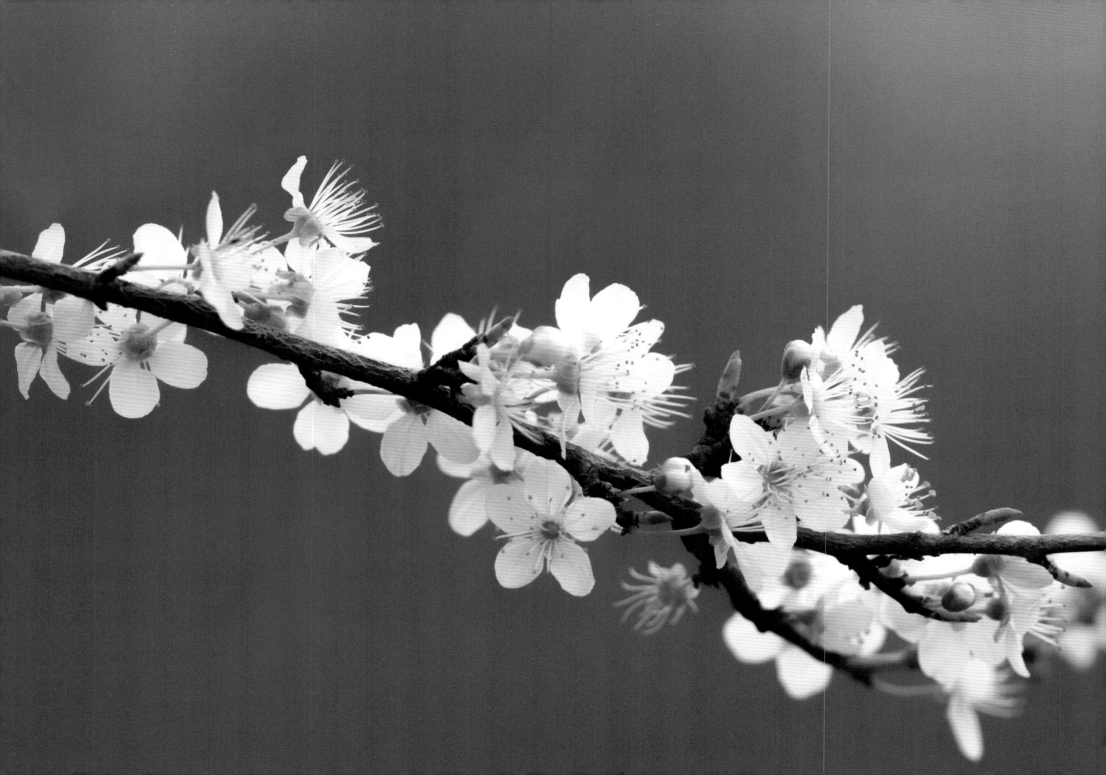

Blackthorn berries
– Sloes (Test).

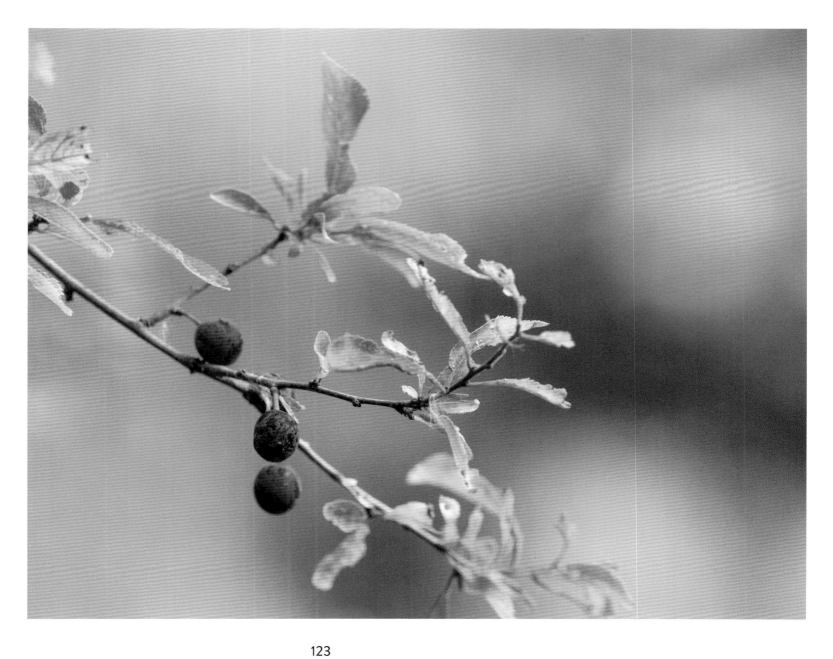

4. Fungi and Lichen

Scarlet elf cup fungi (Itchen). Various lichen (carrier of the Test) – a sign of clean air.

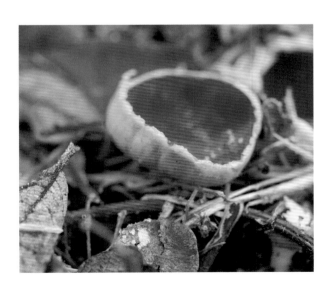

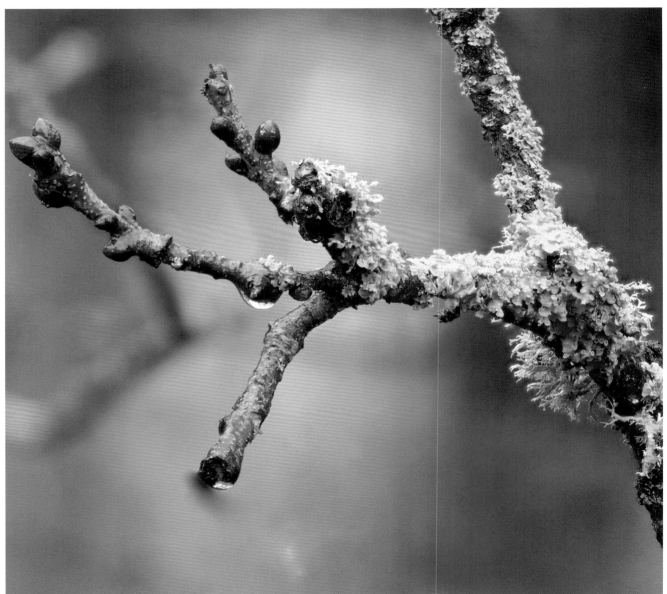

124

WILDLIFE SURVEYS AND PRESERVATION

Hampshire and Isle of Wight Wildlife Trust survey of the native White-clawed crayfish (below right) which is now found only in a very few protected areas in the chalk streams partly because of being driven out by the deadly virus carried by the non-native American signal crayfish. A secret location (below left) in one of the headwaters where White-clawed crayfish are being reintroduced and protected.

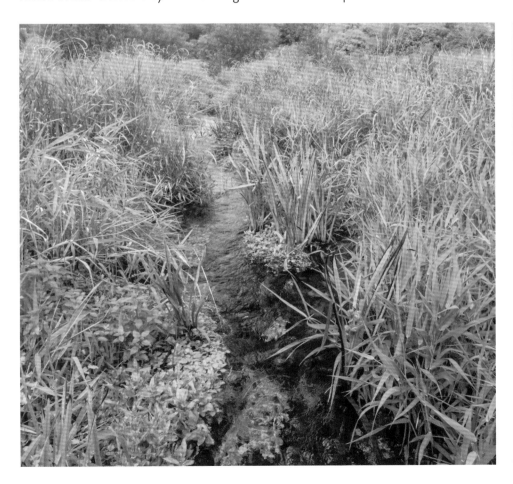
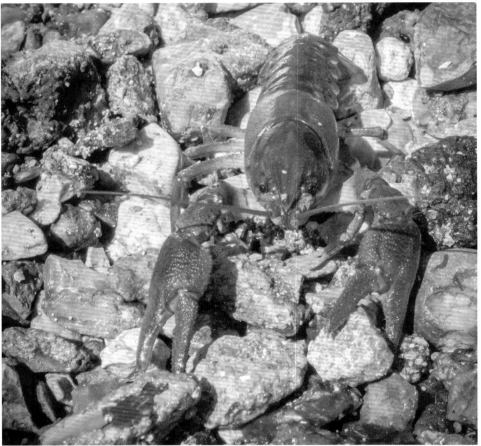

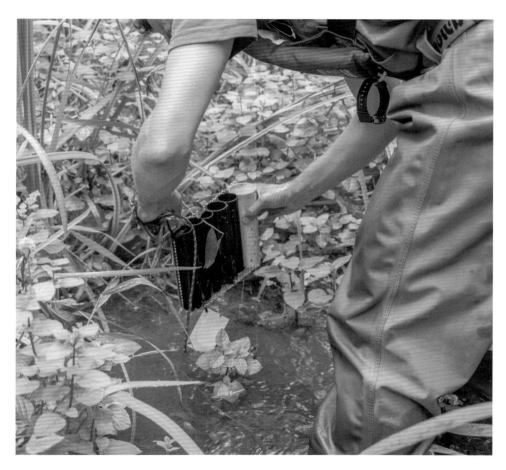

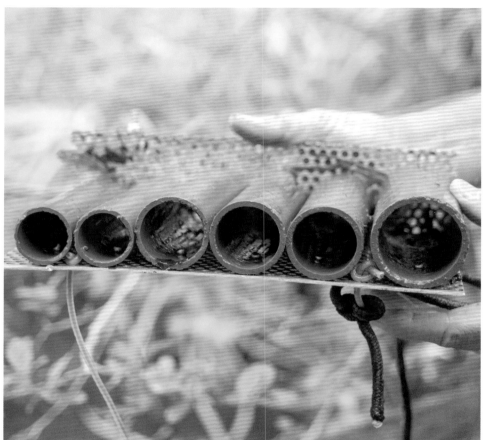

Special habitats for the White-clawed crayfish.

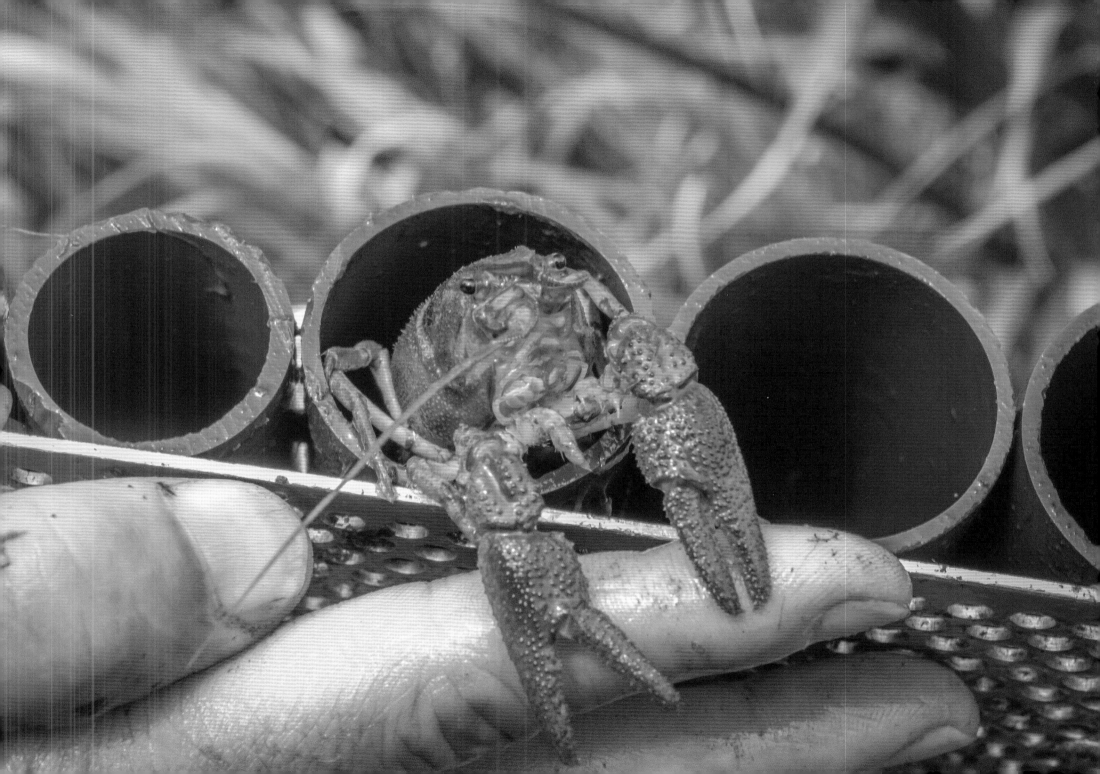

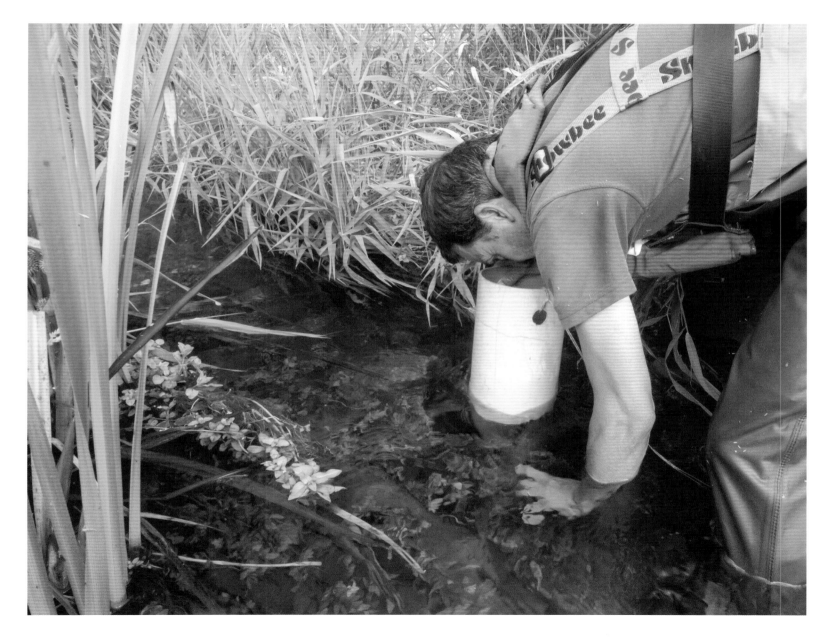

Searching by hand using a glass bottomed tube to assist viewing through the water surface.

128

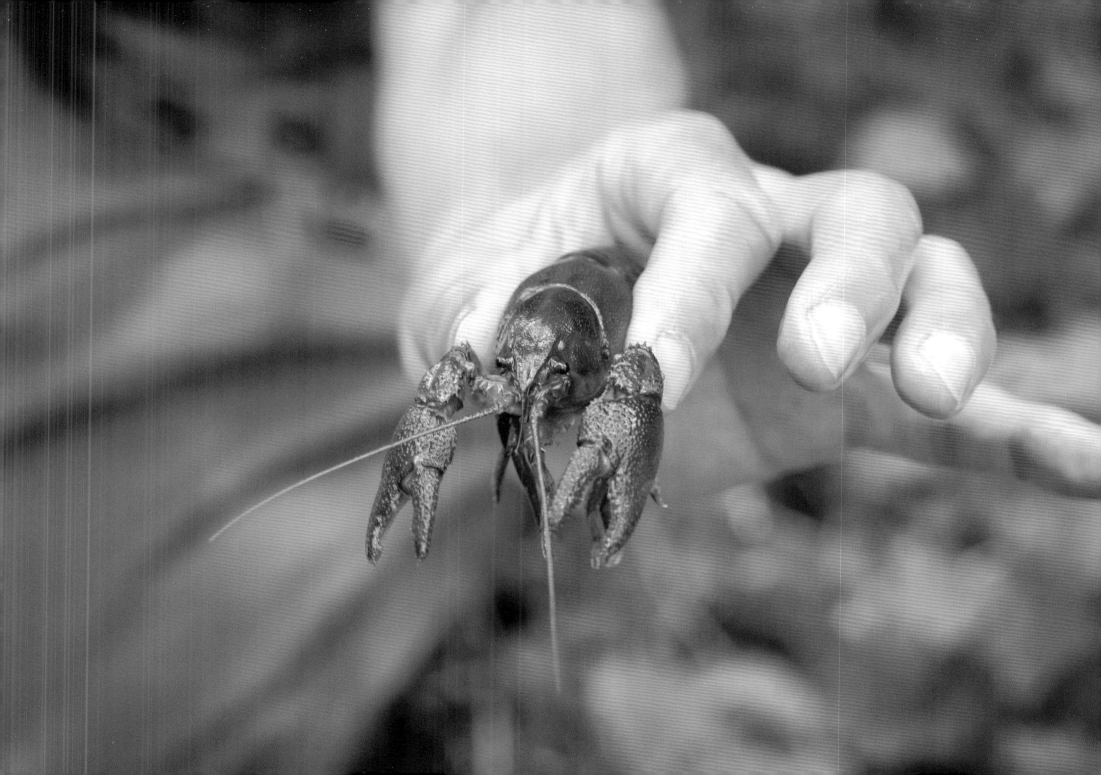

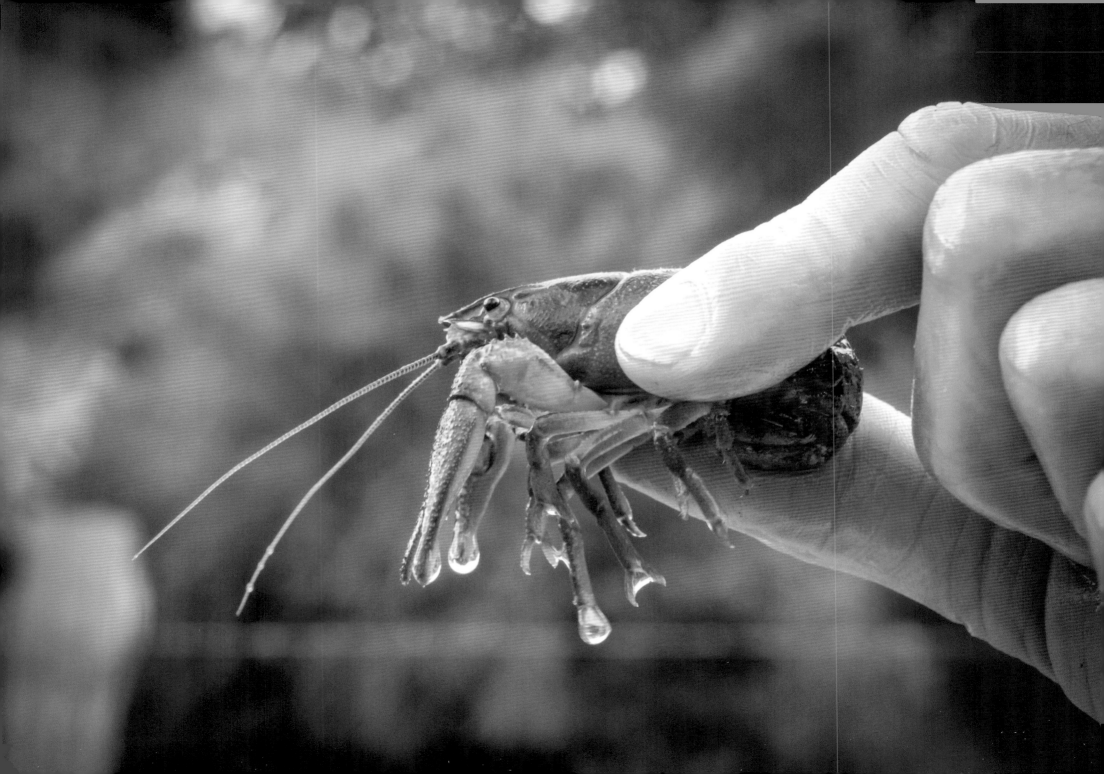

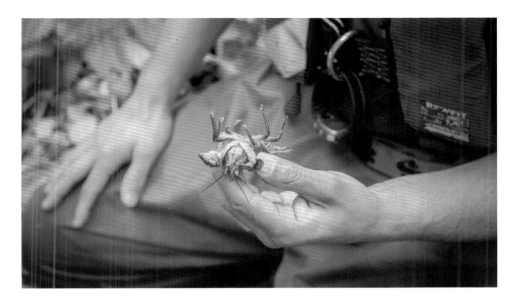

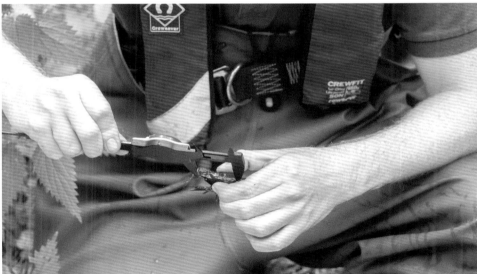

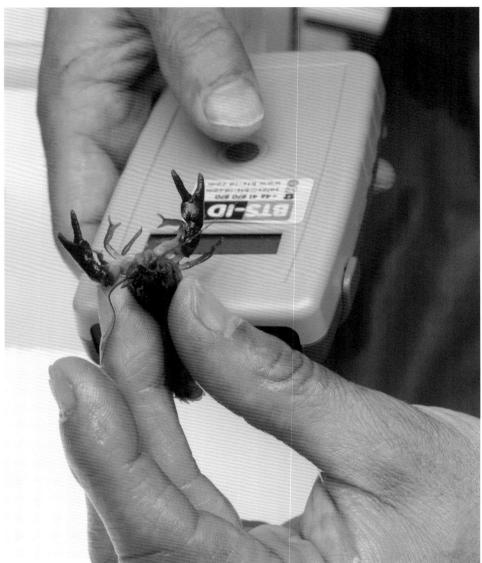

Measuring the White-clawed crayfish and checking electronic tags.

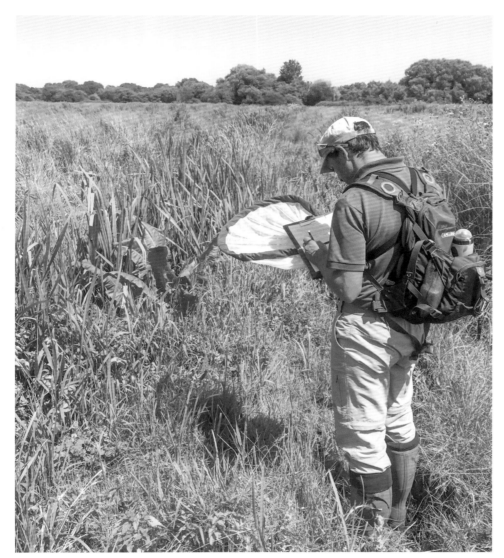
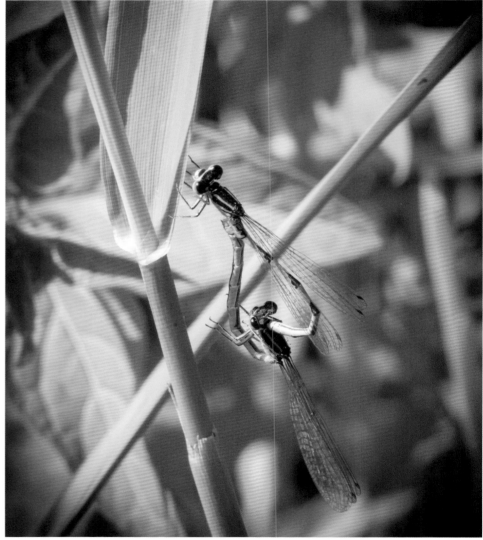

▲ Hampshire and Isle of Wight Wildlife Trust ecologist undertaking surveys in the protected habitat of the extremely rare Southern damselfly (left). Mating male – blue and female – green (right)

Southern damselfly
– recognisable by
the distinctive skull
like black marking.

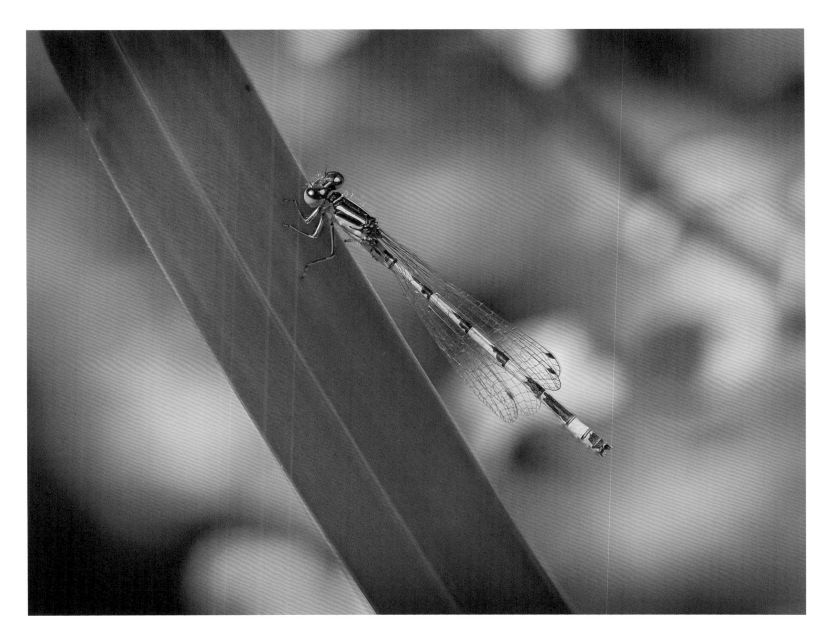

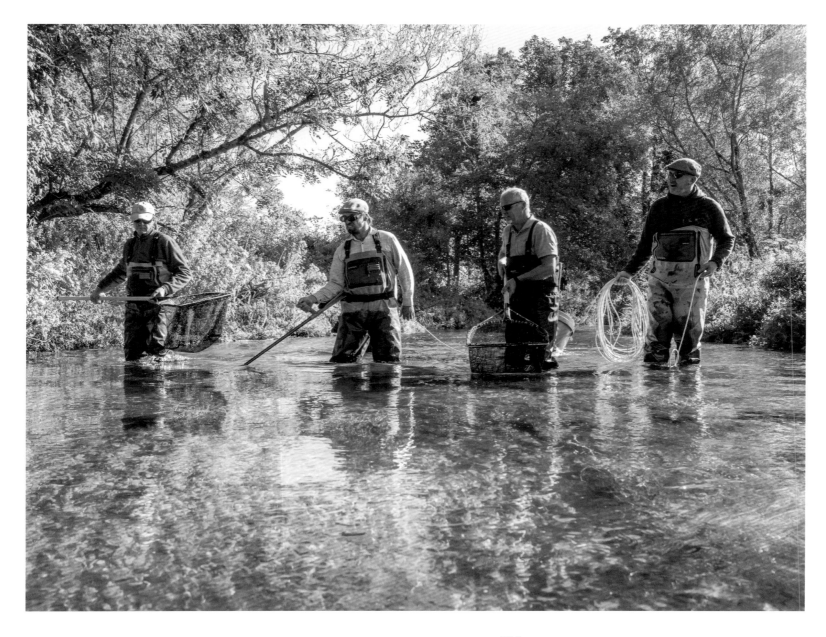

Netting to carry out fish monitoring surveys, vital for understanding the health of the rivers.

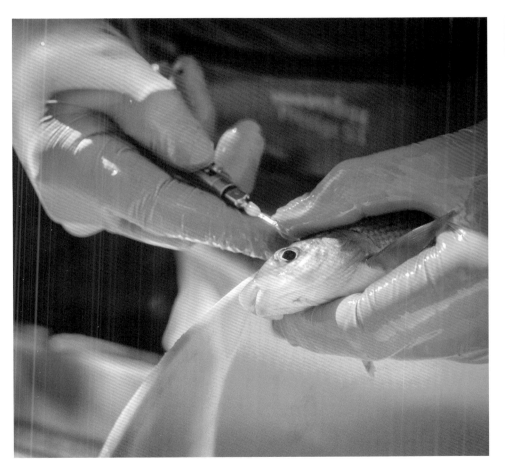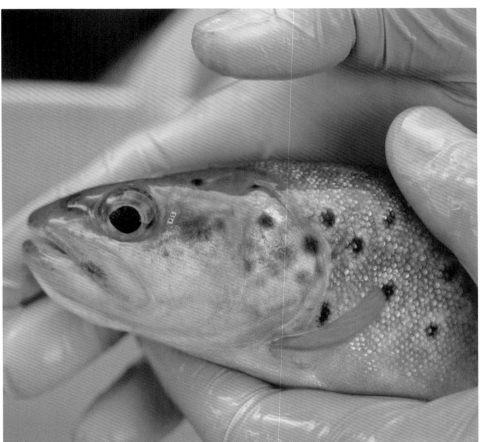

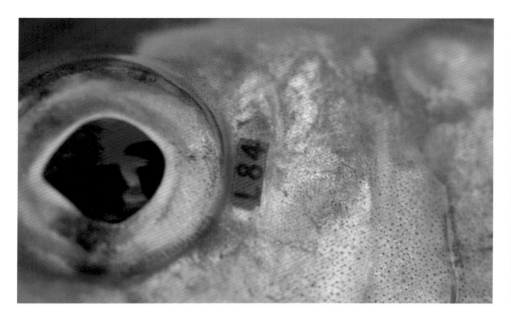

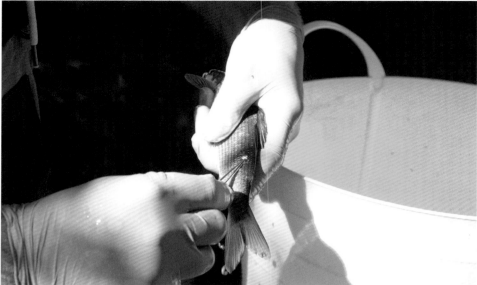

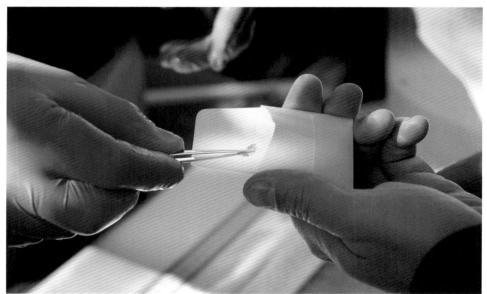

Weighing, measuring length, tagging and taking a scale for further analysis (this and previous page).

FISHING

The chalk streams are world famous for dry fly fishing for trout. The fishing societies are important sources of funding for the conservation of the habitats. Some of them, an example being The Piscatorial Society, manage the waters to preserve their natural beauty and provide habitats where the natural recruitment of wild fish can take place.

Casting a dry fly on the upper Itchen.

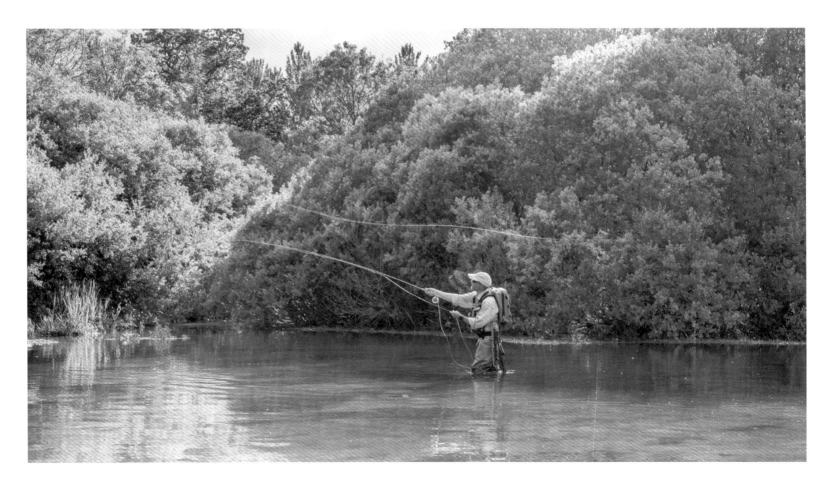

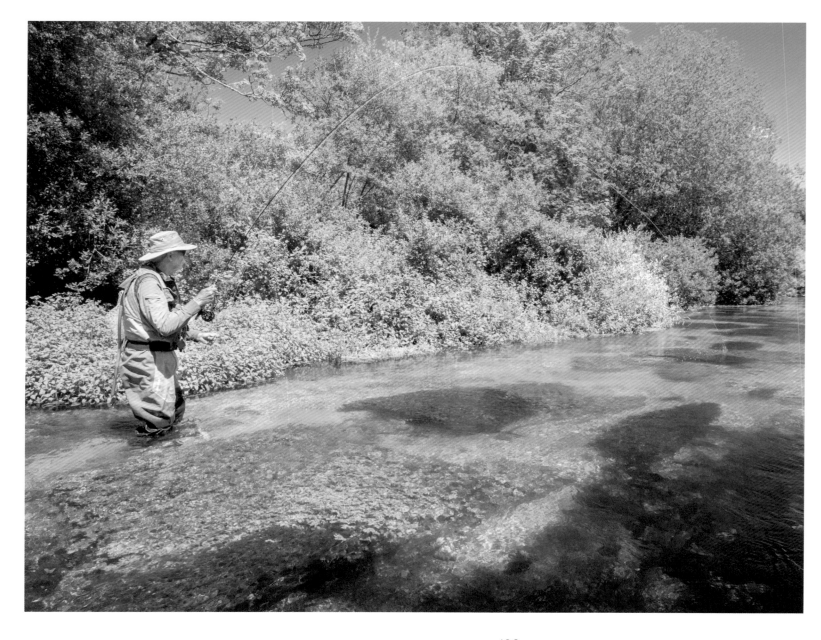

Fishing in the crystal clear waters of the upper Itchen.

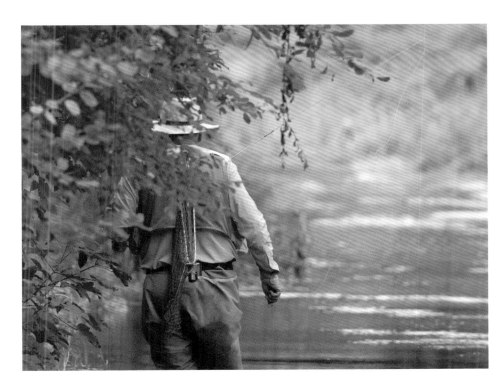 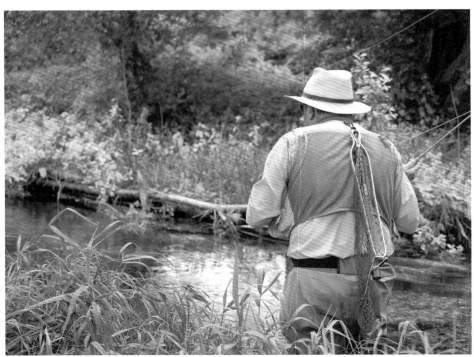

Stalking brown trout on the Bourne Rivulet.

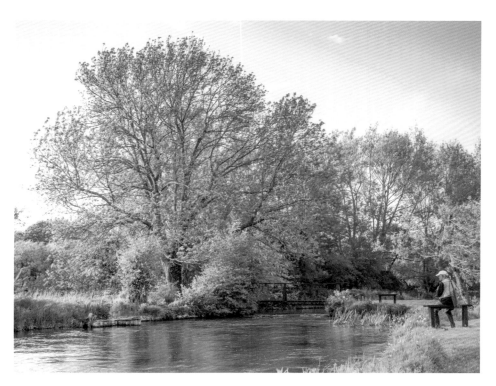
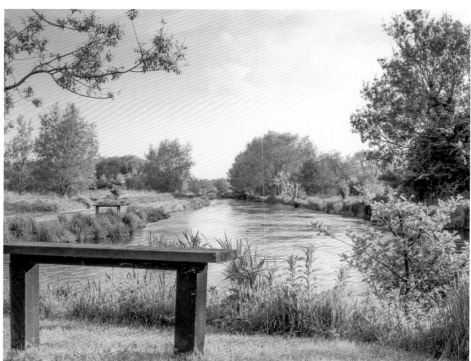

Fishing beat on the lower Itchen.

Fishing beat on the middle Itchen.

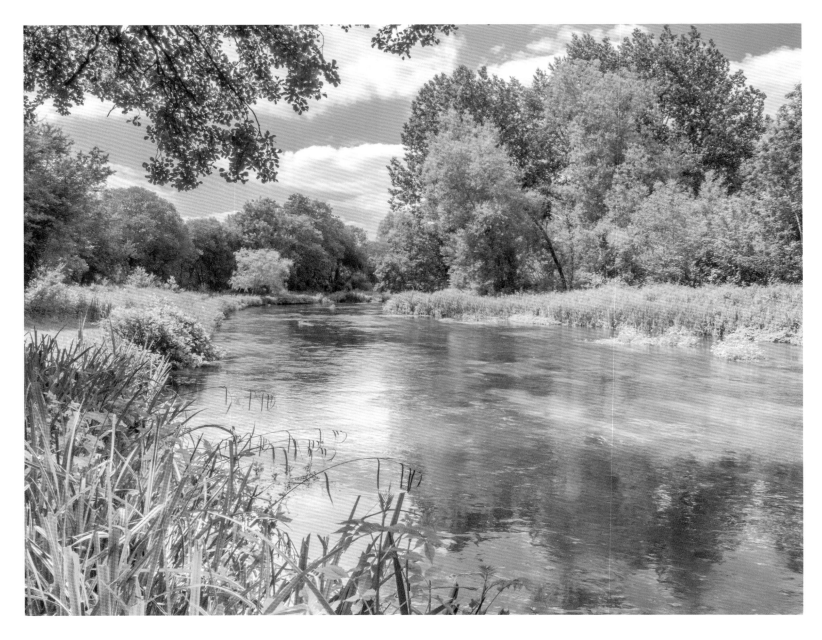

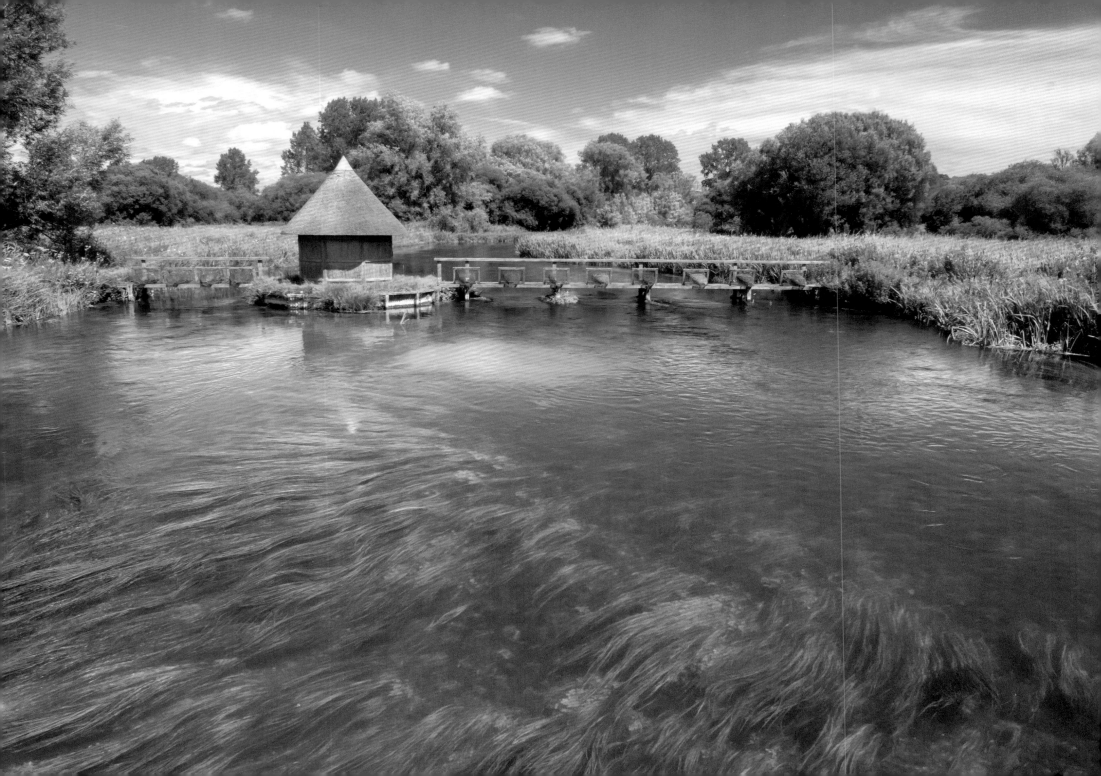

Fishing beat on the middle Test – the eel traps at Leckford.

 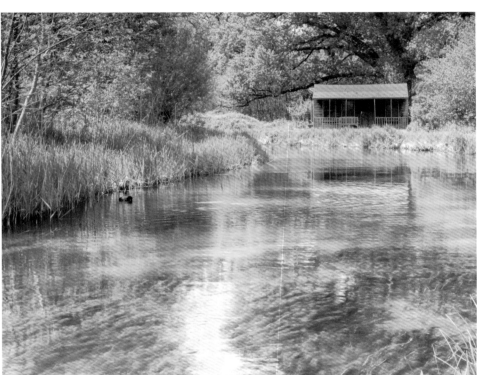

Fishing beat on the upper Test. Overleaf, the same beat in Autumn.

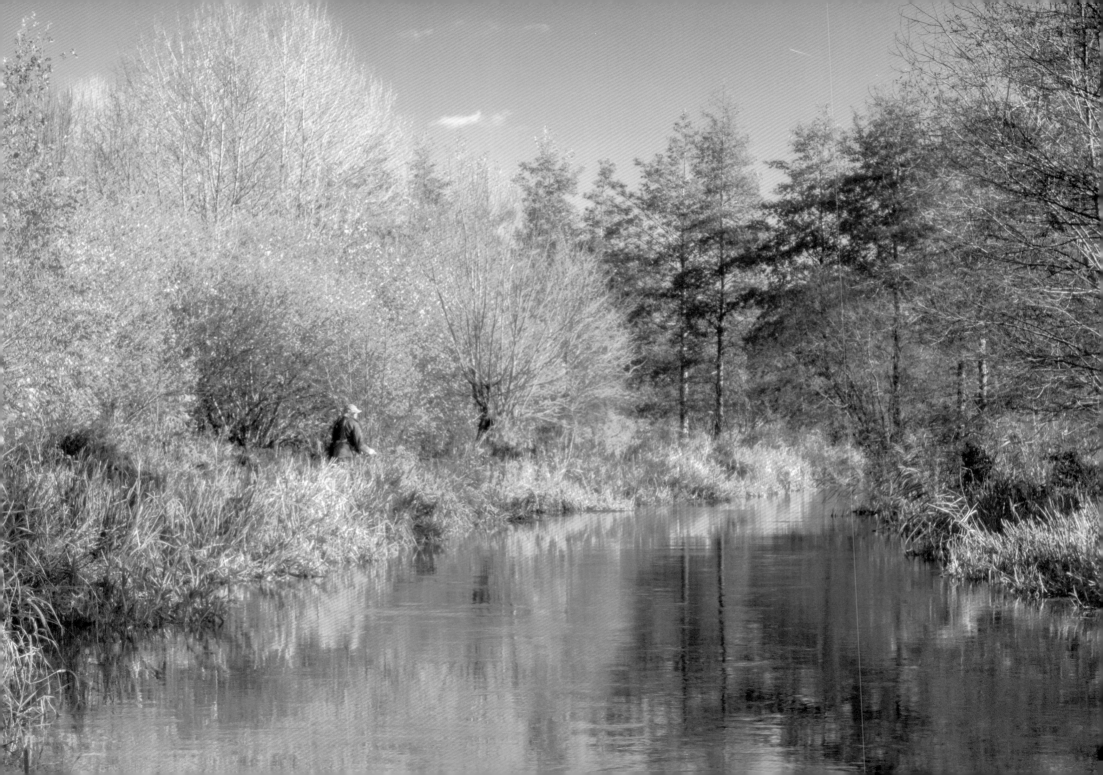

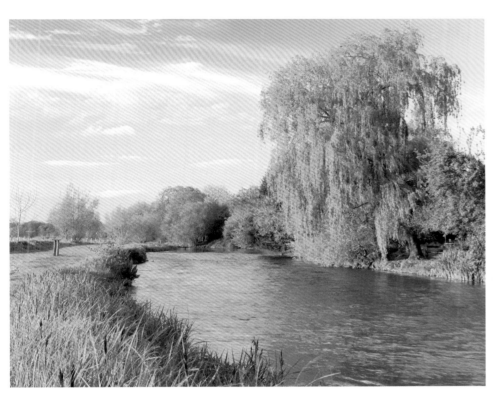

△ Lower Test beat in the Spring.

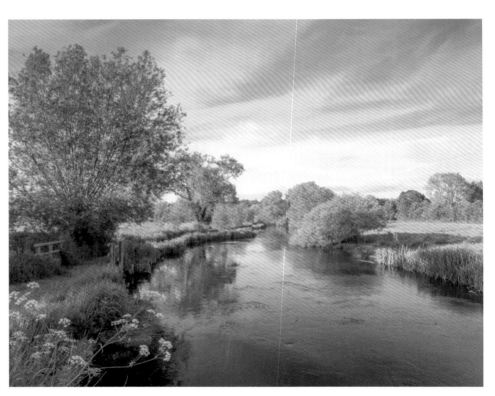

△ A fishing beat on the Avon.

MAINTENANCE

The conservation of these environments requires the constant attention of keepers, wildlife rangers, volunteers and sympathetic landowners. Weedcutting is an essential part of maintenance to keep flows and water levels under control, prevent silting up and to ensure healthy growth of the aquatic weeds that are so important to fish and invertebrates. A traditional scythe used for woodcutting (left). Chequer board pattern cut in weed to maintain cover for invertebrates and fish while opening up gaps showing clean gravel on the river bed.

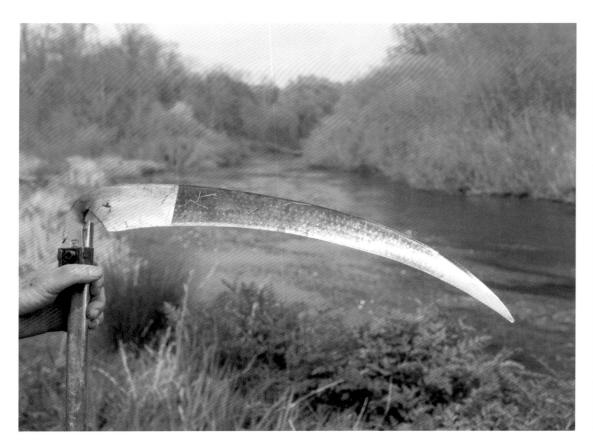
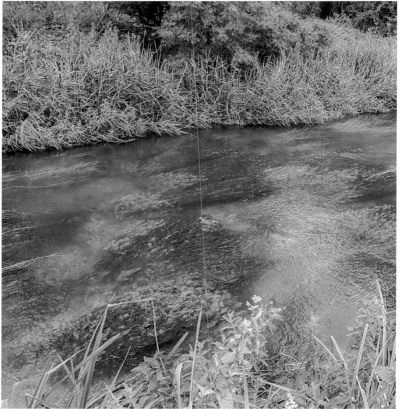

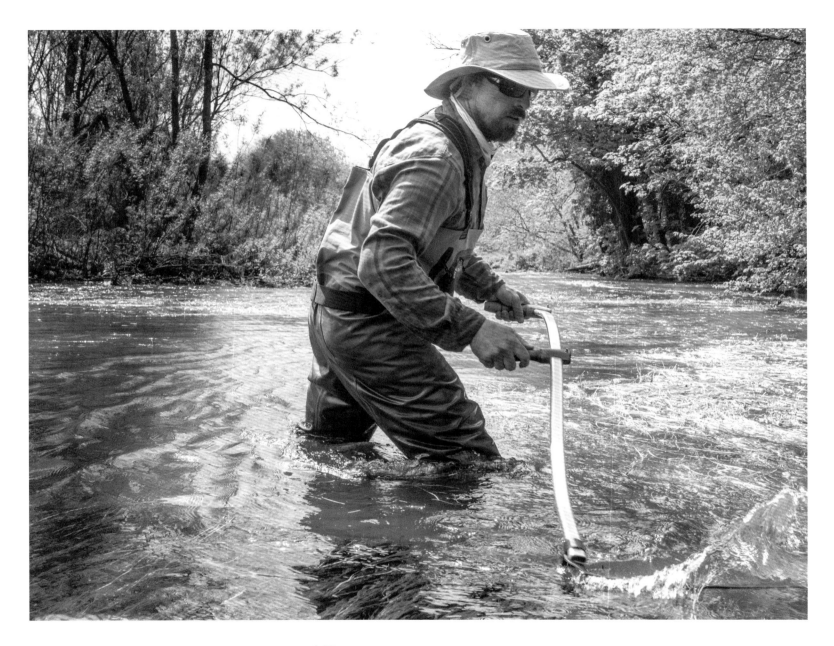

Weedcutting on
the Avon.

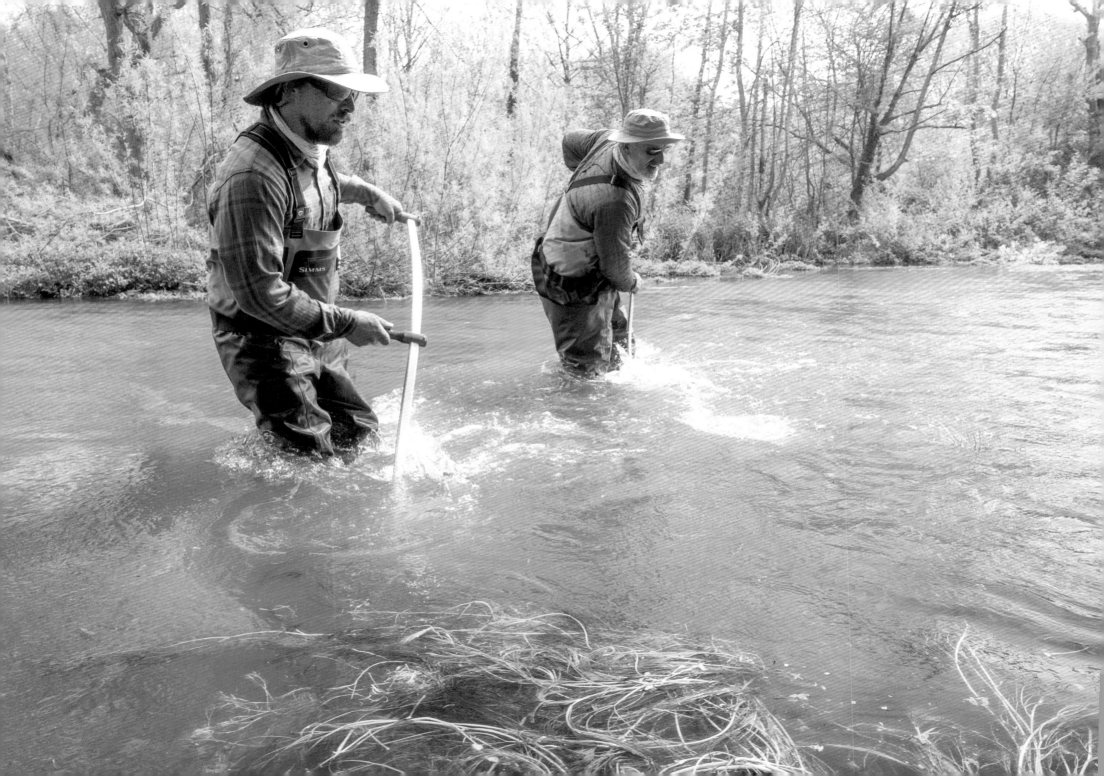

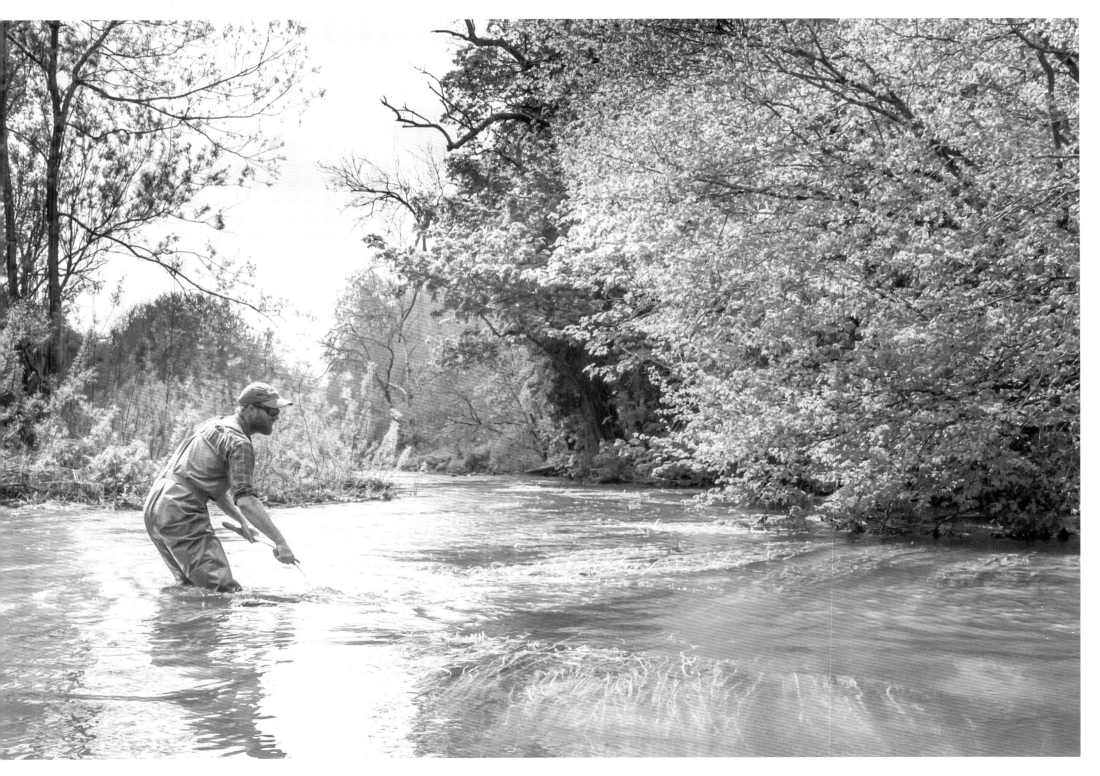

CONSERVATION AND RESTORATION

A featureless part of the upper Meon on a concrete bed before restoration (left). The second image (middle) is a hundred yards upstream in the village of East Meon after the restoration by the South Downs National Park Authority and local volunteers. The other image (right) is an Environment Agency staffer monitoring the flow of the headwaters of the Itchen at Cheriton.

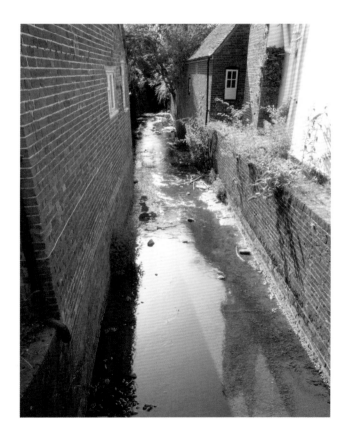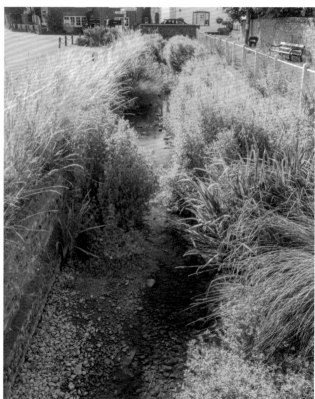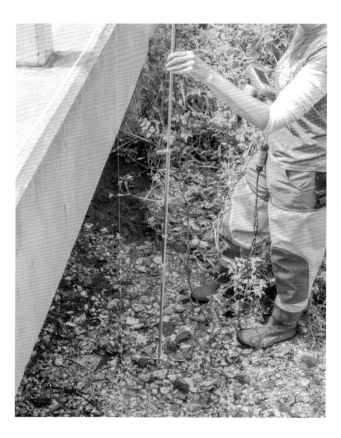

Woody material can be utilised to create more diverse aquatic habitat. Fallen trees left in the water or repositioned create cover and hiding places for fish and other aquatic organisms. Water flowing over and around large wood material, produces localised scouring to the river bed and banks, creates pools and undercuts banks to provide additional shelter for fish. Finer substrate, such as small gravel, is deposited upstream of large woody material as flows are slowed, providing an important spawning habitat for some fish species. The wood provides a surface for algae to grow on and often traps leaves, and other organic material, which are food sources for a variety of aquatic macroinvertebrates. (right and overleaf)

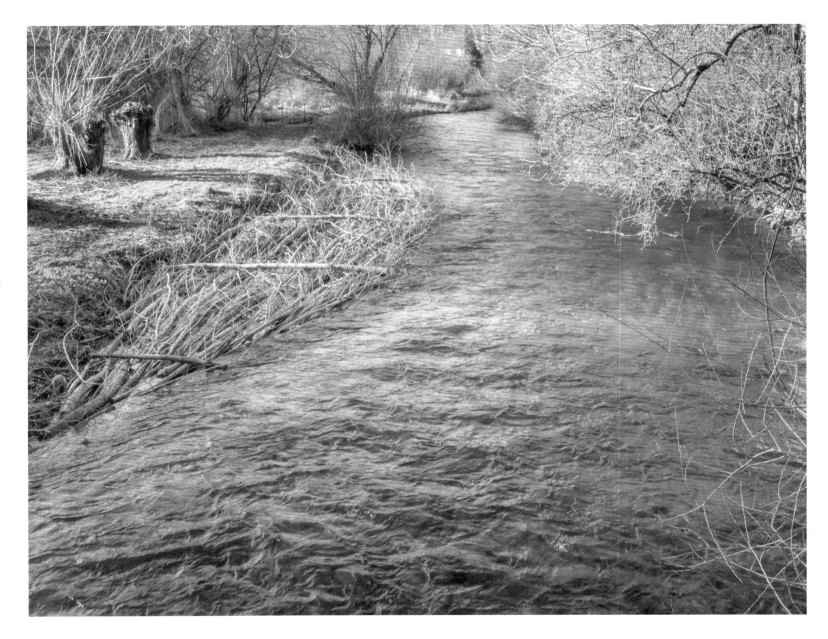

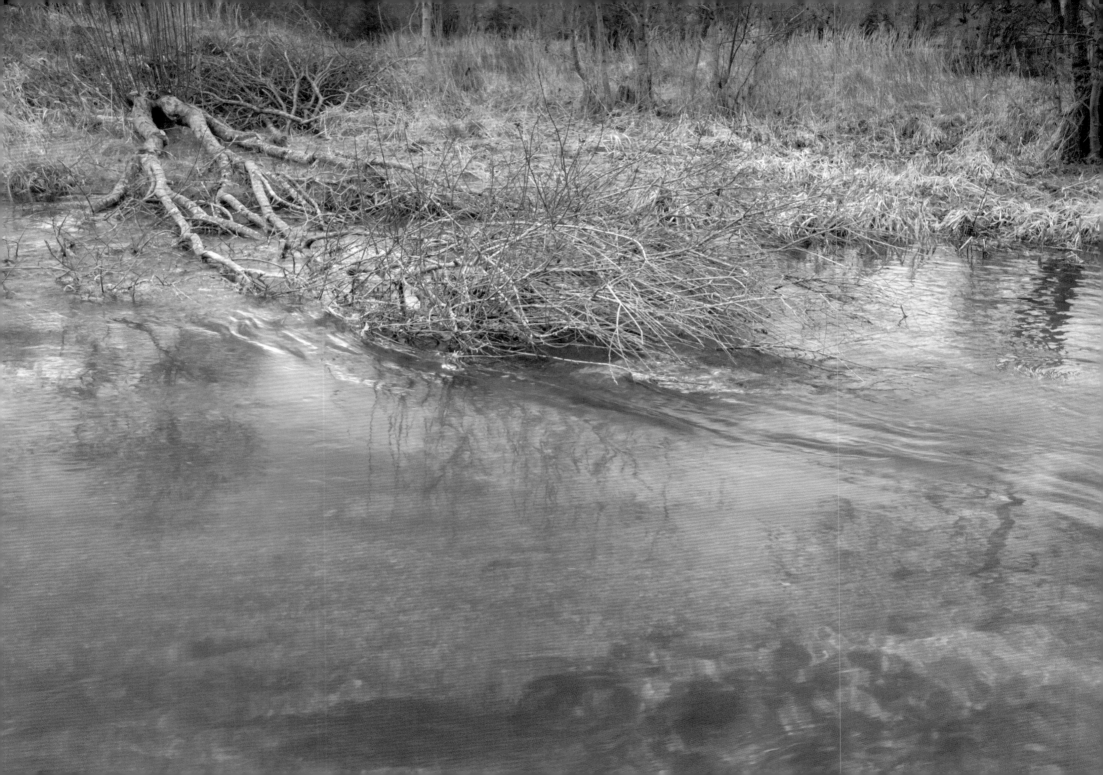

THREATS

There are many threats to the fragile environment of the chalk streams – harmful chemicals getting into the aquifers or directly into the river from poor agricultural methods, farm effluent and industrial pollution; over-abstraction; climate change and urban development. Evidence of this is being scientifically monitored by organisations such as the Salmon & Trout Conservation UK. But it needs the general public to put pressure on Government and its agencies to minimise the damage and degradation of these precious habitats. There are many visible signs of this degradation. Ribbon weed, which grows in late summer when water flows are weak, can clog the river and smother the varieties of weed that provide habitat for macroinvertbrates (upper Itchen).

Filamentous algae, which is so damaging to the habitat for macroinvertebrates, can be caused by high levels of phosphates in the water (right image).

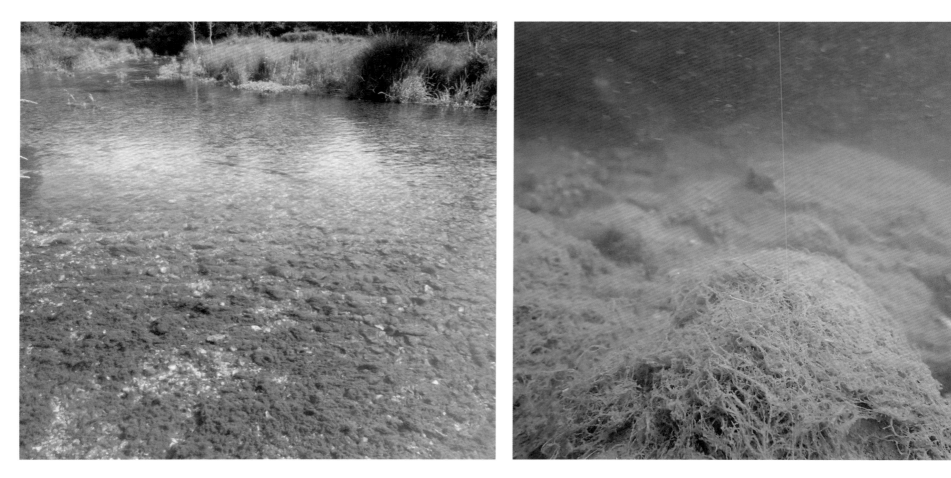

▲ Pollution is a constant threat. Algae, caused by low flows and high levels of phosphates in the water, stifling everything else on the upper Itchen (left). The image above right shows a disgusting sight three miles from the source of the Wylye – massive mounds of algae on the river bed and sediment choked weed. This can be caused by phosphates and other toxic chemicals getting into the water from commercial and agricultural sites.

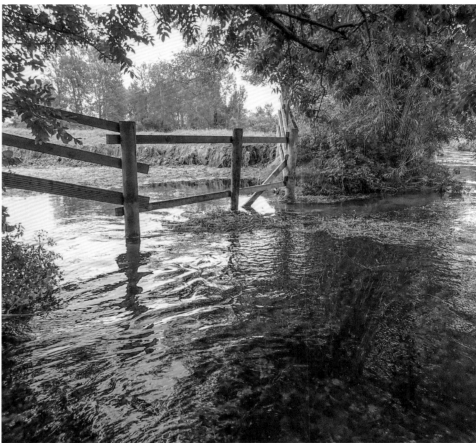

Cress farms (left) which depend on plentiful supplies of clean water from the rivers, need to ensure that they do not pollute the water they return to the river. This will happen if they use toxic chemicals for rinsing the watercress and other salad products or for cleaning machinery. The fenced cattle drink on the Wylye (right) is to ensure the cattle do not breakdown the banks and put excess sediment into the river. This one still requires some work as there is significant erosion from the field.

Invasive Species

There are a number of examples of invasive, non-native species introduced into this country which have had unforeseen consequences. The best known is the Grey squirrel and the effect on our native Red squirrel. On the rivers there are plants such as Himalayan balsam. American signal crayfish (below) were introduced to this country in the 70's but they are carriers of a plague that is thought to kill the native White-clawed crayfish which is now a highly endangered species. The American signal crayfish is found in huge numbers on some chalk streams. They burrow in the river bank to such an extent that it can become unstable.

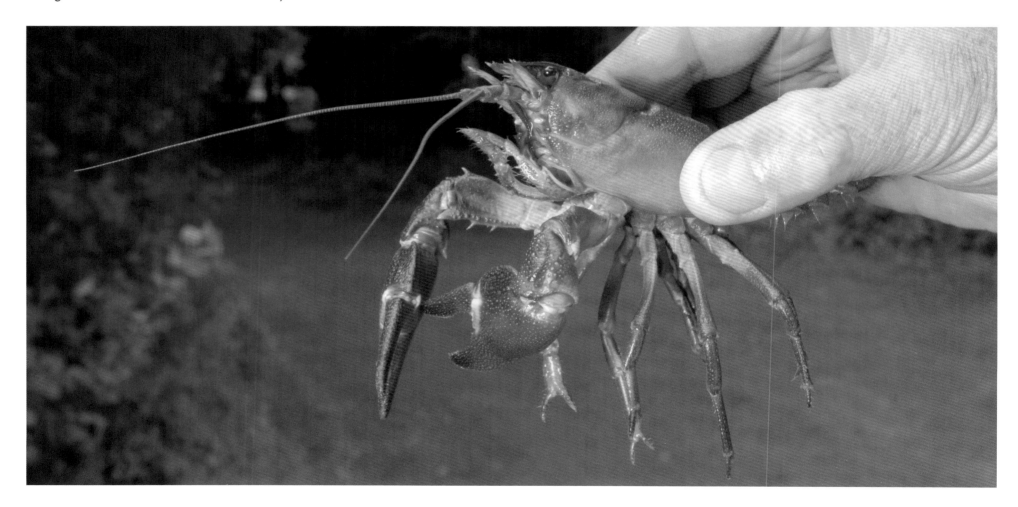

Aggressive looking American
signal crayfish!

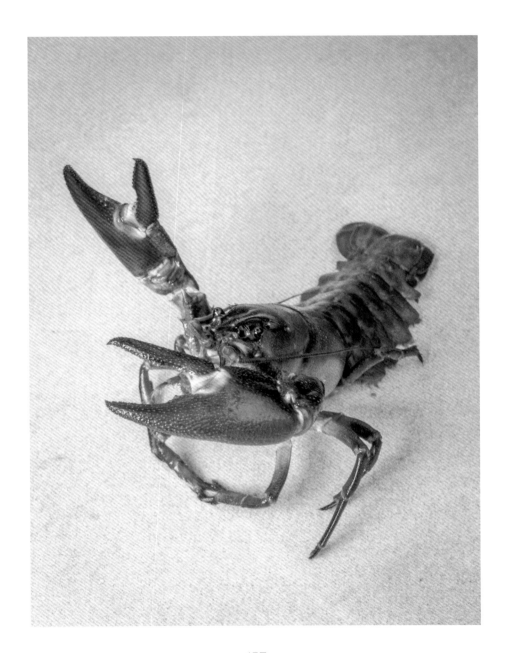

ACCESS

Some stretches of chalk streams run through private land and some are owned by or looked after by Wildlife Trusts and fishing societies, so access can be limited. But many have public footpaths along sections, with The Itchen Way and The Test Way being examples. The bridge over the Itchen (below right) that features several times in this book is on a public footpath. The image of the eel traps at Leckford shown in the section on fishing beats was photographed from the public road. There are many pubs with gardens running down to the rivers (below left, the Mayfly at Fullerton on the Test). All flow through towns and cities, for example Winchester (Itchen) and Salisbury (Avon). While many chalk streams flow through beautiful countryside, not all. For instance, the little known River Wandle flows through the urban sprawl of South London into the River Thames and is easily accessible to all via public footpaths.

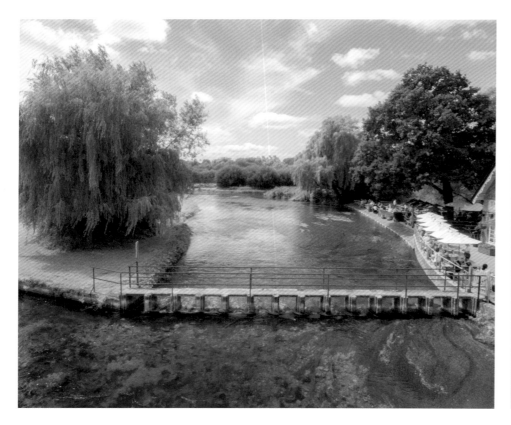 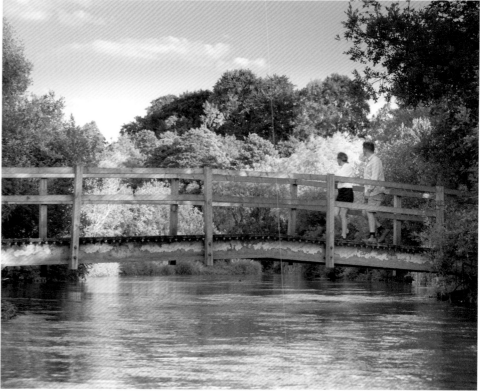

ACKNOWLEDGEMENTS

I would like to thank the many people who have helped me with this book – it would not have been possible without them.

Key to managing the practicalities of time and logistics was the guidance on locations and the introductions that helped me to be in the right place and at the right time. Thanks to David Blake, Tony Bird, Simon Cain, Craig Dawson, Joe Emmett, David Harrison, Peter Hellard, Lee Jackson, Shaun Leonard, Stuart McTeare, Nick Measham, Ali Morse, Bob Wellard and Bruce Wheeler.

Mick Green for access to the Bishopstoke Fishing Club waters.

Stuart Wilson for access to Britford water meadows.

Anthony Edwards for access to his fishery and also help with getting pre-orders of the book.

Nick Gooderham for his support, without whom I would not have been able to get the photographs of spawning activity of Brown trout.

Elaina Whittaker-Stark, without whom I would never have located the elusive water vole on the river Meon.

Hadrian Cook and Janet Fitzjohn of Harnham Water Meadows Trust.

Dr Ben Rushbrook for allowing me to trail him on field surveys.

Dr Stephen Gregory for checking the first draft.

David Watson, who provided a review of a first draft, some constructive suggestions on content and the confidence I was on the right track with the format of the book.

Nigel & Felicity Stribley for their belief in the project and their support.

Mike Baker for his encouragement and support throughout the project.

Duncan Potter at Riverside Publishing Solutions for being patient with a first time author.

My wife Lynne, daughters Charlotte and Katherine for their support and encouragement.